Exhibition and catalogue sponsored by United Technologies Corporation

The American-Australian Foundation for the Arts
International Cultural Corporation of Australia Limited

Distributed by Harry N. Abrams, Inc., New York

AMERICA: Art and the West

Text by Celeste Marie Adams, Franklin Kelly, Ron Tyler

Exhibition Tour:

Art Gallery of Western Australia
Perth, Western Australia
December 11, 1986–January 21, 1987

Art Gallery of New South Wales
Sydney, New South Wales
February 6–April 5, 1987

Published jointly by The American-Australian Foundation for the Arts and the International Cultural Corporation of Australia Limited.

This publication Copyright © 1986 by The American-Australian Foundation for the Arts and the International Cultural Corporation of Australia Limited.
ISBN 0-642-10135-3
ISBN 0-8109-1856-0 (Abrams)
Library of Congress Catalogue No. 86-71833

America: Art and the West is designed by Derek Birdsall R.D.I.
Production supervised by Martin Lee
Edited by Carolyn Vaughan and Anne Feltus
Typeset in Modern No.7 & Clarendon
and printed on Parilux Matt White 150gm²
by Balding + Mansell Limited, England, 1986

An exhibition organized by The American-Australian Foundation for the Arts in association with the Art Gallery of New South Wales.

Managed by the International Cultural Corporation of Australia Limited.

Supported by a grant from the U.S.I.A.

Indemnified by the Australian Government through the Department of Arts, Heritage and Environment.

Official Carrier: Qantas Airways Ltd.

Cover: Wayne Thiebaud, *Cliffs* 1968 (detail)
Private Collection. Cat. no. 70

Contents

Lenders to the Exhibition

Amon Carter Museum, Fort Worth, Texas
Australian National Gallery, Canberra
Sarah Campbell Blaffer Foundation, Houston, Texas
California Historical Society, San Francisco
The Cleveland Museum of Art
Collection of The Fort Worth Art Museum
Collection of the San Antonio Museum Association, San Antonio, Texas
Collection of the Santa Barbara Museum of Art
Cooper-Hewitt, Smithsonian Institution's National Museum of Design, New York
Courtesy of the Buffalo Bill Historical Center, Cody, Wyoming
The Denver Art Museum
The Enron Art Foundation/Joslyn Art Museum, Omaha, Nebraska
The Fine Arts Museums of San Francisco
Thomas Gilcrease Institute of American History and Art, Tulsa, Oklahoma
The Harmsen Collection
Harvard University Art Museums (Fogg Art Museum)
Carol Hepper
Kennedy Galleries, New York
Kraushaar Galleries, New York
Lane Publishing Company (Sunset Magazine, Books and Films)
Maier Museum of Art/Randolph-Macon Woman's College, Lynchburg, Virginia
Mr. and Mrs. John W. Mecom, Jr.
Mr. and Mrs. Alexander K. McLanahan
The Museum of Fine Arts, Houston, Texas
Museum of Fine Arts, Museum of New Mexico, Santa Fe, New Mexico
National Gallery of Art, Washington, D.C.
National Museum of American Art, Smithsonian Institution, Washington, D.C.
New Orleans Museum of Art
The Oakland Museum
Mr. and Mrs. Roy S. O'Connor
The Pace Gallery, New York
Mr. and Mrs. James R. Patton, Jr.
Mr. and Mrs. Gerald P. Peters, Santa Fe, New Mexico
The Phillips Collection, Washington, D.C.
David Rockefeller, Jr.
Roswell Museum and Art Center
San Francisco Museum of Modern Art
Vassar College Art Gallery, Poughkeepsie, New York
Whitney Museum of American Art, New York
Michael and Stephanie Young
and those private collectors who wish to remain anonymous

Foreword

The International Cultural Corporation of Australia is once again delighted to be associated, as the managing body, with another major and very special exhibition for Australia. This exhibition, *America: Art and the West* has been organized to coincide with the sailing of the prestigious and exciting America's Cup races in Perth and will then be shown in Sydney.

This is the first project to be undertaken by the newly established American-Australian Foundation for the Arts. In thanking Grace Grasselli Bowman and Angela Downer Clauson for all their work in realizing this initial exhibition, I must also pay due acknowledgment to the initiative they have taken in forming the Foundation. We look forward to future cooperative undertakings with the Foundation.

The Australian Government, through the Department of Arts, Heritage and Environment, has once again helped bring a major exhibition into existence through its Indemnity Scheme which ICCA manages. We are also glad to acknowledge the special financial support of the United States Information Agency.

This is the second exhibition that United Technologies Corporation has sponsored for Australia. In 1985 we enjoyed a most successful partnership with United Technologies in bringing the Pop Art exhibition to Sydney, Melbourne, and Brisbane. Its generous support of that exhibition and the outstanding catalogue set new standards in the presentation of major art exhibitions in this country. We are greatly indebted to United Technologies, for its continuing and imaginative support. Most especially we are grateful to Messrs. Robert Daniell and Harry Gray of that Corporation. Finally, to all the lenders, the curators, and participating galleries may I, on behalf of the Board of Directors of the International Cultural Corporation of Australia, express our deepest thanks.

James B. Leslie
Chairman
International Cultural Corporation of Australia Limited

We hope our Australian friends will be as pleased and interested as we were to find, in this exhibition, that art of the American West goes far beyond the expected cowboys and Indians to include some of the most adroit and powerful of contemporary American work.

It is a pleasure to support such an impressive show and such a handsome catalogue.

Robert F. Daniell
President and Chief Executive Officer
United Technologies Corporation

Acknowledgments

It has been a great privilege to bring together for this international loan exhibition so many fine works of nineteenth and twentieth century American art. This is the first exhibition of American art, inspired by the West, to have been seen by an Australian audience.

For this initial project of The American-Australian Foundation for the Arts the theme of the landscape of the American West seems particularly appropriate. Works of art, although independent of national considerations, have an identity formed by the environment that nurtures them. In the 'confrontation, not only with an awe-inspiring landscape but also with an indigenous people' that is described by Edmund Capon in his foreword to this catalogue, the West, as a resource from which American artists could draw, provided an experience that was in a sense paralleled in Australia. This experience and the American artists' response to it are themes of this exhibition.

We are particularly pleased to have this opportunity to express our sincere appreciation to United Technologies Corporation for its extremely generous grant in support of this exhibition and catalogue. We are very grateful for its endorsement and for its encouragement and cooperation throughout this project.

We are also indebted to the United States Information Agency; to Cargo Development Group; to the Lane Publishing Company; and to the Brown Foundation, Inc. Rupert Murdoch and Mr. and Mrs. Roy S. O'Connor have also given their most generous support. We wish to thank all of these organizations and individuals who have made this exhibition possible.

Many others have helped to make this exhibition a reality. We are most deeply indebted to the lenders who have given us the opportunity to share their works with an Australian audience. Twenty-five public collections and sixteen private collectors have participated. Their generosity and enthusiasm have been an enormous support. The trustees of the Thomas Gilcrease Institute of American History and Art, and its Director, Fred A. Myers, have been especially gracious.

We are especially grateful to Celeste Adams of the Museum of Fine Arts, Houston. As Curator, she has worked with us closely throughout the project and has given unstintingly of her time and expertise. We thank the authors of the catalogue, Celeste Adams, Franklin Kelly of the National Gallery of Art and Ron Tyler, Director of the Texas State Historical Association, who acted as Consulting Curator for the show. Our warm appreciation goes to Derek Birdsall who designed the catalogue, Martin Lee who supervised its production and to those who have provided invaluable assistance in the preparation of the manuscripts for publication: Editors Carolyn Vaughan and Anne Feltus; Dornith Doherty, Research Assistant; Neal von Hedemann, who designed the maps, and Jill Morgan, who typed the manuscripts.

Our thanks are due to Dr. Evan H. Turner, Director of the Cleveland Museum of Art, for his encouragement and advice in the earliest days of the project, and to Dr. Peter Marzio, Director of the Museum of Fine Arts, Houston, for his support.

We express profound gratitude to the Honorable Laurence William Lane, Jr., American Ambassador to Australia for his encouragement and support, and to His Excellency Mr. F. Rawdon Dalrymple, Australian Ambassador to the United States. We also wish to thank Dr Henry Ryan of the United States Information Service in Canberra. We are most grateful to the Australian Government for the indemnification of the exhibition and to the International Cultural Corporation of Australia for managing the project.

We would like to thank our colleague Edmund Capon, whose professional expertise has been an invaluable help. Many other people have helped in the success of this endeavor in crucial ways, and we especially thank the following: Frank Ellis, Former Director of the Art Gallery of Western Australia; Sir James Cruthers; Samuel A. Bowman; Ray Johnson; Ann T. Lurie, Hannelore Osborne and Martha Thomas of the Cleveland Museum of Art; and Karen Bremer, Amy Studer, Robert Frank and Patricia Rosenstein.

Grace Grasselli Bowman
Chairman
The American-Australian Foundation for the Arts

Angela Downer Clauson
President
The American-Australian Foundation for the Arts

Preface

This exhibition should, and I am sure will, strike many a poignant chord with Australian audiences. After all, the processes of evolution from early European settlement in North America to the present day bear many similarities to the Australian experience, and those processes have been similarly recorded and expressed by the artists in both continents.

What, above all, they have in common is the confrontation with a landscape of truly 'New World' proportions and immense diversity. The paintings of Bierstadt and Moran, for example, capture with vivid majesty the grandeur and scale of the North American landscape, particularly the rolling plains of the Midwest, the daunting deserts, and the towering peaks of the Rockies. And yet these artists, just as Von Guerard and Piguenit in Australia, captured those momentous landscapes with a European sense of detail that sometimes reminds us that we could be looking at the Scottish highlands or the Alps.

There was, in both America and Australia, a confrontation not only with an awe-inspiring landscape but also with an indigenous people. Inevitably the iconography of the North American Indian permeated the ethic and touched the aesthetic of artists who followed in the tracks of the pioneers, just as Australian artists have been moved by the persuasive elements of aboriginal material culture. Interestingly, in both America and Australia, this awareness of and sympathy for the cultural identity of the indigenous population occurred only after the landscape had to some extent been digested. In America, Marsden Hartley was the first to be seduced by such motifs, while in Australia the submission was a little later, in the 1920s, but the evolutionary processes of recognition were essentially similar in both America and Australia.

The parallels do not end there. It is an indisputable fact that the art of the so-called Western World, America and Australia included, is essentially an urban art reflecting the bias of population distribution. And yet in America and Australia the unforgettable presence of the landscape, monumental, daunting, beautiful, sometimes embracing, sometimes hostile, cannot be overlooked and has, therefore, contributed to the distinctive aesthetic of the artists of both countries, even to the present day. It is that pervasive theme that this exhibition seeks to trace, and in doing so reminds us of the enduring and regenerative permanence of the natural environment.

The Art Gallery of New South Wales is proud to be associated with an exhibition of such indisputable originality, distinction and pertinence. On behalf of the two participating galleries, the Art Galleries of Western Australia and New South Wales, I extend grateful thanks to all those who have made the exhibition possible and, in particular, to Angela Clauson and Grace Bowman of The American-Australian Foundation for the Arts; the principal curator, Celeste Adams, Assistant Director of the Museum of Fine Arts, Houston; and to the lenders who have so generously made works, many of which are icons in the history of American art, available to Australia.

Finally, our thanks to United Technologies Corporation, firstly, for its most generous financial support of the exhibition, and secondly, for their characteristic concern and interest in supporting the production of an accompanying catalogue of such quality.

Edmund Capon
Director
Art Gallery of New South Wales

Introduction

America, less than fifty years from declaration of national independence, turned its persistent gaze away from Europe in the East toward the expanse of its native unsettled West. All that was purely America shone in the late-day sun, untouched and untroubled by the shadow of European culture.

The westward explorations launched at the beginning of the nineteenth century piqued the curiosity of eastern seaboard residents seeking information about the peculiar character of a remote frontier. Early enthusiasm for the Indian portraits and documentary renderings of the western trails by painter-explorers gave way to changing attitudes by mid century.

Inspired by a new spirit of national idealism, America's first school of formally trained artists created grand and monumental landscape paintings of the West. A land of rugged primordial beauty, untapped resources, and unlimited space crystallized in the collective American consciousness as an abiding image of the native land. The promise of the West became the promise of America itself as waves of settlers crossed the Great Plains and braved the treacherous Rockies in search of prosperity and a better life.

To define the character of American art in the nineteenth and twentieth centuries, the West must be considered not only as the subject of art, but also as a physical and psychological reality of the American experience that continues to influence the outlook of American artists and to endow their works with distinct characteristics. The visual impact of the West and the assimilation of its spirit and substance into the mainstream of American art forms the premise of this exhibition. The works selected span 150 years of an evolving national art and pose some of the complex issues encountered in a nation's journey toward self definition.

Celeste Marie Adams
Curator

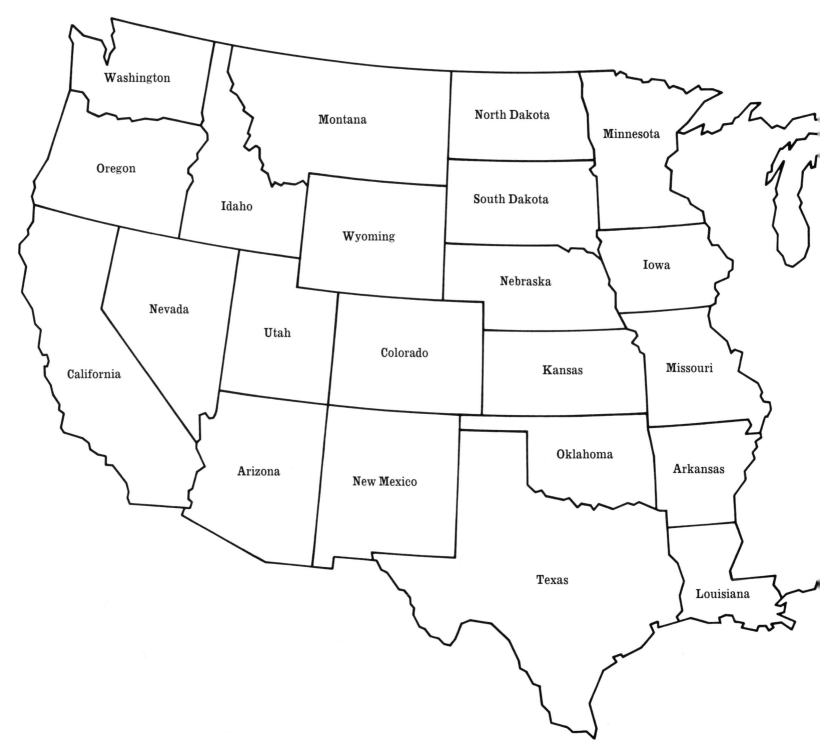

Reference Map of the West

Major geographical landmarks of the West
and sites mentioned in this catalogue appear
on this reference map.

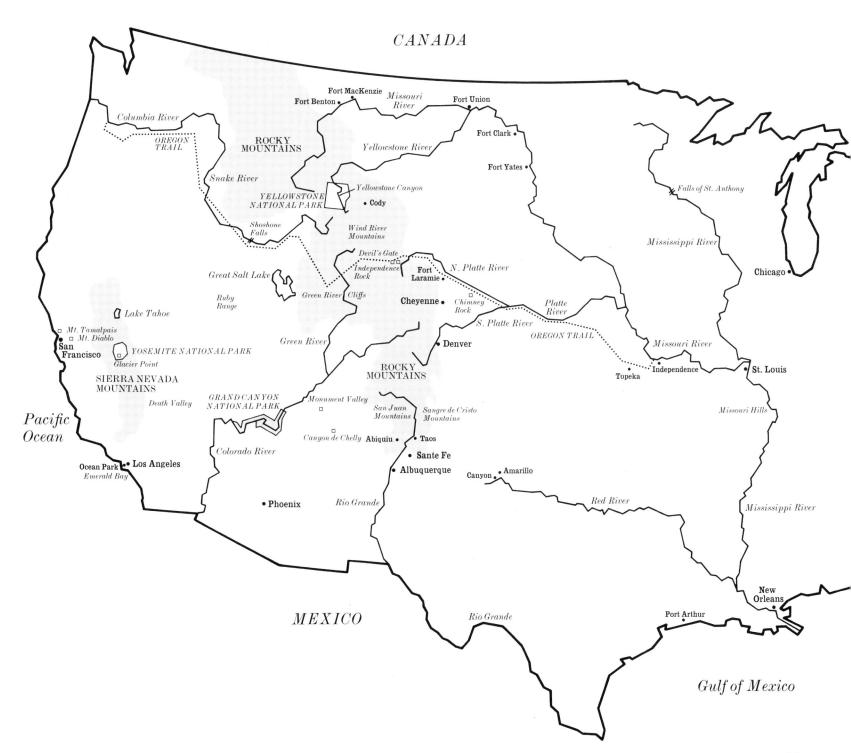

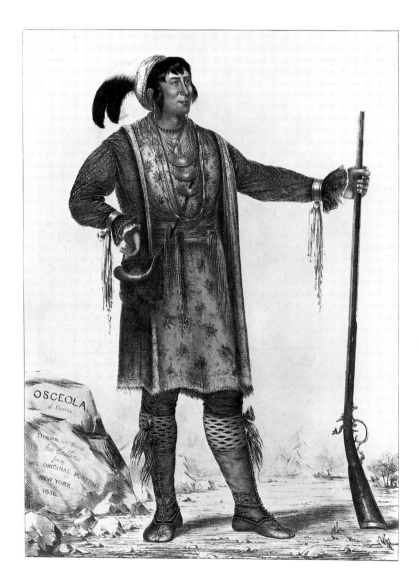

George Catlin (1796–1872)
Osceola of Florida, 1838, 69.8 × 52.4 cm., 27½ × 20⅝ inches
Courtesy Amon Carter Museum, Fort Worth, Texas

The discovery of the American West took place over several decades of the nineteenth century, for the Spaniards and French had done little to reveal it to the world while it was a part of their domain. Industrious Americans began probing it even before they had legal title. From 1803 to 1806, Captains Meriwether Lewis and William Clark led a successful expedition across the Great Plains to the Pacific Ocean at President Thomas Jefferson's behest, inspiring a nation, not yet sure of what it had acquired from France in the Louisiana Purchase of 1803, to think in terms of continental expansion. Zebulon M. Pike and Stephen H. Long followed with expeditions to different parts of the unexplored plains, greatly benefiting science and filling in maps of the *terra incognita* but having little popular impact.

The addition of artists to the exploring parties involved the public in a manner that could be accomplished in no other way, for the visual documentation of the West satisfied a long-felt urge to know more about this new land. The first artist to popularize the West was George Catlin, who gave up a potentially lucrative law practice to devote himself full time to painting. He was probably the most dedicated of those who documented the Indians and their culture, for he feared their imminent demise at the hands of the white man.[1]

Catlin's work was welcomed in Philadelphia, the intellectual center of the country and home to a large group of philosophers and naturalists who had long been curious about the new land and now hoped to learn more about it. Catlin was also encouraged by William Clark, then Governor of the Missouri Territory, who took the artist to a treaty-signing at Prairie du Chien during the summer of 1830.

Catlin began to paint the Indians of the Great Plains the following year, traveling up the Missouri River as far as Fort Leavenworth in present-day Kansas. In the spring of 1832, he made his way almost 2,000 miles up the Missouri, working feverishly to complete some 170 paintings, mostly small, hastily done landscapes and portrait sketches, which he finished the following winter. The *Buffalo Chase*, *Brick Kilns*, and *Prairie Meadows Burning* resulted, all exhibiting a hurried brushwork but also the artist's sure grasp of his subject.

Buffalo Chase illustrates a favorite Indian method of killing the animal that provided their food, clothing, and shelter. A bull attempts to protect a cow and calf in the final, fatal moment as a lance or arrow concludes the chase. *Prairie Meadows Burning* documents one of the great natural disasters that occurred periodically on the Great Plains, a prairie fire that swept everything before it, creating winds that fanned it to even greater heights, leaving a broad swath

of charred destruction. The *Brick Kilns* depicts an area that the travelers had named for its red appearance. Catlin later explained in his *Letters and Notes*, 'The curious bluffs must be seen as they are in nature, or else in a painting, where their colors are faithfully given, or they lose their picturesque beauty, which consists in the variety of their vivid tints.'[2]

Both Catlin and fellow portrait artist, John Wesley Jarvis, painted one of the most famous Indians of the day, Black Hawk, who led the Sauk and Fox tribe in an unfortunate frontier conflict known as the Black Hawk War. Catlin painted him in the fall of 1832, after he had been imprisoned near St. Louis. Jarvis depicted the dignity that Black Hawk, and his son, Whirling Thunder displayed during their 1833 visit to Washington, D.C., to negotiate with President Andrew Jackson for their freedom.

Eager to share his paintings with the public and to earn additional income, Catlin exhibited them in Pittsburg and Cincinnati in the spring of 1833. 'These are not the portraits of the depraved savages who linger upon the skirts of our advanced settlements,' commented James Hall, editor of *Western Monthly Magazine*. 'They are those of the manly Indian, as he exists in his own wide plains, joint-tenant with the buffalo, the elk, and the grisly bear; and they exhibit in a striking manner the distinctive features of the tribes to which they belong.'[3] Following additional trips into the Southwest and up the Mississippi to the Falls of the St. Anthony, Catlin began showing his Gallery of Indian Portraits in the fall of 1837.

When government troops captured the famous Seminole chief Osceola, who had for years heroically resisted the military occupation of Florida, Catlin went to Fort Moultrie, South Carolina, where the Indian was being held, to paint his portrait. Hoping to gain publicity for the Indian Gallery, which he was trying to sell to the American government, he quickly issued a lithograph of the full-length portrait. When no offer was forthcoming, he took the Gallery, accompanied by a troupe of performing Indians, on the road. The entourage toured Baltimore, Philadelphia, Washington, D.C., and Boston, then London and Paris, where they entertained King Louis Philippe, who had spent two years in exile in America and was familiar with Catlin's work.[4] It was probably during the British segment of the tour that Catlin painted the stunning portrait of White Cloud, a chief of the Iowas, whom he described as being among 'the aristocracy of the tribe.'[5] White Cloud, a member of Catlin's troupe, attracted much attention because of his colorful body paint, headdress of eagle feathers and quills, bear claw necklace, and white wolf skin.

Catlin's career did not end happily; the crowds dwindled until he could no longer afford to rent a hall for his Gallery, and in 1852 he sold the collection to Joseph Harrison, an American locomotive manufacturer. Eventually, it was deposited in the Smithsonian Institution, which had recently been established as the United States National Museum.

Even as Catlin was exhibiting his unfinished collection in Pittsburgh and Cincinnati in the summer of 1833, a more talented Swiss artist boarded the steamer that had carried Catlin up the

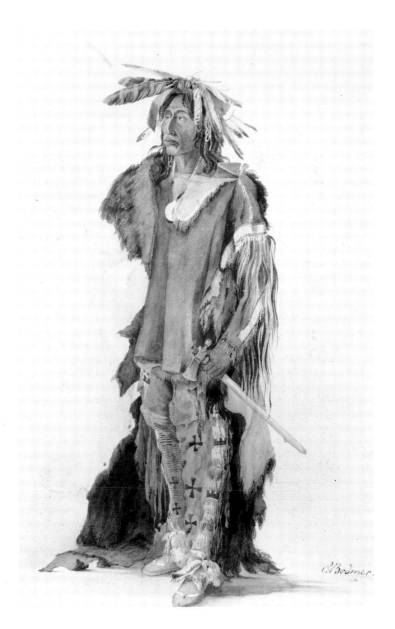

Karl Bodmer (1809–1893)
Wahktageli, Yankton Sioux Chief, 1833
42.5 × 29.5 cm., $16\frac{3}{4} \times 11\frac{5}{8}$ inches
The Enron Art Foundation/Joslyn Art Museum, Omaha, Nebraska

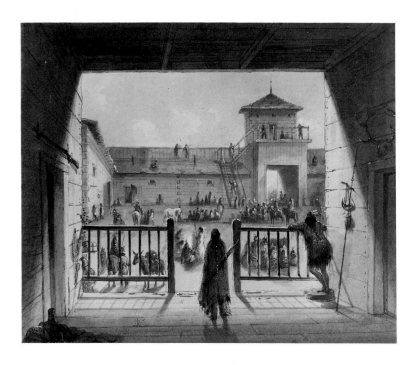

Alfred Jacob Miller (1810–1874)
Interior of Fort Laramie, 1858–60
29.5 × 35.9 cm., 11⅝ × 14⅛ inches
Courtesy Walters Art Gallery, Baltimore, Maryland

Missouri two years earlier and headed toward the same country, also intending to document the Plains Indians in paint. Young Karl Bodmer had been sketching along the banks of the Rhine River when he was discovered by the noted naturalist Maximilian, Prince of Wied-Neuwied, a student of the great Prussian scientist and scholar Alexander von Humboldt. Maximilian had already toured South America, completing a book on the native peoples of Brazil in 1820–21. Now he was preparing for a trip to the American West and needed an artist of Bodmer's ability to document the journey.[6]

Bodmer's exquisite watercolors, made under the watchful and exacting eye of the prince, comprise the most complete visual record of the Missouri River Valley — its land, flora, fauna, people, and settlements — during the early period of western exploration. In the summer and fall of 1833, Maximilian and Bodmer ascended the Missouri as far as Fort McKenzie, in present-day Montana, with Bodmer sketching all the way. *View of the Mississippi, Missouri Hills, Rock Formations, Assiniboin Camp, Assiniboin Medicine Sign,* and dozens of other fresh views come from this leg of the trip. Returning down river, they wintered at Fort Clark, near the villages of the Mandan and Hidatsa Indians in present-day North Dakota. Bodmer's stunning portraits, such as *Wahktageli, Yankton Sioux Chief,* are all the more valuable because of Maximilian's careful notes describing the Indian's appearance.

Wahtageli — or Big Soldier, as he was called by the Americans — was six and one-half feet tall and about sixty years old when Bodmer painted him. He is shown dressed in moccasins, leggings, and a shirt embroidered with bands of dyed porcupine quills and fringe on the sleeve that was said to be hair of one of his Mandan foes. His elegant buffalo robe was tanned to a brilliant white that even Maximilian noticed as being of exceptional quality. Wahtageli was a patient model, posing for two days while Bodmer completed the picture. When a smallpox epidemic decimated the Mandans and killed more than half of the Blackfeet in 1837, Bodmer's careful portraits assumed an even greater importance as a record of the individuals and their society.

By the time Bodmer began working with engravers and print-makers to produce the book that would record Maximilian's journey,[7] another young artist was making his way across the Plains who would penetrate even farther into the Rocky Mountains than had either Catlin or Bodmer. He was Alfred Jacob Miller, whose romantic and exuberant paintings convey a spirit that is absent in the more precise and scientific efforts of his predecessors. A Baltimore youth who had just returned from a year of study in Europe, he had established a studio in New Orleans. Miller was trying to earn a living by painting portraits of the Creole gentry and whiling away his time producing scenes of his native city, when Captain William Drummond Stewart happened into his studio in the spring of 1837. Stewart, a veteran of the Waterloo campaign, was headed west for what he thought might be his last adventure, and he wanted to commission a pictorial memento of the trip.[8]

The party left St. Louis in the spring, moving briskly toward the

Green River Mountains of southwestern Wyoming, along the route that would later be called the Oregon Trail. Miller documented life on the trail: camp scenes, traders pulling the bounty-laden wagons out of streams and up hillsides, wild horses, buffalo hunts, and finally Indians — unfriendly and threatening until Miller ascertained that they were friends with the veteran traders.

Fort Laramie, in present-day Wyoming, provided a pleasant break in the trek. There Stewart and Miller were surprised by the sophisticated taste of their host, Lucien B. Fontenelle, who had decorated his quarters with what Miller called 'large first-class engravings.'[9] Miller had a few days there to recover from the rigors of the trail and to discover that the Fort was a veritable crossroads for plains and mountain Indians. His handsome paintings, the only visual records of the original Fort Laramie, show a stockaded post approximately 100 feet square and defended by three towers, one over the entrance and the other two at opposite corners.

Stewart's destination was the Rendezvous in the Green River Mountains, an annual gathering of trappers and traders that by 1837 had turned into a grand affair, characterized by one observer as 'one continued scene of drunkenness, gambling, and brawling and fighting, as long as the money and credit of the trappers last.'[10] At the Rendezvous, traders, trappers, and Indians exchanged blankets, cheap cloth, vermilion, traps, and other goods for the pelts that they had accumulated during the year. Miller was the only artist to witness the Rendezvous during its halcyon days. His paintings are among the only visual documents of these colorful events in American history.

An accepted fact of western life was the ubiquitious presence of herds of bison. Thirty million bison may have ranged over the continent from the Mexican border and into Canada, testing the skill of the painter as well as the writer. 'The face of the country was dotted far and wide with countless hundreds of buffalo,' Frances Parkman wrote in 1849.

They trooped along in files and columns, bulls, cows, and calves, on the green faces of the declivities . . . They scrambled away over the hills to the right and left; and far off, the pale blue swells in the extreme distance were dotted with innumerable specks . . . The prairie teemed with life. There was nothing in human shape amid all this vast congregation of brute forms.[11]

Catlin, Bodmer, and Miller painted the buffalo hunt, but the artist who best documented the beast was William Jacob Hays, whose *Herd on the Move* is the only painting to illustrate adequately Parkman's prose.

Hays made one trip west, in 1860, and by the fall of that year he was back in New York City at work on the canvas, which he hoped would 'convey the width and breadth of these innumerable hordes of bison.' He showed them as they crossed a river bottom 'in search of water and food, their natural instincts leading them on They form a solid column,' he wrote, 'led by the strongest and most courageous bulls, and nothing in the form of natural obstructions seems ever to deter their onward march'[12]

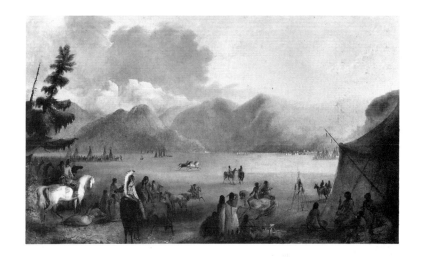

Alfred Jacob Miller (1810–1874)
Indian Village, c.1850
76.8 × 122.5 cm., $30\frac{1}{4} \times 48\frac{1}{4}$ inches
Courtesy Amon Carter Museum, Fort Worth, Texas

By 1865 and the end of the Civil War, which brought American internal exploration to a virtual standstill, western life had changed considerably. The discovery of gold near Sacramento had led to an unprecedented western migration and almost immediate statehood for California in 1850. The transcontinental railroad was completed in 1869, bringing tourism with it, and Easterners were picnicking in Yosemite Valley by the time that William Hahn, a painter of genre scenes, arrived there in 1874.

Born in Saxony in 1829, Hahn had studied in Dresden and Dusseldorf before coming to the United States. By 1872 he was in San Francisco, where his paintings were winning praise from the local critics. *Yosemite Valley from Glacier Point*, depicting a party of tourists viewing the breathtaking California scenery, is one of a series of three paintings that he did of the region in 1874.[13]

By the end of the century, two painters had firmly established the cowboy and the Indian as familiar western images. Henry Farny, who was born in France in 1874 and moved to America at age six, chose the Indian as his subject. Frederic Remington, more than ten years younger than Farny, painted the cowboy as a quintessentially American character.

Following extensive study in Europe, Farny made his first western trip in August 1881, to Fort Yates on the Missouri River. He took photographs and gathered Indian artifacts, which he later represented in his paintings. The Sioux allegedly gave him a name, which is represented by the circle and dot that appear on many of his paintings. He returned to the East, enthusiastic about the West as a subject for artists. 'The plains, the buttes, the whole country, and its people,' he concluded, are 'fuller of material for the artists than any other country in Europe.'[14] Subsequent trips as an illustrator for *Century Magazine* took Farny to Helena and Fort Benton in Montana Territory. By 1885 he had established his mature style and was depicting the Indians and their way of life in the sensitive images for which he is famous. *Days of Long Ago*, composed in the studio in 1903, recalls Farny's many experiences and observations in the West.

Remington had returned from his western trips to find himself acclaimed as an illustrator and well on his way to becoming the most famous journalistic artist in the country. Known especially for his pictures of General Crook's campaign to capture the Apache Indian chief Geronimo, Remington had earned a reputation for accuracy. As an artist, however, Remington aspired to a more creative style than was allowed to him as a journalist. At the height of his career two developments led to his best work. One was his turn to sculpture in 1895. His first sculpture, *The Bronco Buster*, was a huge critical and commercial success; it became the most famous American sculpture of the late nineteenth century. In this work he moved away from the narrative detail and context that had permitted his audience to identify his work with specific times and places. He wanted the viewer to look beyond the specific subject and to focus upon the universal quality in his work. 'Every man sees with his own eyes,'[15] he wrote. The viewer would now have to provide the context; he would have to focus his attention on the conflict that Remington presented.

Other handsome and successful bronzes quickly followed: *The Cheyenne*, which he described as 'an indian & a pony which is burning the air,' came in 1901; *The Mountain Man*, 'one of those old Iriquois [*sic*] trappers who followed the Fur Companies in the Rocky Mountains in the '30s & '40s' in 1903; and *The Stampede*, which Remington was working on at the time of his death, cast post-humously in 1910.[16]

The second development came about as a result of Remington's realization that the West of his images had become an historic fact. The West was no longer a place where his 'men with the bark on,' could fulfill their potential. Where clear skies once had welcomed the weary traveler to Denver, by 1900 smokestacks greeted him. 'My West . . . put on its hat, took up its blankets, and marched off the board,' he said. Writing to his wife from Santa Fe in November 1900, he continued, 'Shall never come west again . . . It spoils my early illusions — and they are *my* capital.'[17]

An enormous artistic outburst followed, as Remington created some of his best paintings, modern in style and concept, celebrating an historic West. *His First Lesson*, painted in 1903, demonstrates Remington's awareness of the achievements of impressionism. Unlike his earlier illustrations, *His First Lesson* carries a meaning beyond the immediate scene. The viewer, after noting how cautiously the two men approach the pony, and the distance that the mounted cowboy is keeping, also observes the horse's panic. This is more than an anecdotal scene. This pitiful bronco evokes an immediate sympathy and a larger understanding: it represents Remington's historic West, tied-up, saddled, and about to be broken — civilized and brought much against its will, but surely and certainly, into the modern world.

The Stampede, painted in 1908, demonstrates Remington's belief in the ultimate conflict between man and nature. 'I think . . . man was never called on to do a more desperate deed then [*sic*] running in the night with long horns taking the country as it comes and with the cattle splitting out behind him, all as mad as the thunder and lightning above him, while the cut banks and [prairie] dog holes wail below,' Remington wrote a friend in 1908. An excellent example of his mature, painterly style, this dynamic and desperate rider, brilliantly spattered by light and set against a green-blue shroud of rain and sky, struggles in the elemental conflict that Remington envisioned. 'Nature is merciless,' he concluded.[18]

The Stampede provides an enduring image of the old West. The lonely figure of the cowboy on his horse battling nature's elements is a symbol of the romance, freedom, and will to survive that still characterize the spirit of the western frontier. In such paintings as this, and in his sculpture, Remington's cowboy figures take on a universality that provides for twentieth-century America an enduring symbol and a lasting connection with the historic West.

1. William H. Truettner, *The Natural Man Observed: A Study of Catlin's Indian Gallery* (Washington: Smithsonian Institution Press, 1979), p. 14.

2. George Catlin, *Letters and Notes on the Manners, Customs, and Condition of the North American Indians* (2 vols.; London: Published by the author, 1841), Vol. 1., pp. 69–70.

3. Quoted in Truettner, *The Natural Man Observed*, p. 26.

4. Ibid., p. 48.

5. Ibid., p. 294.

6. William H. Goetzmann, et al., *Karl Bodmer's America* (Lincoln: Joslyn Art Museum and University of Nebraska Press, 1984), p. 186.

7. Maximilian, *Reise in das Innere Nord-America in den Jahren 1832 bis 1834* (Koblenz: J. Hoelscher, 1839–41), later appeared in French and English editions. The text was later edited and included as Maximilian, Prince of Wied, *Travels in the Interior of North America 1832–1834*, vols. 22–25, in Rueben Gold Thwaites, ed., *Early Western Travels, 1784–1846* (Cleveland: Arthur H. Clark Co., 1906).

8. Ron Tyler, ed., *Alfred Jacob Miller: Artist on the Oregon Trail* (Fort Worth: Amon Carter Museum, 1982), pp. 19–20.

9. Quoted in Marvin C. Ross, ed., *The West of Alfred Jacob Miller (1837), from the Notes and Water Colors in the Walters Art Gallery* (Rev. and enlarged ed.; Norman: University of Oklahoma Press, 1968), p. 49.

10. George Frederick Ruxton, *Ruxton of the Rockies: Autobiographical Writings by the Author of Adventures in Mexico and the Rocky Mountains and Life in the Far West*, comp. Clyde and Mae Reed Porter, ed. LeRoy P. Haven (Norman: University of Oklahoma Press, 1950), p. 230.

11. Frances Parkman, *The Oregon Trail*, ed. by E. N. Feltskog (Madison: University of Wisconsin Press, 1969), p. 82.

12. For information on Hays, see Robert Taft, *Artists and Illustrators of the Old West, 1850–1900* (New York: Charles Scribner's Sons, 1953), pp. 36–52, quotes on p. 47.

13. Marjorie Dakin Arkelian, *William Hahn: Genre painter, 1829–1887* (Oakland, California: The Oakland Museum, 1976), esp. pp. 22–27.

14. Quoted in Denny Carter, *Henry Farny* (New York: Watson-Guptill Publications, 1978), p. 21.

15. Remington to Owen Wister, October and January, 1895, in Ben Merchant Vorpahl ed., *My Dear Wister: The Frederic Remington-Owen Wister Letters* (Palo Alto, California: American West Publishing Company, 1972), pp. 158–165.

16. Peter H. Hassrick, *Frederic Remington* (New York: Harry N. Abrams, Inc., 1973), pp. 192, 194, 210.

17. Ibid., p. 39.

18. Quoted in Peter H. Hassrick, *Treasures of the Old West: Paintings and Sculpture from the Thomas Gilcrease Institute of American History and Art* (New York: Harry N. Abrams, Inc., Publishers, 1984), p. 71.

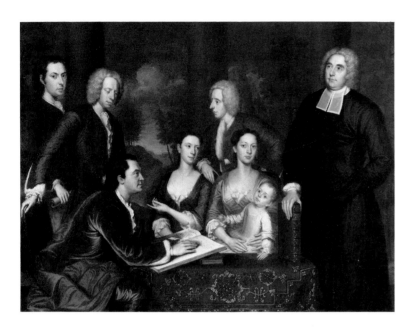

John Smibert (1688–1751)
Dean George Berkeley and his Family (The Bermuda Group), 1728–29
176.5 × 236.2 cm., 69½ × 93 inches
Yale University Art Gallery, New Haven, Connecticut

'In the beginning,' wrote John Locke, 'all the world was America.'[1] The discovery of the New World, a vast, unknown continent untouched and unchanged from its primeval state, provided an opportunity to see the world as it had been at Genesis. In the Old World, centuries of habitation and the mixed blessings of civilization had erased all vestiges of Paradise, but the New World was, as yet, unsullied. Thus, even before very much of America had been explored and seen, a pervasive vision of what it represented had formed in the minds of Europeans.[2] It was, quite simply, 'Paradise Regained,' as Captain Arthur Barlow put it in 1584 after having seen the lush beauty of coastal Virginia.[3]

The initial concept of the New World as a second Eden was quickly tempered by the realization that this untouched land did not yield up its bounty easily, nor did it always accept its new inhabitants willingly. The battle to settle the New World, first in the Colonies of the eastern seaboard and ultimately across the face of the entire country, represented the 'first example of the struggle between civilized man and barbarous, uncultivated nature.'[4] The field where that battle was fought — the 'frontier' — was not fixed, and it constantly shifted westward as civilization took hold.

The very word 'frontier' has a special place in American history and, even more, in American mythology. Unlike the traditional European designation for a boundary between two countries, the word in America came to mean an unknown, untouched, and unused place that offered fresh opportunities and challenges.[5] That the word still carries these associations today is evident in the popular perception of space as the final frontier.

Some have argued — Frederick Jackson Turner chief among them — that the pull of the vacant continent, with its constantly receding frontier drawing the population ever westward, was the single most important element in defining what is thought of the 'American character.'[6] Turner asserted that the advance of American civilization westward along the frontier could 'explain American development' by its encouragement of such basic traits as individualism and self-sufficiency and by its fostering of democracy and nationalism.[7] To understand the landscape images of the West that are presented here — images that were primarily produced for an eastern audience far removed from the realities of frontier life — it is useful to bear in mind some aspects of the frontier thesis: namely, that the American landscape was different, new, unspoiled and, in some fundamental yet elusive way, special to the development of American cultural

attitudes and beliefs. How artists not only gave pictorial form to the physical realities of the American landscape but also gave voice to the vision of what those realities promised is a subject of considerable complexity.[8] It is, first of all, necessary to trace the story from its beginning, when the frontier of America lay on its eastern coast.

The first images of America were made by artists who were members of early exploratory teams.[9] This link between art and exploration in the New World remained in place for a considerable time. The drawings and watercolors of Jacques Le Moyne de Morgues, who accompanied the French expedition to Florida in 1564, and of John White, who was with Sir Walter Raleigh in 1585, recorded the appearance of native inhabitants, flora and fauna, and the topography of the coastal regions. These are extraordinary documents, and their publication and dissemination in Europe played an important early role in informing the Old World about the character and appearance of the New World. Nevertheless, these straightforward, factual images are not charged with any special message or vision.

The first picture that legibly and forcibly expressed something about the character of the New World was John Smibert's *Dean George Berkeley and His Family* (*The Bermuda Group*). The painting has long been a landmark in the history of American art, primarily because it is the first fully professional portrait created in this country. Its subject commemorates Berkeley's plan to establish a college in the New World as a first step in transforming the wilderness into a civilized version of Paradise. Although Berkeley's plans were never realized, his vision of the inherent potential of the New World had considerable influence on American thought, especially in the nineteenth century. Indeed, it was he who wrote the words that would become a rallying cry of nationalistic fervor a century later: 'Westward the course of empire takes its way.'[11]

It may seem curious to find in this formal group portrait the first effective representation of the New World frontier. It is primarily an image of Berkeley and his assistants and an homage to what they hoped to achieve. In the background, unobtrusive but impossible to miss, is a landscape that unmistakably represents the New World. The rocky cliffs surrounding an inlet and the tall trees suggest the landscape of Newport, Rhode Island, where Berkeley settled briefly. Significantly, there is nothing of man's handiwork visible. The slate is, as yet, blank, but the landscape beckons like a gateway, challenging men such as Berkeley to take advantage of its potential.

For colonists of Smibert's day and much of the eighteenth century, the actual frontier of the New World had receded from the coast, but it still lay close at hand in the mysterious lands beyond the Appalachian Mountains. Much of the East itself remained wilderness, and there was little incentive to expand beyond the broad coastal plains of the South and the Northeast. Landscapes of the period, which do not survive in any great number, were generally in a Claudian or picturesque mode, depicting the New World as if transformed by the civilized tastes of Europe. But the dominance of this imposed Old World vision would soon give way, as it proved unsuitable to ambitions and beliefs of the new republic.

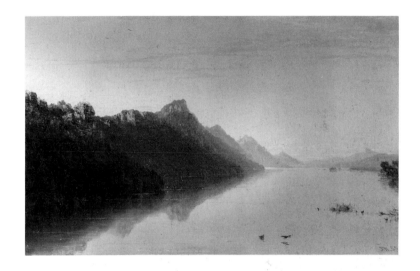

John Frederick Kensett (1816–1872), *The Upper Mississipi*, 1855
47 × 77.5 cm., 18½ × 30½ inches
The Saint Louis Art Museum, Saint Louis, Missouri

With the political and economic consolidation of the newly independent nation in the late eighteenth and early nineteenth centuries came a growing sense of national pride and well-being. As nationalist sentiment increased, so did the urge to explore the boundaries of the New World and to take full measure of this new version of Paradise. Although French and English trappers and traders had long been active in the remote areas of the West, few detailed, accurate descriptions of western scenery had reached the East by the early nineteenth century. Many writers, relying on limited personal experience and uncritical acceptance of stories they heard, spun tales of a region of exceptional beauty, unending bounty, and limitless fertility. The notion that the West was a kind of pastoral sanctuary that God had reserved for the expansion of the American nation was an appealing myth, and it helped fuel the great surge of exploration that occurred during the nineteenth century.

No one was more fervent in championing the opening of the West than Thomas Jefferson, who constantly encouraged exploration of the trans-Mississippi regions. After Jefferson became president in 1801, he convinced Congress to appropriate funds in support of an expedition, led by his private secretary, Captain Meriwether Lewis, which was to locate a land route to the Pacific. Lewis and his co-leader, William Clark, were gone some two and a half years, and covered three thousand miles through unexplored territory inhabited by dangerous animals and numerous, often hostile Indian tribes. The success of the expedition opened the way for further exploration of the interior of the continent.

No artist accompanied Lewis and Clark, but painters and illustrators of varying competence were included on many subsequent journeys. Among the most talented was the Swiss-born Karl Bodmer, who accompanied the German naturalist Maximilian, Prince of Wied-Neuwied, on a privately funded expedition in 1832–34. Bodmer's role was to provide pictorial documentation of the trip, and his watercolors are testaments to his careful powers of observation. As the party traveled along the Missouri River, Bodmer recorded the unusual rock formations they observed with results that are both descriptively factual and poetically beautiful.

On occasion, Bodmer created works of exceptional, almost startling power, as in his *Assiniboin Medicine Sign*. Here, the stark image of a buffalo skull placed atop a pile of rocks looms eerily before a vast, almost otherworldly landscape. An oddly beautiful yet disquieting image, it conforms to none of the canonical traditions of landscape painting as they were known in the East. Such watercolors were among the most striking depictions of the western landscape that had been produced up to that time, and they would not be equaled until almost a half century later, when Thomas Moran began creating his own watercolors of spectacular sites.

Bodmer's watercolors were used as illustrations to Maximilian's published account of the journey, which appeared in German in 1839, but they were not generally known to eastern audiences. On the whole, works by Bodmer and other artists who accompanied early expeditions played only a minor role in establishing what came to be

the most potent and familiar vision of western scenery. That task fell to other, younger artists who were members of an increasingly active landscape fraternity in the East.

During the years Bodmer was traveling in the West, the landscape painter Thomas Cole was enjoying considerable success in New York. Cole, more than any other single figure, established landscape as the predominant form of painting in this country during the nineteenth century. Although he never visited the West, Cole's role as founding father of the American landscape school was an influence on several of the finest artists who did. More importantly, Cole's ideas and beliefs about landscape and its significance convinced many Americans that it was the most appropriate vehicle for conveying nationalist sentiment and pride.[11] America might lack the storied past of the Old World, but it had scenery of a unique character and beauty, and it had the promise of a limitless future.

Cole's earliest subjects were the wilderness areas of the Northeast, particularly in the Hudson River Valley and the White Mountains of New Hampshire. Working with a basic knowledge of the European landscape tradition, Cole interpreted the American scene in a manner that was at once faithful to its general appearance and acceptably within the parameters of what Americans felt was 'artistic.' Cole's works of the 1820s and 1830s are the most powerful visions of the New World landscape, and eastern collectors and connoisseurs accepted them eagerly. Although his ambitions for 'a higher style of landscape' — one that was essentially allegorical and imaginary — ultimately led Cole away from pure landscape, his followers in the Hudson River School continued the tradition well into the 1860s and 1870s. By mid century, landscape had taken on the character of a national art, for it portrayed not only the physical reality of the American scene but also expressed the pride and faith Americans had in their country. This link between landscape painting and the national identity was a powerful one, and it remained in force for much of the nineteenth century.

The flourishing of the Hudson River School in the middle decades of the nineteenth century coincided with the great era of the opening of the West. In 1869 the golden spike was driven that joined the eastern and western halves of the transcontinental railroad. As more Easterners became aware of the spectacular beauty of the West, more trained artists made their way there.

Asher B. Durand, who succeeded Cole as the leader of the American landscape school, cautioned young painters against going abroad in search of beauty, advising instead that they seek out, among other American sites, 'the ocean prairies of the West.'[12] A number of leading eastern landscape painters, including John F. Kensett, Samuel Colman, Sanford Gifford, and Worthington Whittredge, followed Durand's advice and made journeys to the West. The works they created, however, were in large measure dominated by the style of landscape they had perfected in the East. Thus, Kensett, when painting *The Upper Mississippi*, created a radiantly still image very much like his views of the northeast coast. Similarly, Sanford Gifford sought in the West quiet valleys and luminous atmospheric effects

that corresponded to those he had known in the Hudson Valley. Although sensitive to the special beauty of the West, these painters were unprepared to restructure their approach to landscape.

Whittredge, however, in his superb series of the Platte River, responded with a fresh vision. Unlike others, who were drawn to majestic mountain vistas, Whittredge loved the open plains. He wrote, 'Whoever crossed the plains at that period, notwithstanding its herds of buffalo and flocks of antelope, its wild horses, deer and fleet rabbits, could hardly fail to be impressed with its vastness and silence and the appearance everywhere of an innocent, primitive existence.'[13] In the Platte River paintings, Whittredge captured the sublime and empty beauty of the plains more successfully than did any other painter of his generation.

It was Albert Bierstadt who would establish the most enduring vision of the West as a place where 'Nature plays with the illimitable and grand,'[14] a land of sublime vistas, towering mountains, spectacular waterfalls, and dramatic valleys.

Bierstadt was born in Germany but came at an early age to America. In 1853 he returned to Germany, where he studied with the popular Düsseldorf landscape painter Andreas Achenbach. Bierstadt was a ready pupil, and he quickly mastered the conventions of the Düsseldorf manner, with its sweeping compositions and dry, almost metallic detail. After touring and sketching in the Alps and Italy, he returned to America, eager to make his reputation in an increasingly crowded circle of landscape painters. Bierstadt's European training set him apart from the mainstream, but it did provide him with skills that guaranteed an almost immediate success.

Bierstadt realized that new and different subject matter would help him stand out in the crowd of Hudson River School artists. He set his sights on 'the Rocky Mountains, to study the scenery of that wild region, and the picturesque facts of Indian life, with reference to a series of large pictures.'[15] In 1859, he joined the party of Colonel Frederick West Lander, who was engaged in surveying alternate routes for the famous Overland Trail to California. In September of that year, New York's leading art journal, *The Crayon*, published a letter from Bierstadt postmarked 'Rocky Mountains, July 10, 1859.'[16] Describing the sights he had seen on his journey, Bierstadt noted, 'If you can form any idea of the scenery of the Rocky Mountains and of our life in this region, from what I have to write, I shall be very glad' Preparing his audience for the pictures he knew would result from his studies, the artist compared the Rockies to the Bernese Alps, 'one of the finest mountain ranges in Europe, if not in the world.'

Bierstadt's plan was clear. He was going to take the raw material of the American West — which was not easily palatable to eastern landscape taste — and reshape it, skillfully so that it rivaled the finest European scenery. It was a shrewd ploy and one that did not go unrecognized by his detractors. Nevertheless, many Easterners believed that American scenery, like American culture and manufactured goods, ought to stand with the best Europe had to offer.[17] If the Rockies could equal Europe's fabled Alps, so much the better.

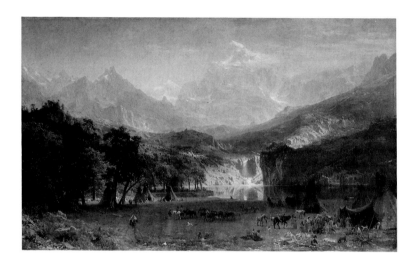

Albert Bierstadt (1830–1902), *The Rocky Mountains*, 1863
186.7 × 306.7 cm., 73½ × 120¾ inches
The Metropolitan Museum of Art, New York

Upon his return to New York late in 1859, Bierstadt began to deliver what his letter to *The Crayon* had promised. Dramatic scenes of the Rockies started to appear in New York exhibitions, and in 1864 his colossal canvas of *The Rocky Mountains* went on view to exceptional critical and public acclaim. Painted in emulation of Frederic Church's similarly sized *The Heart of the Andes*, 1859, *The Rocky Mountains* was a vast tour-de-force of illusionistic space filled with carefully rendered details. Although ostensibly an image of a specific place, Lander's Peak, in reality Bierstadt's painting was representative of western mountain scenery in general. In a smaller version of Lander's Peak included here, Bierstadt showed the mountains disappearing into the clouds, as if their true height could only be guessed.[18] Streams of brilliant sunlight illuminate the rocky flanks, and great trees are so dwarfed by the cliffs that they appear "like mere lashes on the granite lid of the Great Valley's upgazing eye."[19] Such scenes are undeniably stirring, though they betray some artistic license. As one contemporary critic noted, they present 'a perfect type of the American idea of what our scenery ought to be, if it is not so in reality. . . .'[20]

Ever in search of spectacular scenery, Bierstadt made additional trips west in 1863 and 1871–73. On the first of these, he reached California and traveled as far north as Washington state. Deeply impressed by Yosemite Valley and by the lofty Sierra Nevada Mountains, Bierstadt discovered material for some of his finest landscapes. Some of these depicted specific views within Yosemite Valley, but others were more generalized compositions based on the Sierra Nevada.

Among the finest of the latter is his *Sierra Nevada Morning*, with its huge mountains and towering clouds forming a curtain across the rear of the composition. Here, as in other paintings of the high Sierras, Bierstadt introduced a verdant meadow in the foreground bordered by majestic trees and a shimmering lake leading from the middle-ground to the distance. Three deer have paused at the edge of the water, and their tense, alert posture hints at the presence of some unseen danger in the dark woods. The autumnal tints of the foliage foretell the coming of winter, adding a further note of uncertainty. Nevertheless, for the moment, nothing disturbs the natural harmony and beauty of this unspoiled corner of the New World Eden.

Like all of Bierstadt's most successful large landscapes, *Sierra Nevada Morning* invites the viewer to lose himself in contemplation of the majestic scenery, which is at once pastoral and sublime. The borders between the real world and the pictorial realm become blurred, and it seems almost possible to wander into this painted vision of an ideal world.[21]

Such paintings by Bierstadt and those of his contemporary Thomas Moran established the classic image of western scenery in the minds of Easterners. Fortunately, they also helped convince Americans of the need to preserve the finest areas of the West as national parks, the first of which — Yellowstone — was established in 1872. Moran, whose works were particularly influential in the preservation process, made his first trip to the West more than ten

years after Bierstadt. Throughout his career Moran focused his attention on Yellowstone in Wyoming, the Grand Canyon of Arizona, and the Tetons of Idaho. These areas were generally less verdant than those favored by Bierstadt, but they were nevertheless even more spectacular in their geology. Unlike his rival, Moran was not easily given to exaggeration, although he hardly shunned dramatic effects.

A gifted watercolorist who was deeply influenced by Turner, Moran found a realistic equivalent for the great Englishman's art in the strange hues of the mountains of Wyoming and Nevada, the bubbling springs and vaporous geysers of Yellowstone, and the fantastic rock formations of Arizona. Though ultimately faithful to their subjects and surprisingly accurate in their coloring, his watercolors are of almost visionary intensity. Moran also painted the kind of grand, large-scale landscape that by the 1870s had become virtually synonymous with the West. His most famous works were two enormous canvases, *The Grand Canyon of the Yellowstone* and *The Chasm of the Colorado*, 1873, which were purchased by Congress and are now owned by the United States Department of the Interior. The related oils in this exhibition suggest Moran's effectiveness in handling such dramatic scenes.

Even more impressive is his *Shoshone Falls on the Snake River*. One of Moran's most memorable achievements, it presents the viewer with one of the many natural paradoxes of the western scene: a raging river flowing through a seemingly barren, desert-like landscape. The sheer scale of the work is overwhelming, and its assertive presence conveys something of the actual experience of standing before such a sight in the West.

In the works of Bierstadt and Moran the great era of western landscape painting reached its apogee. Within their own lifetimes, however, they saw their works decline in popularity, and they found themselves deemed old-fashioned for their dramatic compositions and meticulous brushwork.[22] The West they had known was changing rapidly, and they witnessed an influx of tourists and sightseers into the once pristine and untouched lands they had painted for a wondering audience. The change is apparent as early as 1874; in William Hahn's *Yosemite Valley from Glacier Point*, fashionable tourists overwhelm the foreground, relegating the natural wonders to the distance. Only a stark, dead tree and soaring bird of prey serve as reminders that this was once a land untouched and unvisited by man. Inevitably, much of the sense of exotic remoteness and mysterious luster that the western landscape once held began to dim.

The major artists who went west in the late nineteenth and early twentieth centuries brought with them firmly established modes of painting that yielded results very different from the epic landscapes of the past. George Inness, in his *California*, chose an unexceptional scene near his hotel and painted it in the poetic and suggestive tones of his late style. This is not Yosemite Valley or the Sierra Nevada; it could, in fact, be anywhere in the country. John Twachtman, when painting some of the same sites visited by Moran, sought not to convey the awesome spectacle of chasms or geysers in realistic detail but instead used his own soft-focused version of Impressionism to

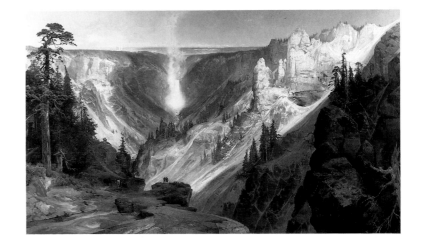

Thomas Moran (1837–1926)
The Grand Canyon of the Yellowstone, 1872
218.4 × 358.2 cm., 86 × 141 inches
United States Department of the Interior, Washington, D.C.

capture the myriad hues of Yellowstone. Their vision of the West, distinctly different from that of Bierstadt and Moran, was ultimately more personal that the grand public art of their predecessors.

At the turn of the century, America increasingly turned its attention both artistically and politically to the international arena. The story of the West and the opening of the frontier became history, and the great landscapes of the nineteenth century were, for a time, forgotten. Eloquent and expressive visions, they now stand as great American icons, monuments to an era when art and the national identity were so closely interwoven as to be inseparable.

1. This famous statement occurs in Locke's *Essay Concerning the True Original Extent and End of Civil Government*; quoted in Leo Marx, *The Machine in the Garden: Technology and the Pastoral Ideal in America* (New York: Oxford University Press, 1964), p. 120.

2. For a useful discussion of this subject, see Hugh Honour, *The New Golden Land: European Images of America from the Discoveries to the Present Time* (New York: Pantheon, 1975).

3. Quoted in Louis Hawes, *The American Scene* ex. cat., Indiana University Art Museum, Bloomington, 1970, p. 8.

4. George Perkins Marsh, *Address Delivered Before the Agricultural Society of Rutland County* (1848); quoted in Marx, p. 204. Marsh was perhaps the most perceptive analyst at mid century of American nature and its role in the development of the nation.

5. David W. Scott, *American Landscape: A Changing Frontier* ex. cat., Washington, D.C.: National Collection of Fine Art, 1966, p. 1.

6. Turner's thesis was first set forth in an 1893 paper, 'The Significance of the Frontier in American History.' On Turner and his importance, see Henry Nash Smith, *Virgin Land: The American West as Symbol and Myth* (Cambridge, Mass.: Harvard University Press, 1950), pp. 250–60.

7. For a recent discussion of Turner's importance and the changing critical response to his frontier thesis, see Steven Hahn and Johathan Prude, *The Countryside in the Age of Capitalist Transformation* (Chapel Hill and London: The University of North Carolina Press, 1985), pp. 3–7.

8 Over the past two decades, American landscape painting of the nineteenth century has received more scholarly attention than any other single area of American art. Although some current methodological trends discourage generalizations about the broad cultural 'meanings' of landscape, I am compelled to rely on a certain amount of generalization to stay within the length allowed for this essay. Suffice it to say that all Americans of the nineteenth century did not think the same way and did not necessarily hold the same ideas about landscape and its meanings. My remarks best reflect the attitudes and beliefs of the eastern intelligensia who, for all practical purposes, controlled the production of landscape art throughout much of the nineteenth century.

9. There is no comprehensive study of early American exploration art, but there are two works which address many of the basic issues of importance in the broader tradition: Bernard Smith, *European Vision and the South Pacific, 1768–1850: A Study in the History of Art and Ideas* (Oxford, England: Clarendon Press, 1960) and Barbara Maria Stafford, *Voyage into Substance: Art, Science, Nature, and the Illustrated Travel Account, 1760–1840* (Cambridge, Mass.: MIT Press, 1984).

10. 'Verses on the Prospect of Planting Arts and Learning in America,' quoted in Smith, *Virgin Land*, p. 8.

11. Although several artists had tried to establish history painting in the grand manner in America, they were unsuccessful, since their themes were generally from Old World history and mythology. Americans were willing and even eager for a national style of art that was meaningful and profound, but it had to be directly relevant to the New World. Cole's particular genius lay in his ability to transfer many of the elements of history painting to landscape.

12. 'Letters on Landscape Painting: Letter II,' *The Crayon*, no. 1 (Jan. 3, 1855), p.35. Durand's 'Letters' are generally considered the most complete statement of the aesthetics of the Hudson River School.

13. Quoted in Edward H. Dwight, *Worthington Whittredge*, ex. cat. Utica, N.Y.: Munson-Williams-Proctor Institute, 1969, p. 19. There are numerous works in the Platte River series, but the two most important are *Crossing the Ford, Platte River, Colorado* (1868–70, The Century Association, New York) and *On the Plains, Colorado* (1872, St. Johnsbury Atheneum, St. Johnsbury, Vermont). The work included in this exhibition is most closely related to the St. Johnsbury Atheneum picture. Since it was favored by Indian tribes, the Platte River Valley had been one of the major routes through the West even before European explorers first reached it; see Colonel William F. Cody and Colonel Henry Inman, *The Great Salt Lake Trail* (New York: The Macmillan Company, 1898), p. 227. The poet Walt Whitman echoed Whittredge's sentiments when he wrote: 'While I know the standard claim is that Yosemite, Niagara Falls, the Upper Yellowstone and the like afford the greatest natural shows, I am not so sure but the prairies and the plains, while less stunning at first sight, last longer, fill the aesthetic sense fuller, precede all the rest, and make North America's characteristic landscape. . . . Even their simplest statistics are sublime.' (From *Specimen Days*, 1882, quoted in Barbara Novak, *Nature and Culture: American Landscape and Painting, 1825–1875* [New York: Oxford University Press, 1980], p. 154.)

14. *Cosmopolitan Art Journal* (September 1859), p. 183; quoted in Novak, p. 139.

15. *The New Bedford* [Massachusetts] *Daily Mercury*, Jan. 17, 1859; quoted in Gordon Hendricks, *Albert Bierstadt, Painter of the American West* (New York: Harry N. Abrams, 1973), p. 73.

16. 'Sketchings: Country Correspondence,' *The Crayon*, no. 6 (September 1859), p.287.

17. Americans were constantly vexed by European visitors who wrote travel books in which American scenery was criticized as inferior to that of the Old World. Excerpts from one such book, 'By a Distinguished English Traveler,' were run in *The Crayon* in August of 1859. After criticizing various areas of the New World, including the Rocky Mountains, as having 'nothing that could be called worthy of the artist's or the poet's observation,' the writer noted that travel in America was especially hazardous because of wild animals: 'A distinguished member of the United States parliament informed me that a railroad train was last year attacked by a drove of raccoons while crossing a prairie, and every passenger destroyed. These raccoons are the terror of this wild country, and have depopulated thousands of miles of its surface' (p. 248). Raccoons are generally no larger than a small dog, do not travel in 'droves,' and certainly are not capable of attacking a train. Clearly, the 'distinguished Englishman' was the gullible victim of a 'tall tale' spun by an American seeking a small measure of revenge.

18. The Fogg Museum picture is one of Bierstadt's relatively rare works in a vertical format, and this, of course, enhances the illusion of great height. Bierstadt painted at least one full-scale vertical picture, *The Great Trees — Mariposa Grove* (1875, 117 × 50 inches, private collection). Thomas Hill's *Among the Giant Redwoods* (cat. no. 24) depicts the same stand of redwoods (sequoias) from a different point of view. Giant sequoias are the largest trees in the world, reaching heights of 300 feet. In the nineteenth century, just as today, they were familiar symbols of the West.

19. Fitz Hugh Ludlow, *The Heart of the Continent: A Record of Travel Across the Plains and in Oregon, with an Examination of the Mormon Principle* (1870); quoted in Theodore E. Stebbins, Jr., et al., *A New World: Masterpieces of American Painting 1760–1910* (Boston: Museum of Fine Arts, 1983), p. 251. Ludlow accompanied Bierstadt on his 1863 visit to California, and his words quoted here were in response to the Yosemite Valley.

20. '"Among the Sierra Nevada Mountains," by Albert Bierstadt,' *The Boston Post*, October 1, 1869, p. 4; quoted in Stebbins, p. 251.

21. Bierstadt, like Church, often carefully arranged the display of his paintings for maximum effect of illusion by using window-like frames and controlled lighting.

22. James Jackson Jarves was one of the first to single out Bierstadt, whom he grouped with Church, for criticism: 'With singular inconsistency of mind they idealize in composition and materialize in execution, so that, though the details of the scenery are substantially correct, the scene as a whole often is false.' James Jackson Jarves, *The Art Idea*, 1864, reprint, ed. Benjamin Rowland, Jr., The Belknap Press of Harvard University Press, 1960, p. 191. Jarves was also one of the first to protest against the insular nationalism of mid nineteenth-century American painting, arguing in favor of a more internationally informed (and trained) school.

Abstraction entered the clear, certain vocabulary of American painting in the form of an Impressionism, which derived from French art of the 1870s. In 1895 John Twachtman painted his series of impressionist pictures in the Grand Canyon of Yellowstone, working in a style that had already absorbed the lessons of Post-Impressionism and Neo-Impressionism. The vaporous pools and waterfalls of the Canyon translated on his canvases into rich, decorative patterns of opalescent color that emphasized the flat picture surface over pictorial depth. *Emerald Pool* and *Waterfall in the Yellowstone* were surprising, modern treatments of the western landscape, which left the pictorial issues of nineteenth-century painting well behind.

A painter of extraordinary sensitivity, Twachtman enjoyed limited success with his abstract arrangements of color and light. He exhibited with other American impressionists identified as The Ten American Painters, all of whom experimented with color theory and coloristic surface effects. During the first decade of the twentieth century, The Ten were eclipsed by the more progressive group, The Eight.

Robert Henri was spokesman for the group, which included John Sloan and Arthur B. Davies, who was primarily responsible for organizing the Armory Show. In Paris during the autumn of 1912, Davies had reviewed works by the young American painter Marsden Hartley; he felt that Hartley's work 'embodied the essence of American mysticism,'[1] and selected six of his abstract drawings for the Armory Show. Among the more than 1,000 works of avant-garde European and American art that were exhibited in February of 1913 at the New York National Guard's Armory, Hartley's drawings received little attention from a stunned and outraged public. Americans gradually did accept the modernism boldly announced by the Armory Show, which in effect, also quietly established Hartley among the first American abstract artists of the century.[2]

Hartley moved to Berlin in 1913. Like many American expatriots, as he adapted to European life and became involved in European art circles, his commitment to retain an American identity intensified. Among European avant-garde artists at the beginning of the century, there was a significant interest in all forms of primitive art. American Indian art had become familiar in Europe through traveling exhibitions organized by the Berlin Ethnographical Museum and the Trocadero Museum in Paris. Hartley began a series of paintings on the theme of 'Amerika,' using Indian motifs which may have suggested to him the natural innocence of American culture in contrast to the

decadence of prewar Berlin society. Hartley's bright, emblematic *Indian Composition*, including tepees and ceramic decorative patterns, celebrated an American West that he imagined and idealized but had never actually seen. He wrote to Alfred Stieglitz, who represented his work in New York, that 'the true expression of human dignity would be to paint his face with the symbols of the race he adored, go to the West, and face the sun forever.'[3]

His champion, Arthur B. Davies, had spent many years in the West, traveling there initially in 1879 at the age of seventeen. In 1905 he toured California, sketching and painting in the Sierras and throughout the region. His small works in oil such as *Lake Tahoe* aptly convey the poetic sensibility that he assimilated through an awareness of Art Nouveau and Oriental art. Robert Henri traveled west to California for the first time in 1914, and two years later he was invited to Santa Fe, where he worked intermittently for the next four years. He encouraged John Sloan to visit; and after his first trip in 1919, Sloan spent four months of each year there until 1950.

The works of Henri and Sloan in the West marked the final phase of American social realism. Both men worked also in Taos, an art community near Santa Fe established in the 1890s.[4] Sloan's pictures of Santa Fe, like the genre works of Philadelphia and New York which had established his career, characterize the life of the American town at the beginning of this century. *Down by the D&R, Santa Fe*, his description of flirtation by the tracks of the Denver and Rio Grande Railroad, and *Music in the Plaza* are subtle and perceptive in their social insight.

By the beginning of this century, the American railroad industry had established most of the western roadbeds that began at the Missouri River or at the 100th meridian, the newly defined boundary to the West. In 1880 the Atcheson Topeka and Santa Fe Railroad, originating in Atcheson, Kansas, on the banks of the Missouri, reached Santa Fe, New Mexico. Here the company came into conflict with the Denver and Rio Grande.

Competition between the railroad companies for land rights, government money, and customer revenue was keen.[5] Cities located along the rail systems prospered, and the railroad companies promoted the regions they served, attracting unprecedented numbers of tourists to the West. In 1894 the Southern Pacific railroad, serving the largest number of cities on the West Coast, launched their luxury train, the Sunset Limited, running from New Orleans in the South, through the Southwest, to California.

The railroad began publishing *Sunset* magazine in 1898. Named for the train, it featured photographs and illustrations of Yosemite and other famous western sites by leading artists of the region: Maynard Dixon's work, represented here by *Earth Knower*, later appeared regularly on *Sunset* covers.[6] Other railroad companies used works by western artists for posters, calendars, and promotional advertising.

The railroads played a major role in making the West accessible to Americans in the early years of the twentieth century, and in the decades that followed, the film industry made the appearance of the western landscape familiar to audiences throughout the country. The West entered the mainstream of the American consciousness as the nation's leading artists were developing a new American iconography. Artists turned away from literal representation to confront the essential aesthetic issues posed by the West — immense scale, clarity of light, and seemingly unlimited expanse of space.

Recognizing the significant artistic issues of the western landscape, John Sloan was admittedly more impressed by the problems of light and sense of abstract form that he encountered in the Southwest than by the social customs of a western town. 'I like to paint the landscape in the Southwest because of the fine geometrical formations and the handsome color. Study of the desert forms, so severe and clear in that atmosphere, helped me to work out the principles of plastic design....' He continued, 'When you see a green tree it is like a lettuce against the earth, a precious growing thing. Because the air is so clear you feel the reality of the things in the distance.'[7]

Stuart Davis also reacted to the West's potent visual impact. In 1923 he spent a summer in Santa Fe at Sloan's urging. Davis wrote: 'I spent three or four months there in 1923 — until late fall — but did not do much work because the place itself was so interesting. I don't think you could do much work there except in a literal way. You always have to look at it.... Forms made to order, to imitate.'[8]

Although Davis painted only about a dozen pictures in New Mexico, he succeeded in turning his new subject matter toward the modern language of abstraction. Works such as *New Mexican Gate* and *New Mexico Landscape* were produced in his studio rather than outdoors. Davis isolated pure areas of strong color that he had observed as elements of the landscape and assembled compositions of these flat areas of color units, adding occasional patches of texture. The resulting compositions convey the strong, simple character of the southwestern landscape. Although Davis himself emphasized the critical impact of the Armory Show on his vision, Davis' paintings reflecting his experience in the Southwest advanced his artistic development toward a form of abstraction that utilized emblematic references to the American scene.

Marsden Hartley's work in New Mexico between 1918 and 1920 shifted away from abstraction toward what he termed 'objective realism.' Hartley's *Landscape New Mexico* was executed outdoors in a quick manner that attempted to capture the contours of the landscape that lay before him. He was unhappy in the provincial environment of Taos and suffered from the high altitude. Back in postwar Berlin in 1921, Hartley's yearning for America was expressed in

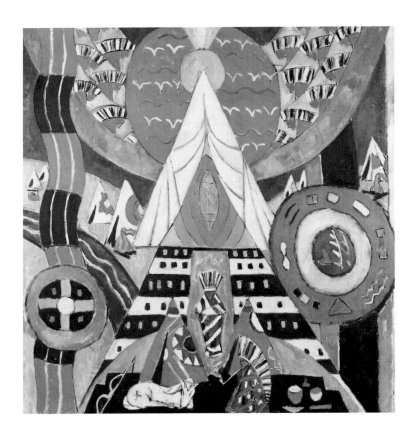

Marsden Hartley (1877–1943)
Indian Composition, 1914–15, 119.6 × 119.3 cm., 47⅛ × 47 inches
Vassar College Art Gallery, Poughkeepsie, New York
Gift of Paul Rosenfeld

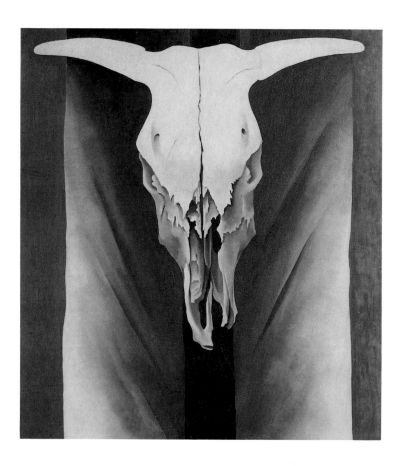

Georgia O'Keeffe (1887–1986)
Cow's Skull: Red, White, and Blue, 1931
101.2 × 91.1 cm., 39⅞ × 35⅞ inches
The Alfred Steiglitz Collection, The Metropolitan Museum of Art,
New York

another American series painted between 1921 and 1923, his *New Mexico Recollections*. Despite the sense of alienation in these darkly expressive pictures, he continued to see the West as the embodiment of that which he considered to be purely American.

In the period following the first World War, the country changed. America had emerged as an international power; the nation was one. The American dichotomy was no longer east-west; it was urban-rural. In 1925 Alfred Stieglitz presented an exhibition of 'Seven Americans.' Included were Stieglitz himself, Paul Strand, Charles Demuth, Arthur Dove, Marsden Hartley, John Marin, and Georgia O'Keeffe, whom he had married the previous year. Stieglitz had been a declared champion of American modernism since 1906 when he opened his gallery at 291 Fifth Avenue in New York. He advanced his vision of an American artist completely free to fulfill his potential without compromise.[9] By the mid twenties defining an *American* art had become as pertinent an issue as defining modernism had been two decades earlier.

Georgia O'Keeffe had always been fascinated by the American West. In 1912 she took a job teaching art in Amarillo, Texas, and remained there for the next two years. After three years back in New York, she returned again to Texas in 1917 to teach in Canyon, near Amarillo. In 1917 on a three-day vacation trip, she visited Santa Fe for the first time. More than ten years later, in May of 1929, O'Keeffe set out for a summer's stay in New Mexico, returning each year until 1949 when, following Stieglitz' death, she settled there permanently.

In 1929 she stayed in Taos and made driving trips along the Rio Grande, to the Grand Canyon, and to Canyon de Chelly. John Marin had arrived in June. He was fifty-nine years old and was one of the major figures in American art. Marin had come there to seek 'the elemental big forms — Sky Sea Mountain Plain . . . to recharge the battery.'[10] He spent two summers in New Mexico, working constantly with characteristic dexterity and speed. He was inspired by the light and the massive land forms.

*Miles upon miles of level stretches covered with sage
brush —
with here and there a drop of a few hundred feet that
would be a canyon —
Hills & mountains of every color . . .
 A sunset seems to embrace the Earth
 Big sun heat
 Big storm
 Big everything . . .*[11]

In December of 1929, Stieglitz opened his new gallery, An American Place. Earlier that year the stock market had crashed, and an era of industrial prosperity was coming to an end. A school of regionalist painters began to develop. Among them were Grant Wood and Thomas Hart Benton, who chose rural America as subject matter appropriate to the social and political issues of the day. American modernists such as Stuart Davis attacked regionalism as reactionary

art. He labeled Benton's work 'regional jingoism.'[12] Arthur Dove wrote,

When a man paints . . . a 1740 house or miner's shack, he is likely to be called by his critics, American. These things may be in America, but it's what is in the artist that counts. What do we call 'America' outside of painting? Inventiveness, restlessness . . . a painter may put these qualities in a still life or an abstraction, and be going more native than another who sits quietly copying . . .[13]

What was 'American' within Georgia O'Keeffe found its manifestation in the West. Because her abstractions were consistently based on observation and fact, she sought out images from the environment through which she could express her instinctive fascination with pure color and form. 'I had wanted to paint the desert and I haven't known how. . . . So I brought home the bleached bones as my symbols of the desert. . . . To me they are strangely more living than the animals walking around.'[14]

In 1931 she painted *Cow's Skull: Red, White, and Blue.*

People wanted to 'do' the American scene. I had gone back and forth across the country several times by then, and some of the current ideas about the American scene struck me as pretty ridiculous. . . . Well, I started painting my skulls about this time. . . . I thought, the people who talk about the American scene don't know anything about it. So, in a way, that cow's skull was my joke on the American scene, and it gave me pleasure to make it red, white, and blue. . . .[15]

The selected images that recur in the works of O'Keeffe — flowers, crosses, animal bones — like Hartley's 'Amerika' series at the beginning of the century, represent the country's cultural heritage tracked to its primitive beginnings. O'Keeffe's skull is a concrete image that she encountered in the New Mexico landscape; it is an ancient Indian symbol of regeneration; and it has become an abstract icon of twentieth century American art.

Stieglitz had written in his notebooks of 1927–29: 'If I could put down in words what I feel when I see the fine line of mountains and sky . . . as they touch, I would be able to write my autobiography.'[16] *The Mountain, New Mexico* and *My Backyard* constitute a part of Georgia O'Keeffe's autobiography, an account of the inseparable union of her life and art that expressed the uncompromising personal freedom Stieglitz had defined as essential to the American artist. O'Keeffe transcended regionalism; for her the West defined the essence of America. The major artists of the next generation, following Marin and O'Keeffe, would again confront without compromise the elemental big forms.

In the period after 1945 that marked the beginning of a new era of American art, Jackson Pollock emerged as the most consequential American artist to come from the West and to establish himself in the East. Born in Cody, Wyoming, Pollock was raised in Arizona and northern California. He studied with Thomas Hart Benton at the Art

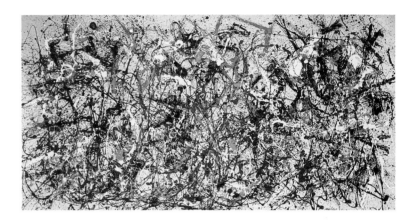

Jackson Pollock (1912–1956)
Autumn Rythym, 1950, 266.7 × 525.78 cm., 105 × 207 inches, Metropolitan Museum of Art, New York, Hearn Fund

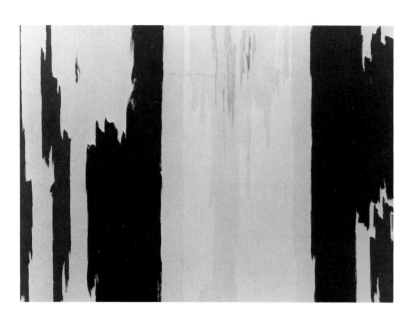

Clyfford Still (1904–1980)
Untitled, 1960, 287.3 × 395.5 cm., 113⅛ × 155⅞ inches
San Francisco Museum of Modern Art
Gift of Mr. and Mrs. Harry W. Anderson

Student's League in New York, and for a time, worked in a manner closely associated with Benton's style. Pollock's works of the 1940s identified him as a major figure in American art; his paintings of that era posed the new artistic issues that would alter the course of modern American painting.

Pictures titled *Guardians of the Secret*, *Moon Woman Cuts the Circle*, *Totem Lesson I*, and *Totem Lesson II* evoke mystical and primitive associations.[17] Critics noted sources in southwestern Indian art for the calligraphic markings and rhythmic arrangement of Pollock's compositions. Pollock confirmed the subconscious assimilation of his western experience as influential in his work.

I have always been very impressed with the plastic qualities of American Indian art. The Indians have the true painter's approach in their capacity to get hold of appropriate images, and their understanding of what constitutes painterly subject matter. Their color is essentially Western, their vision has the basic universality of all real art. Some people find references to American Indian art and calligraphy in parts of my pictures. That wasn't intentional; probably was the result of early memories and enthusiasms.[18]

Pollock affirmed, 'I have a definite feeling for the West: the vast horizontality of the land.'[19] The assertion of a flat picture surface upon which he improvised an unlimited expansion of gestural energy created the term 'alloverness,' which characterized Pollock's work of the late 1940s and early 1950s. Although his technique resembled the automatism of surrealist painters, his orientation was distinctly American in character, favoring what he termed 'directness' in confronting the field of canvas, as he confronted nature: 'My concern is with the rhythms of nature . . . the way the ocean moves. . . . The ocean is what the expanse of the West is for me. . . . I work from the inside out, like nature.'[20] In *Autumn Rhythm*, 1950, Pollock presents a dense coiling pattern extending horizontally across a field. The pattern seems to rise up from the field like an undeciphered language of spoken energy.

Clyfford Still spoke often and fervently about the artist's need for complete freedom 'in a place where an idea can transcend politics, ambition, and commerce.'[21] Born in North Dakota, Still spent his boyhood in Spokane, Washington, and Alberta, Canada. During the 1940s he taught at the California School of Fine Arts in the San Francisco Bay area, and he moved to New York in 1950.

Still's canvases of the 1940s seem to reflect his personal search for a pure landscape of spirit. In *Untitled*, 1945, a skeletal form looms up, cutting across the picture surface — a barren, primordial field of yellow and black. Still spoke of fusing space and figure in his canvases to achieve 'a total psychic entity. . . a living spirit.'[22] By analogy, this process relates to the religious ritual in American Indian culture in which the bones of ancestors were revered as vehicles of solidarity with the eternal earth spirit. Like the works of Pollock during this period, Still combined surrealist theories with native American ritualistic beliefs.

As one of the first American painters to work on mural-size canvases, Still identified scale as an important element of his statement. There is an irresistible temptation to *see* the West in his works.

Still's painting has sometimes been likened to such natural phenomena as the Grand Canyon; while it is naive to suppose that his forms or surfaces have literal parallels with nature, the analogy seems apt in a poetic sense. His works have the overriding presence of natural elements. . . .[23]

Although he strongly denouced regional identification, Still's pictorial forms suggesting organic rock formations, his emphasis upon contrasts of light and dark, and the sheer scale of his canvases from the 1950s through the 1970s seem to evoke his origins in the West. Giant paintings such as *Untitled*, 1960, and *1960-F*, are powerful declarations of his implacable spirit, and may also be metaphorical references to the West which circumscribed his childhood.

Like Pollock and Still, Robert Motherwell grew up in the West and subsequently established his reputation in the East. Unlike them, Motherwell based his art upon color.

I think of color concretely I so to speak, take a piece of color and form it. In some of my pictures, color is the main subject, and in most of my collages color is a major subject
You have to remember that I am a Californian, and that the California landscape is a delight and that the whole physiography of California is very similar to Spain. After all, art is not a philosophy, it is one's eye; and an artist is a 'walking eye,' and if one talked about what an artist likes to look at, one would come closer to his art. . .[24].

In 1960 Motherwell began to execute collages on landscape themes. *The America Cup* of 1964 places a white shape, evoking a ship's sail, upon a field of pure blue. Although its subject is not western, the simplicity of this flat image composed of defined color fields and devoid of horizon line may suggest the clarity of vision that Motherwell associated with the West. The collages of this period led to his open series in the late sixties which further explored issues of pure color and extended space.[25]

In 1958 Motherwell had married Helen Frankenthaler whose experiments with color were strikingly innovative. Although she did not travel to the West until later in her career, Frankenthaler was deeply affected by the works of Jackson Pollock, which she had first seen exhibited in 1951.

It was staggering. I really felt surrounded. . .It was as if I suddenly went to a foreign country and didn't know the language, but had read enough, and had a passionate interest, and was eager to live there. I wanted to live in this land; I had to live there, and master the language.[26]

Frankenthaler assimilated Pollock's elemental approach into her own intuitive manner of working, using poured color as her language in expansive canvases such as *Herald*, 1971. Frankenthaler's first trip to the Southwest to Phoenix, Arizona, in 1976, and second trip to Sedona in 1977, resulted in works such as *White Totem*, 1978. She took samples of the red earth back to New York to create a sedona red that recalled the rocks of the Verde River Valley.

The West's extraordinary canyons and rock formations have continued to attract artists as subject matter. Wayne Thiebaud's *Cliffs*, one of his largest canvases, recalls the national parks of southern Utah where he grew up. The undulating contours of the soaring palisades seem to unfurl in the sunlight, luminous veils of color as compellingly American as the flag. Positioned at a low vantage point without an horizon for reference, the viewer is disoriented and overwhelmed by the scale of the cliff which seems to enfold him. Thiebaud's interest in light, color, and the placement of forms in space is similar to the concerns of late Impressionism in which the viewer is immersed in a diffusion of glowing colors. 'The problem of the painter,' Thiebaud has stated, 'is to have the painting create its own light.'[27] His efforts to achieve luminosity within his works have led to experiments using white either to lighten color values or as the stark field of canvas upon which forms are placed.

The way in which strong light affects forms is a recurring issue for artists in the West. Like Thiebaud, Richard Diebenkorn orchestrates with light and color. His *Ocean Park* series, begun in 1967, continues to restate a single theme with seemingly unlimited variation. Unlike the works of Thiebaud, Diebenkorn's paintings have lost all reference to specific recognizable images. The West is stated metaphorically as a delicate arrangement of finely proportioned lines and pale colors. In these highly refined abstractions, one realizes the moment of sea and sky that is the American western shore at Ocean Park. 'Temperamentally,' Diebenkorn observed, 'I have always been a landscape painter.'[28]

Agnes Martin, working in the clear, strong light of New Mexico, describes the subject of her white paintings as happiness and innocence.[29] 'Art,' she says, 'comes straight through a free mind — an open mind. Absolute freedom *is* possible.'[30] Martin's nonreferential canvases may be considered contemporary heirs to the luminist tradition of nineteenth-century landscape painting, the culmination of a theme on natural light keyed to the white intensity of noon-day sun. They may also be revelations of Martin's independent spirit, optimistic declarations of the freedom she has found living in the Southwest away from the pressures of the New York art community.

The West seems to sustain all of the big ideas about America — freedom, bravery, innocence, and optimism; but it is also someone's backyard, the assimilated experience of day to day. James Surls' powerful wood sculptures evoke his boyhood in East Texas; his rugged, ungainly forms seize life as staunchly as desert plants. Carol Hepper's chrysalis-like constructions utilize buffalo skins from the herds that still exist in her native South Dakota and call up associations with the Sioux Indians for whom that region is homeland.

The physical characteristics of the West continue to affect the style and content of American art today. Yet beyond the issues of scale, space, and light, lie the less easily resolved questions of meaning. There was a moment in the nation's history when the West represented the future of America. In the twentieth century the great western expanse presents itself to the cultural analyst as a cornerstone of the American character.

Pursuit of the essential truths leads every culture to seek and understand its silent, sacred beginnings. The meaning and substance of twentieth century American art is related to the ever present consciousness of a western landscape; for the West *is* America, the place where her ancient spirits walk.

1. Barbara Haskell, *Marsden Hartley*, (New York: Whitney Museum of American Art and New York University Press, 1980), p. 17.

2. Ibid., p. 28.

3. Hartley to Steiglitz, November 12, 1914.

4. Arrell Morgan Gibson, *The Santa Fe and Taos Colonies: Age of Muses 1900–1942*, (Norman: University of Oklahoma Press, 1983), p. 50.

5. LeRoy R. Hafer and Carl Coke Rister, *Western America: The Exploration, Settlement, and Development of the Region Beyond the Mississippi* (New York: Prentice-Hall, Inc., 1941), pp. 551–52.

6. Richards E. Bushnell, *The Rise of Sunset: Western Grandfather of Regional Magazines*, unpublished manuscript, 1986.

7. John Sloan, *Gist of Art* (New York: American Artists Group, 1939), p. 147.

8. James Johnson Sweeney, *Stuart Davis*, ex. cat., Museum of Modern Art, New York, 1945, p. 15.

9. Elizabeth McCausland, 'Stieglitz and the American Tradition,' *America and Alfred Stieglitz* (New York: The Literary Guild, 1934), p. 228.

10. John Marin, *John Marin*, ed. Cleve Gray, (New York: Holt, Rinehardt and Winston, 1974), p. 161.

11. Ibid., p. 56.

12. Sarah Clark-Langager, *Order and Enigma: American Art between the Two Wars* (Utica: Munson-Williams-Proctor Institute, 1984), p. 48.

13. Ibid., p. 51.

14. Georgia O'Keeffe, *An American Place*, ex. cat., January 22–March 17, 1923, p. 3.

15. Calvin Tomkins, 'Profiles — Georgia O'Keeffe,' *New Yorker* (March 4, 1974), pp. 48–49.

16. Dorothy Norman, *Alfred Stieglitz: An American Seer* (New York: Random House, 1960), pp. 174–75.

17. The organizers of the exhibition regret that because of conservation considerations it is impossible to install *Totem Lesson II*, which is illustrated in this catalogue, with other works included in this exhibition. The painting is on public view at the Australian National Gallery, Canberra.

18. Howard Putzel, 'Jackson Pollock,' *Arts and Architecture* (February, 1944), p. 14.

19. Ibid., p. 14.

20. Quoted from B.H. Friedman, *Jackson Pollock: Energy Made Visible* (New York: McGraw-Hill, 1972), p. 228.

21. Clyfford Still, 'An Open Letter to an Art Critic,' *Artforum* (December, 1963), p. 32.

22. Quoted from T. Sharpless, *Clyfford Still* (Philadelphia: Philadelphia Institute of Contemporary Art, University of Pennsylvania, 1963), n.p.

23. Stephen Polcari, 'The Intellectual Roots of Abstract Expressionism: Clyfford Still,' *Art International* (May–June, 1982), p. 30.

24. Barbara Catoir, 'The Artist as Walking Eye,' *Pantheon* (July, 1980), p. 286.

25. E.A. Carmean, *The Collages of Robert Motherwell*, Ex. Cat., The Museum of Fine Arts, Houston, 1973, p. 33.

26. Henry Geldzahler, 'An Interview with Helen Frankenthaler,' *Artforum* (October, 1965), p. 36. Also quoted from Barbara Rose, *Frankenthaler* (New York: Harry N. Abrams, 1974), p. 29.

27. Karen Tsujimoto, *Wayne Thiebaud* (Seattle: University of Washington Press, 1985), p. 47.

28. Quoted from Robert Buck, 'The Ocean Park Paintings,' *Art International* (May–June, 1978), p. 29.

29. Agnes Martin, 'Thirteen Statements,' *Art in America* (October, 1983), p. 132.

30. Quoted from John Gruen, 'Agnes Martin: Everything, everything is about feeling. . . .' *Art News* (September, 1976), p. 92.

AMERICA: Art and the West

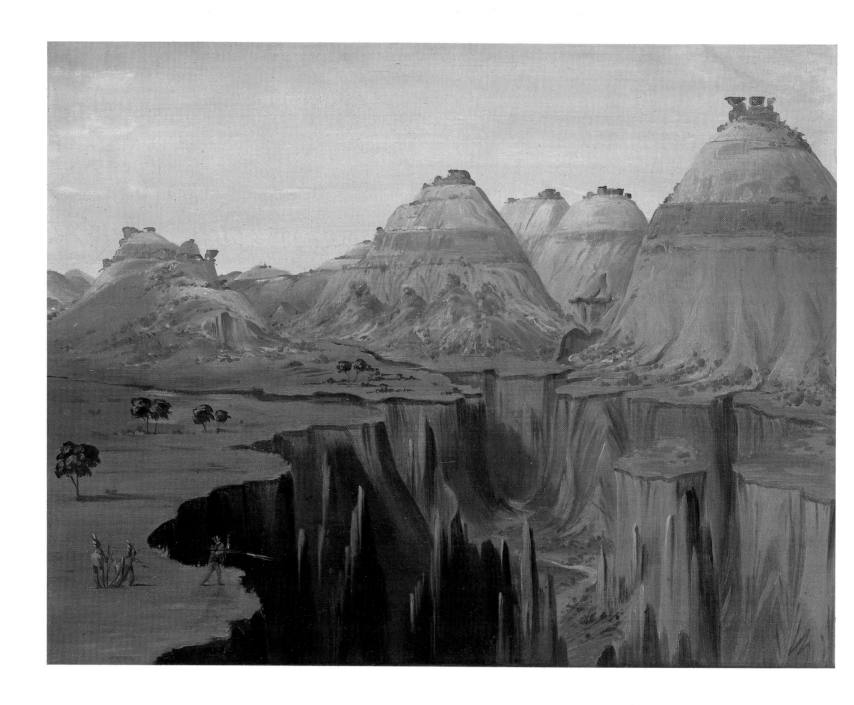

1
George Catlin
"Brick Kilns", Clay Bluffs, 1900 Miles Above St Louis 1832
oil on canvas, 28.6 × 36.5 cm. $11\frac{1}{4}$ × $14\frac{3}{8}$ inches
National Museum of American Art, Smithsonian Institution
Gift of Mrs. Joseph Harrison, Jr.

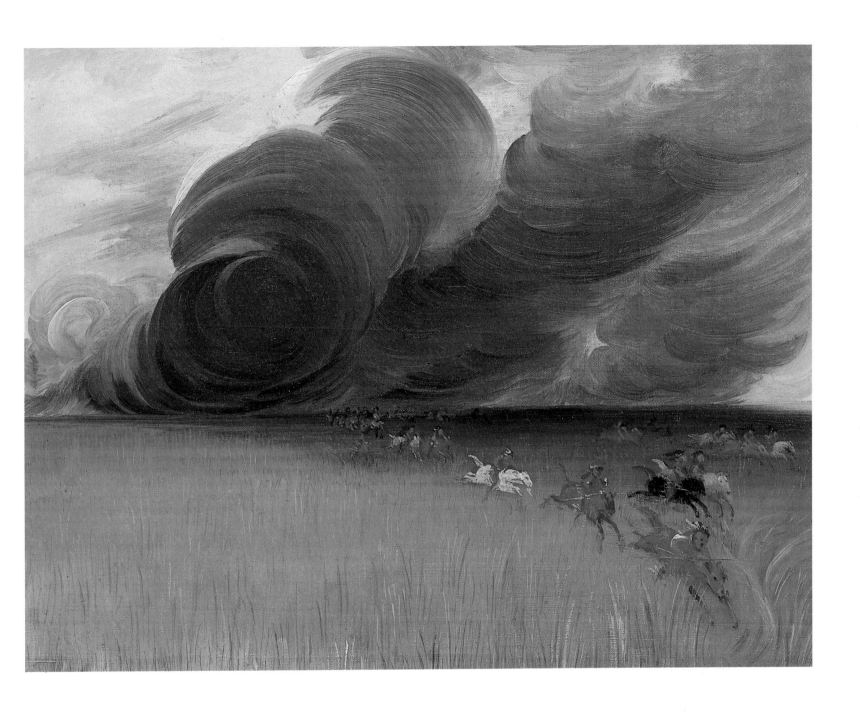

2
George Catlin
Prairie Meadows Burning 1832
oil on canvas, 27.9 × 35.9 cm. 11 × 14⅛ inches
National Museum of American Art, Smithsonian Institution
Gift of Mrs. Joseph Harrison, Jr.

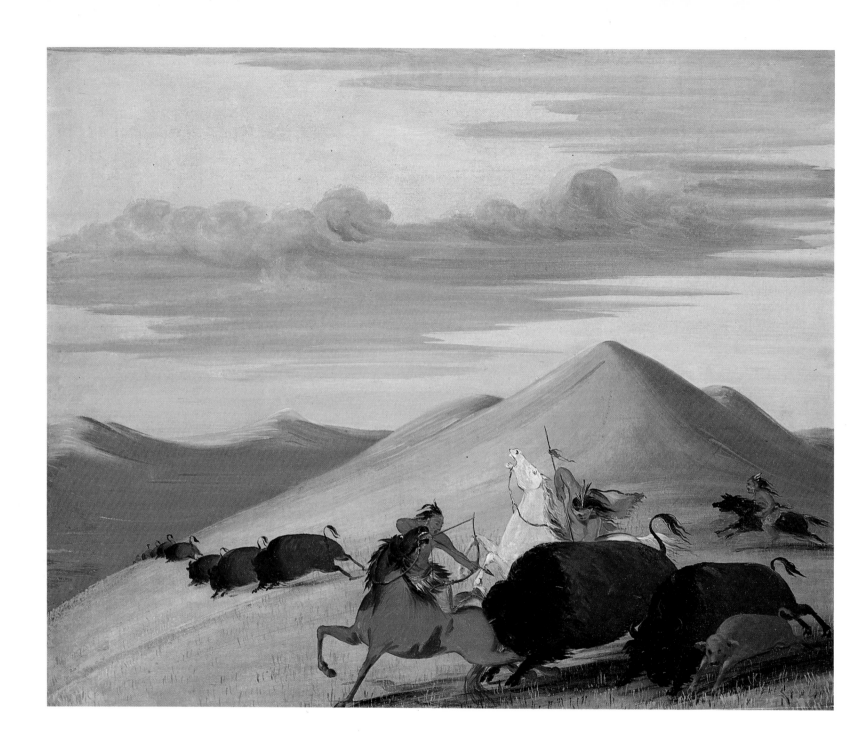

3
George Catlin
Buffalo Chase, Bull Protecting a Cow and Calf 1832–33
oil on canvas, 61.0 × 73.7 cm. 24 × 29 inches
National Museum of American Art, Smithsonian Institution
Gift of Mrs. Joseph Harrison, Jr.

4
George Catlin
The White Cloud, Head Chief of the Iowas c.1845
oil on canvas, 70.5 × 57.8 cm. 27¾ × 22¾ inches
National Gallery of Art, Washington; Paul Mellon Collection

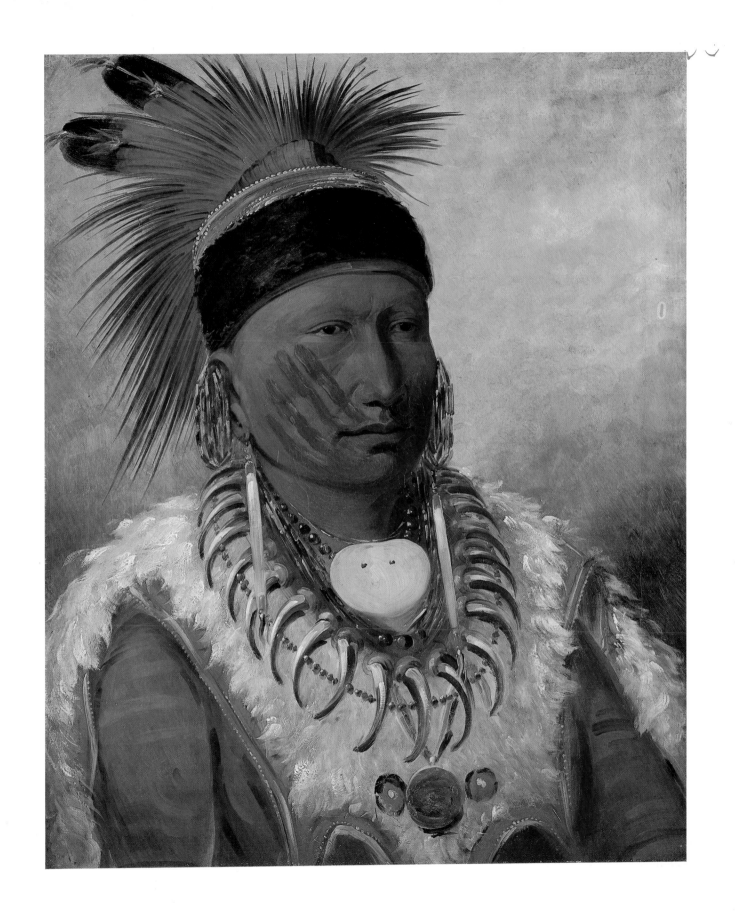

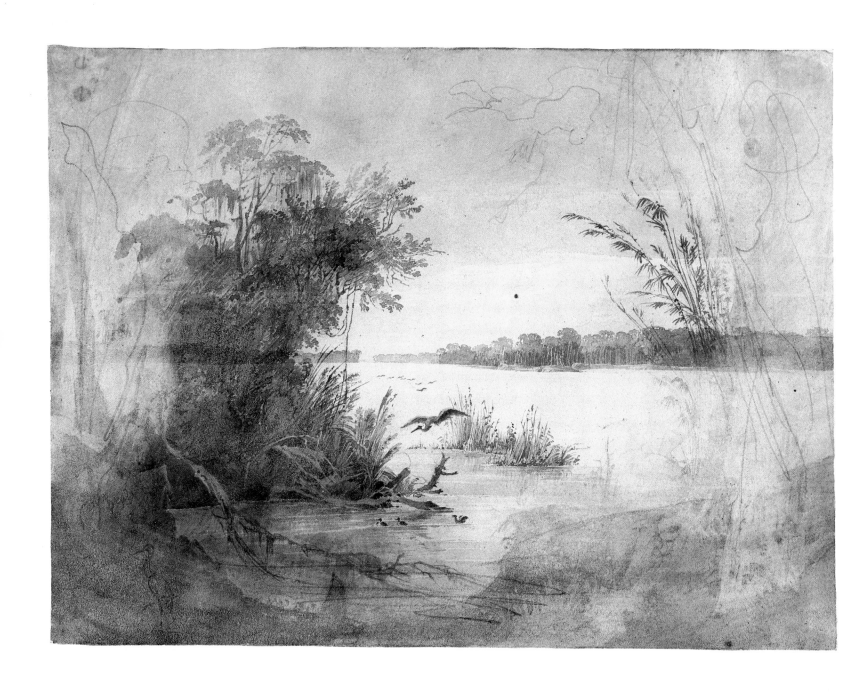

5
Karl Bodmer
View on the Mississippi 1833
watercolor, pencil on paper, 16.2 × 21.9 cm. 6⅜ × 8⅝ inches
The Enron Art Foundation/Joslyn Art Museum, Omaha, Nebraska

6
Karl Bodmer
Lighthouse near Natchez on the Mississippi 1833
watercolor, pencil on paper, 21.6 × 16.2 cm. 8½ × 6⅜ inches
The Enron Art Foundation/Joslyn Art Museum, Omaha, Nebraska

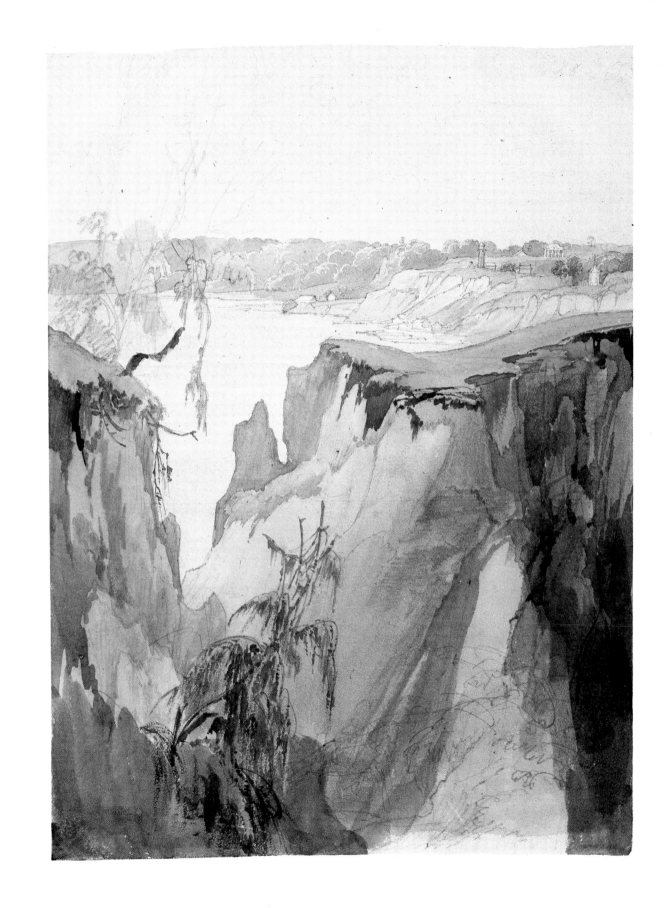

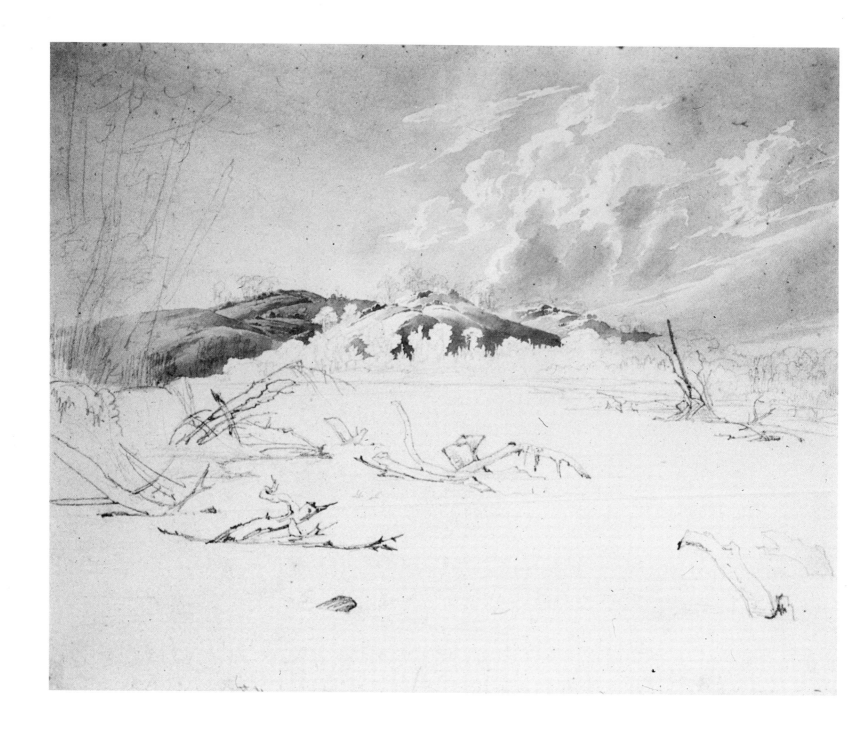

7
Karl Bodmer
Missouri Hills, Site of Former Kansas Village 1833
watercolor, pencil on paper, 21.9 × 27.6 cm. $8\frac{5}{8} \times 10\frac{7}{8}$ inches
The Enron Art Foundation/Joslyn Art Museum, Omaha, Nebraska

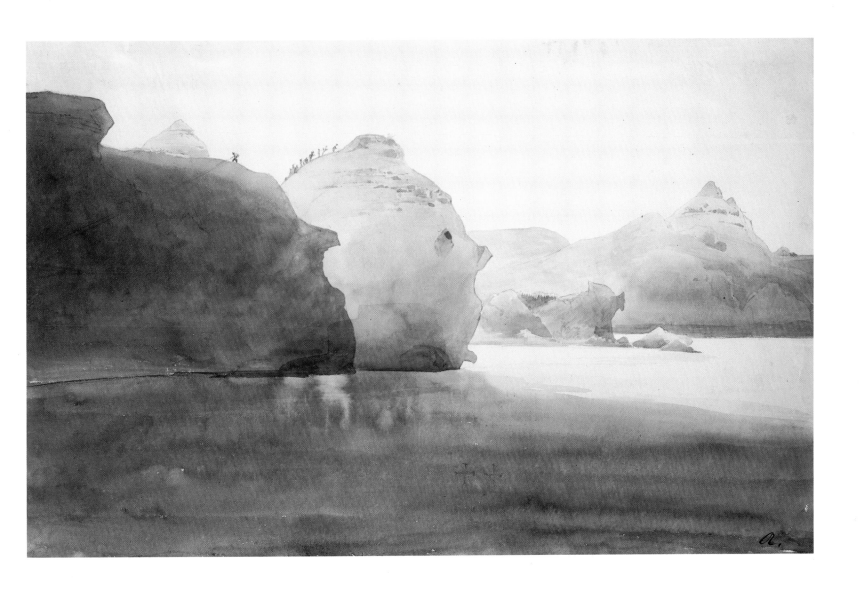

8
Karl Bodmer
Rock Formations on the Upper Missouri 1833
watercolor on paper, 20.0 × 31.4 cm. $7\frac{7}{8}$ × $12\frac{3}{8}$ inches
The Enron Art Foundation/Joslyn Art Museum, Omaha, Nebraska

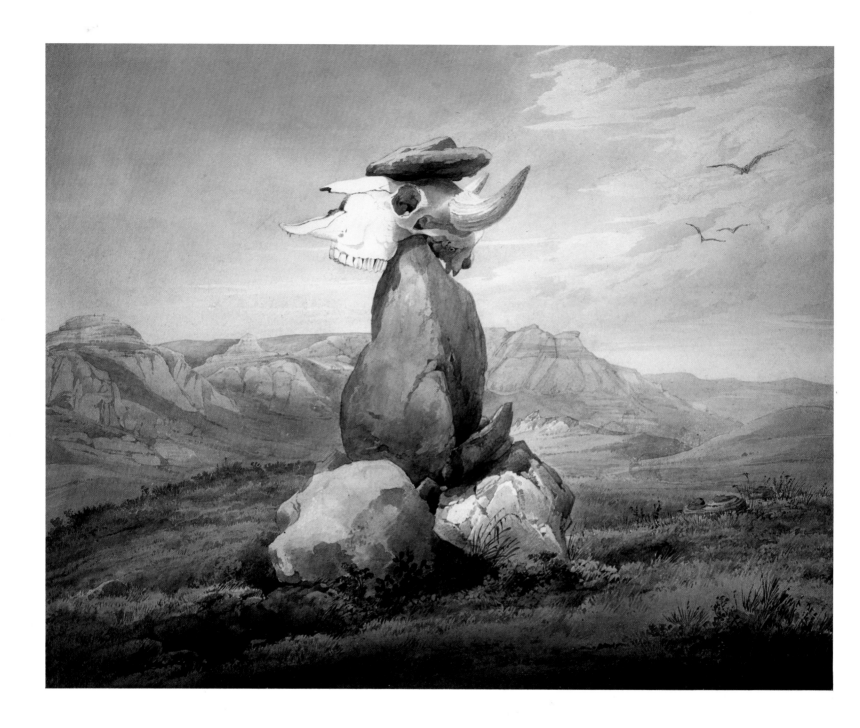

9
Karl Bodmer
Assiniboin Medicine Sign 1833
watercolor on paper, 24.4 × 31.1 cm. 9⅝ × 12¼ inches
The Enron Art Foundation/Joslyn Art Museum, Omaha, Nebraska

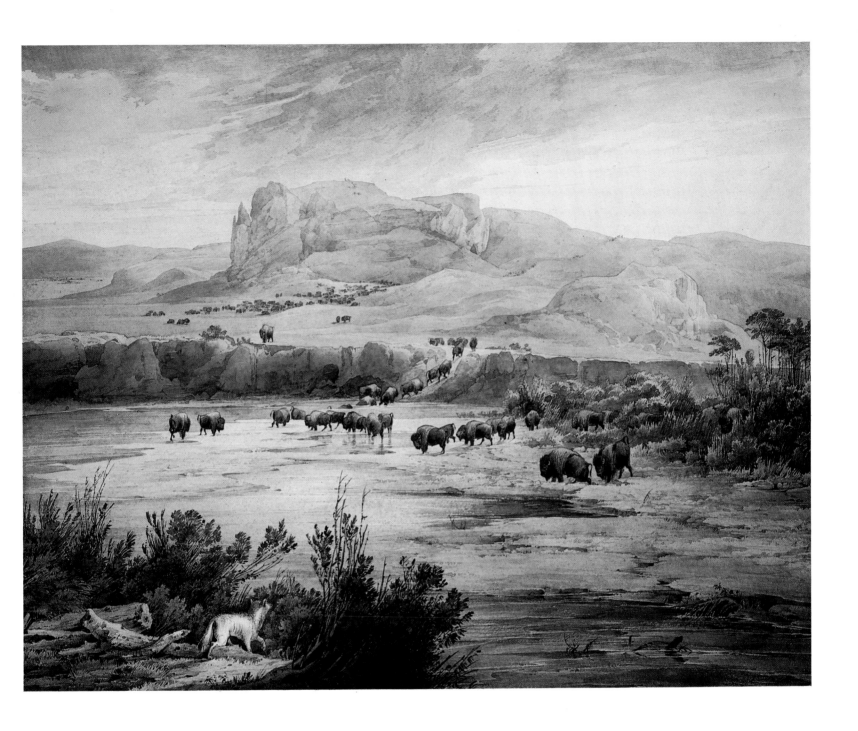

10
Karl Bodmer
Landscape with Herd of Buffalo on the Upper Missouri 1833
watercolor on paper, 24.4 × 31.4 cm. $9\frac{5}{8} \times 12\frac{3}{8}$ inches
The Enron Art Foundation/Joslyn Art Museum, Omaha, Nebraska

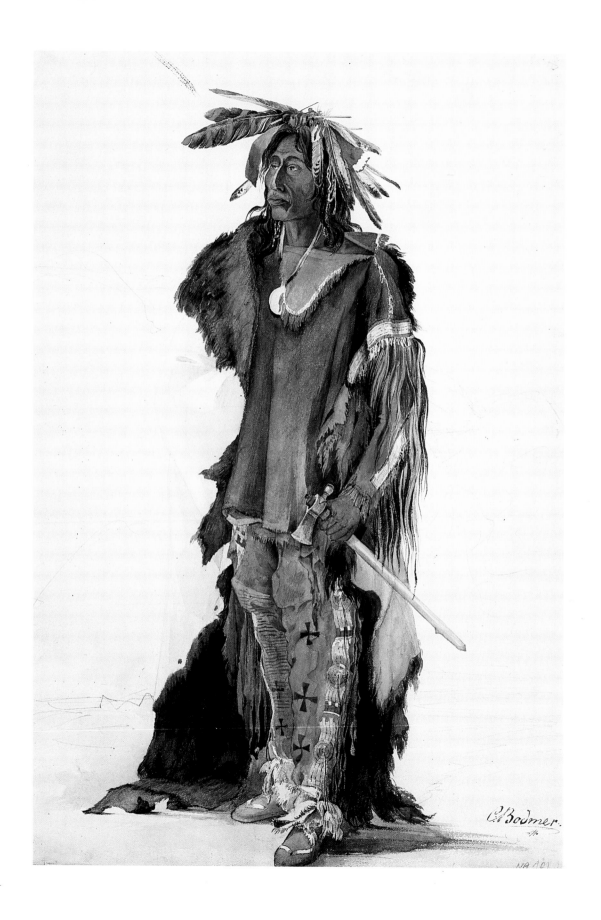

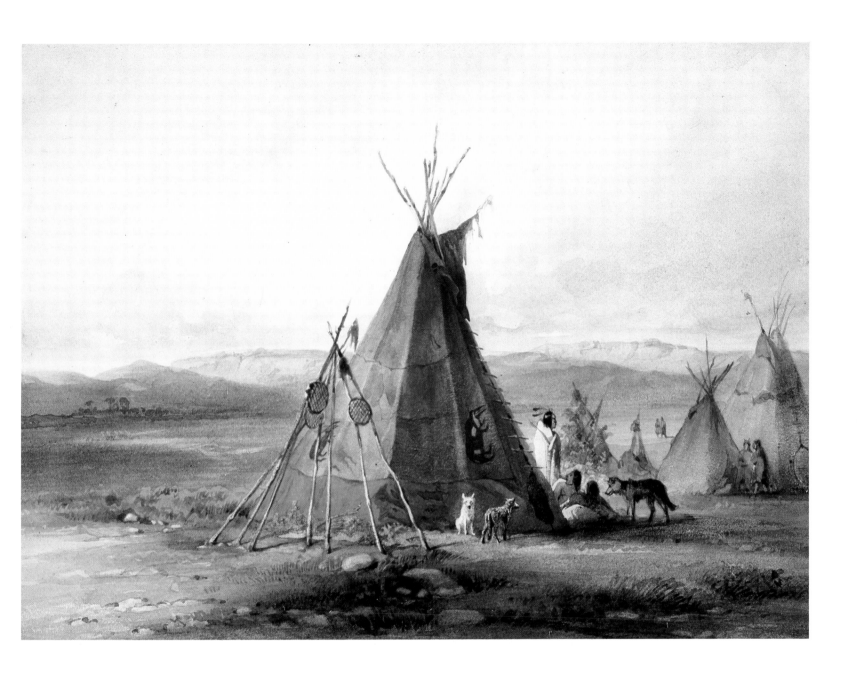

11
Karl Bodmer
Wahktageli, Yankton Sioux Chief 1833
watercolor, pencil on paper, 42.5×29.5 cm. $16\frac{3}{4} \times 11\frac{5}{8}$ inches
The Enron Art Foundation/Joslyn Art Museum, Omaha, Nebraska

12
Karl Bodmer
Assiniboin Camp 1833
watercolor on paper, 19.4×26.4 cm. $7\frac{5}{8} \times 10\frac{3}{8}$ inches
The Enron Art Foundation/Joslyn Art Museum, Omaha, Nebraska

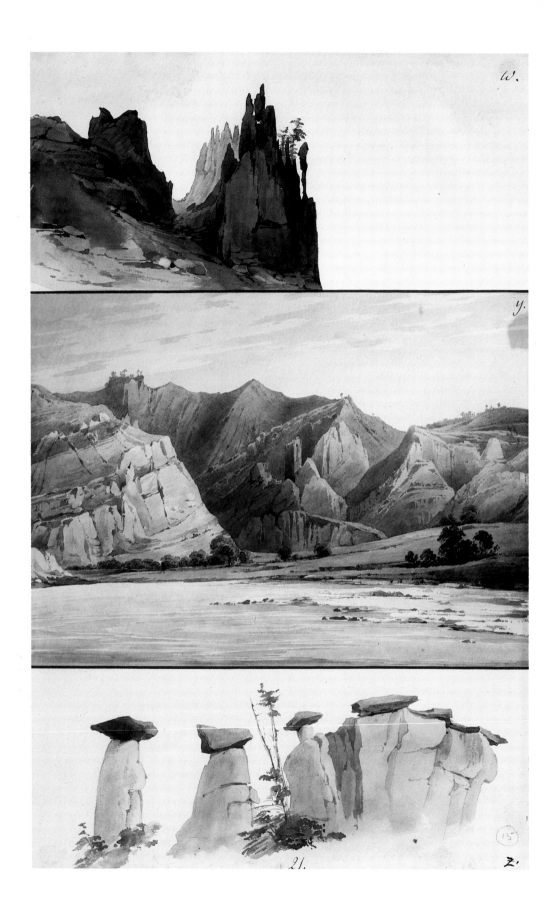

W.

y.

21.

15

Z.

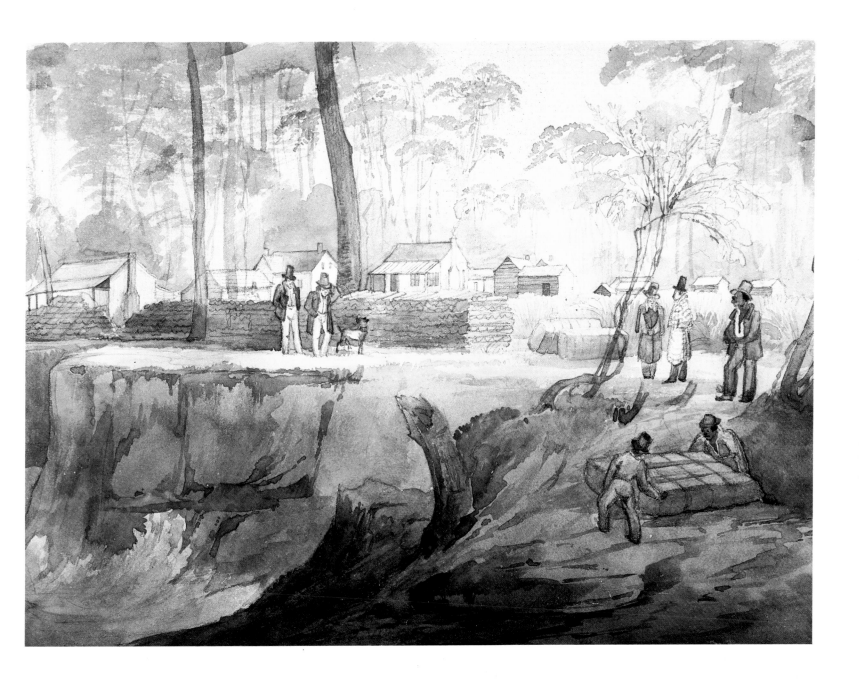

13
Karl Bodmer
Rock Formations on the Upper Missouri 1833
watercolor on paper, 31.4 × 20.0 cm. 12½ × 7¾ inches
The Enron Art Foundation/Joslyn Art Museum, Omaha, Nebraska

14
Karl Bodmer
New Mexico on the Mississippi 1833
watercolor on paper, 16.2 × 22.2 cm. 6⅜ × 8¾ inches
The Enron Art Foundation/Joslyn Art Museum, Omaha, Nebraska

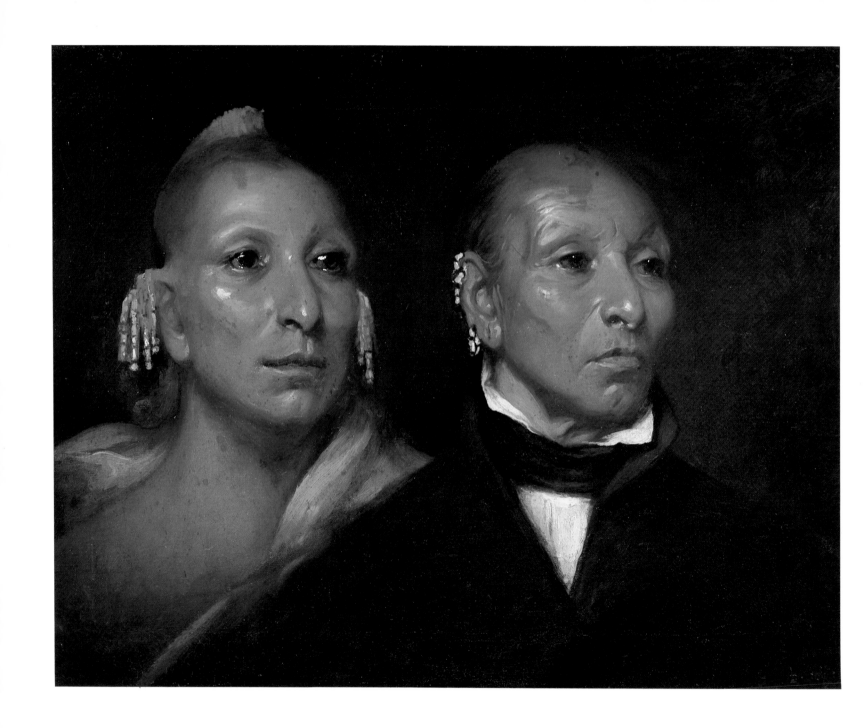

15
John Wesley Jarvis
Black Hawk and his Son, Whirling Thunder 1833
oil on canvas, 59.1 × 76.2 cm. 23¼ × 30 inches
Thomas Gilcrease Institute of American History and Art
Tulsa, Oklahoma

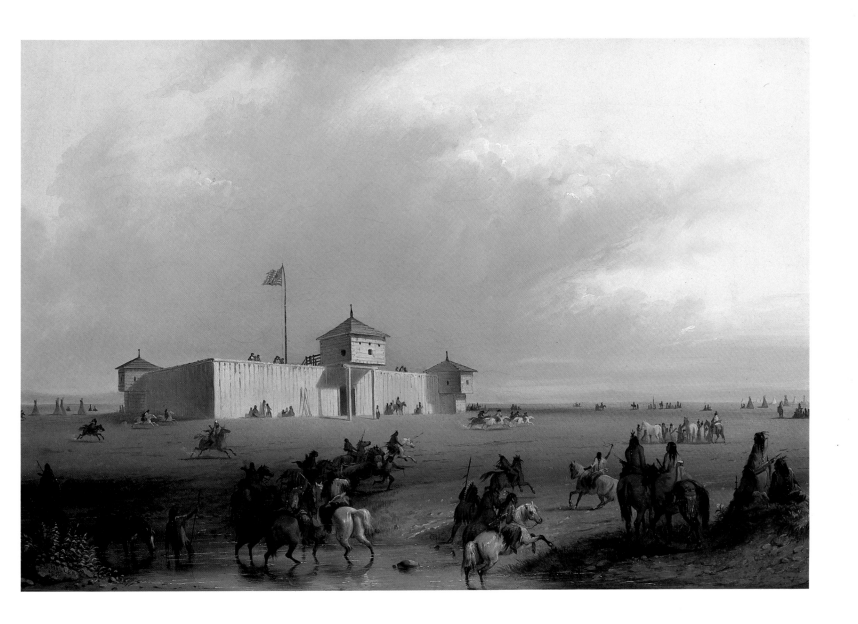

16
Alfred Jacob Miller
Fort Laramie (Fort William on the Laramie) 1851
oil on canvas, 45.7 × 68.6 cm. 18 × 27 inches
Thomas Gilcrease Institute of American History and Art
Tulsa, Oklahoma

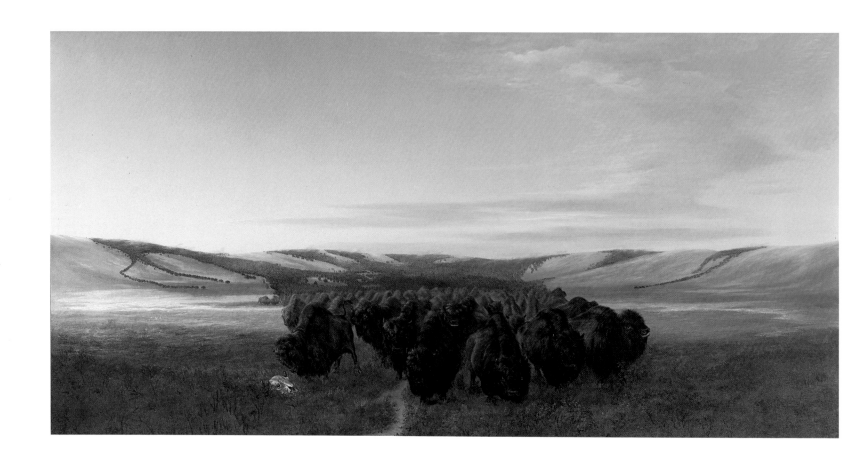

17
William Jacob Hays
A Herd of Buffaloes on the Bed of the River Missouri c.1860–1862
oil on canvas, 91.4 × 182.9 cm. 36 × 72 inches
Thomas Gilcrease Institute of American History and Art
Tulsa, Oklahoma

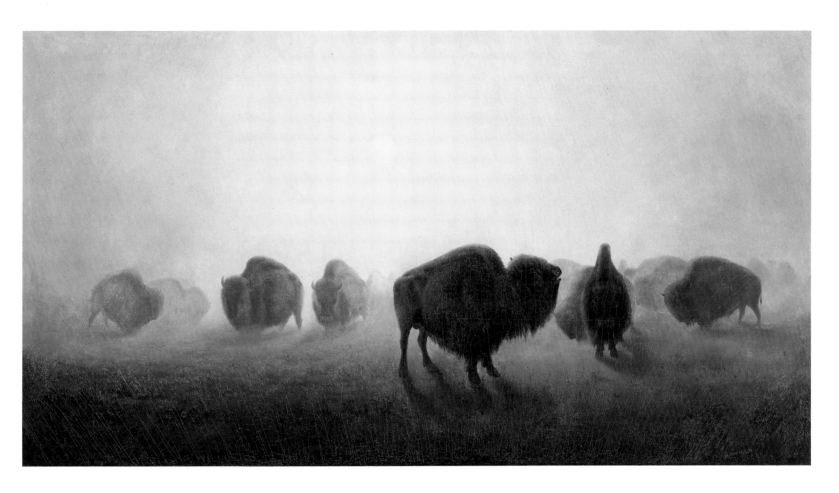

18
William Jacob Hays
Herd of Buffalo 1862
oil on canvas, 64.8×120.7 cm. $25\frac{1}{2} \times 47\frac{5}{8}$ inches
The Denver Art Museum, Museum Purchase: Fred E. Gates Fund

19
Albert Bierstadt
Rocky Mountains, "Lander's Peak" 1863 [incorrect title?]
oil on canvas, 112.7×92.7 cm. $44\frac{3}{8} \times 36\frac{1}{2}$ inches
Harvard University Art Museums (Fogg Art Museum)
Bequest of Mrs. William Hayes Fogg

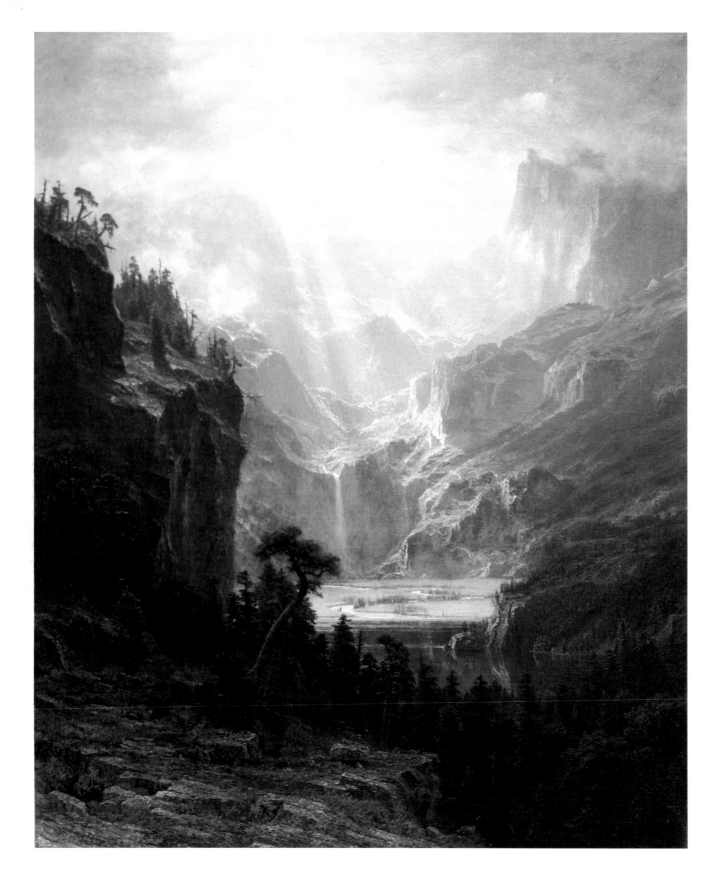

19

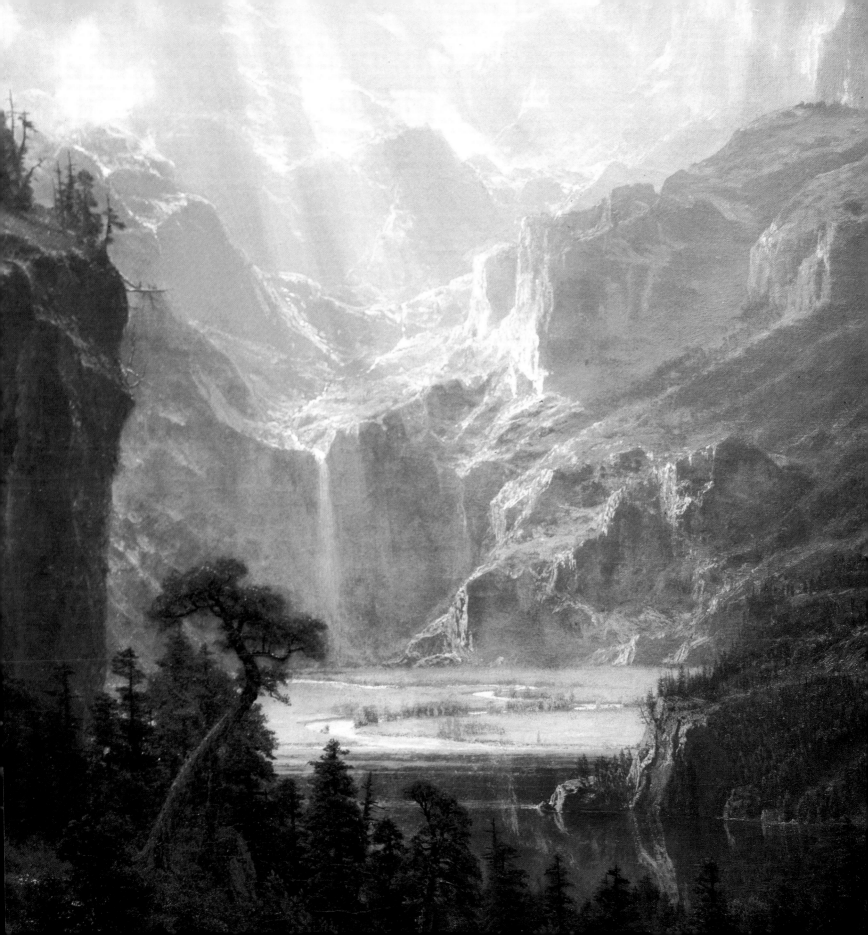

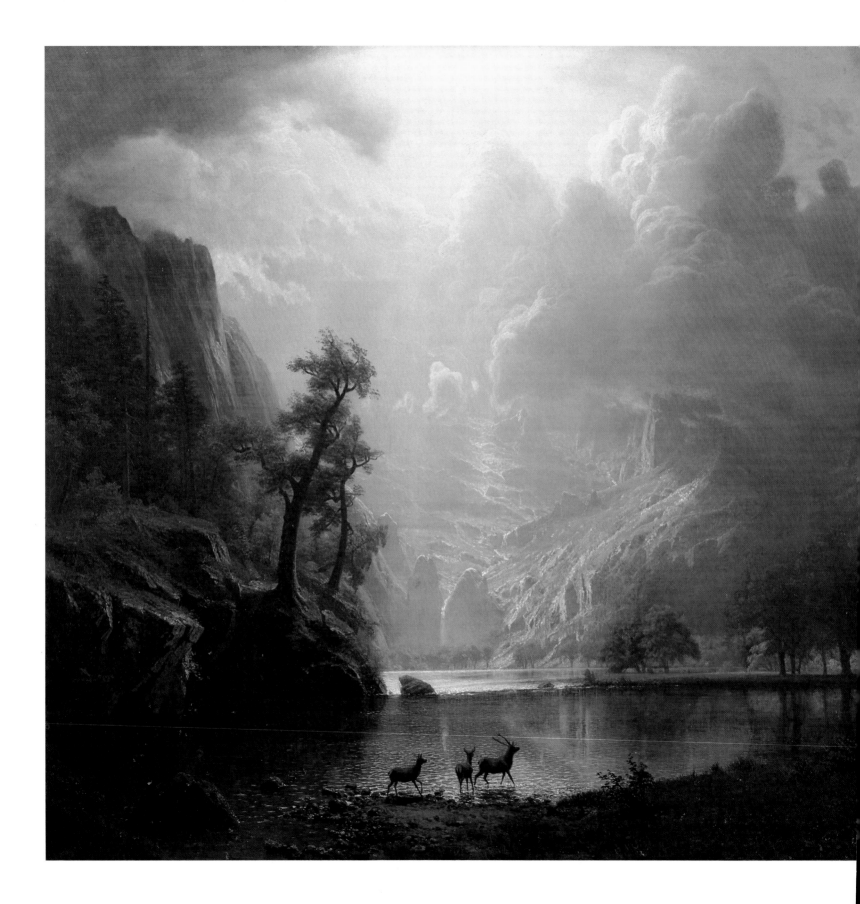

20
Albert Bierstadt
Sierra Nevada Morning c.1870
oil on canvas, 142.2 × 213.5 cm. 56 × 84 inches
Thomas Gilcrease Institute of American History and Art
Tulsa, Oklahoma

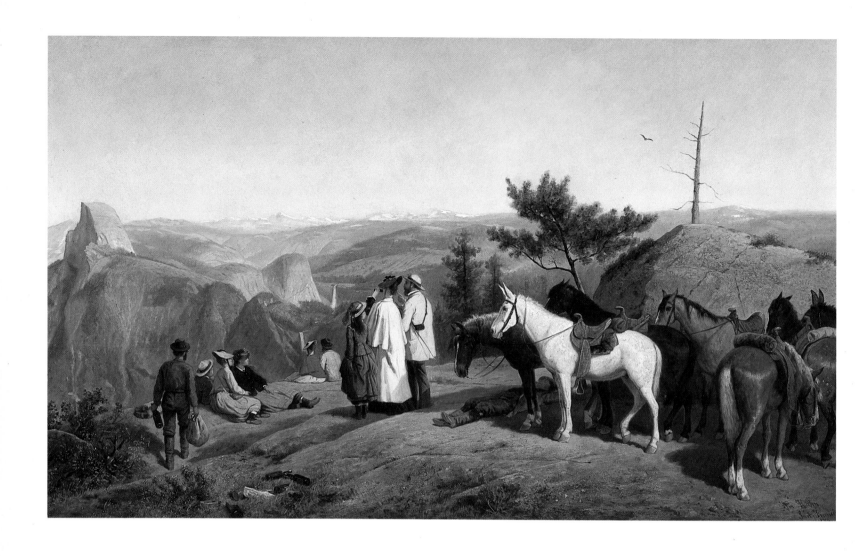

21
William Hahn
Looking Down on Yosemite Valley from Glacier Point 1874
oil on canvas, 69.3 × 162.5 cm. 27 × 46 inches
California Historical Society, San Francisco

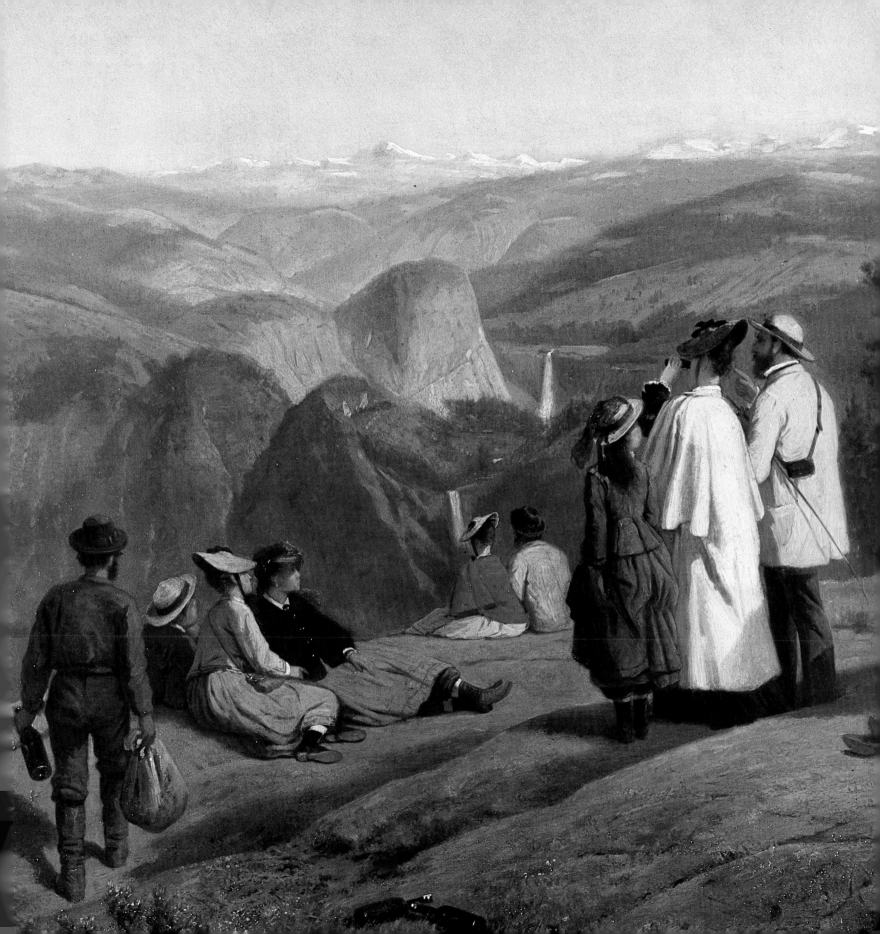

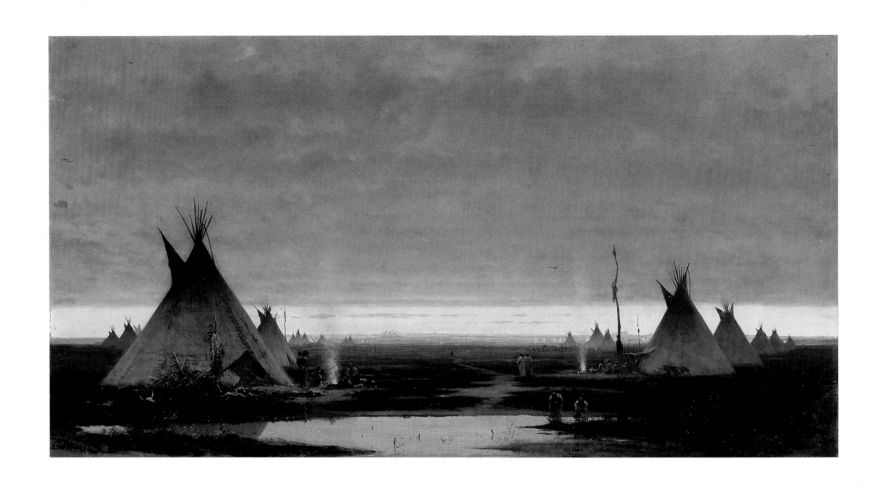

22
Jules Tavernier
Indian Village
oil on canvas, 61.0 × 86.4 cm. 24 × 34 inches
Thomas Gilcrease Institute of American History and Art
Tulsa, Oklahoma

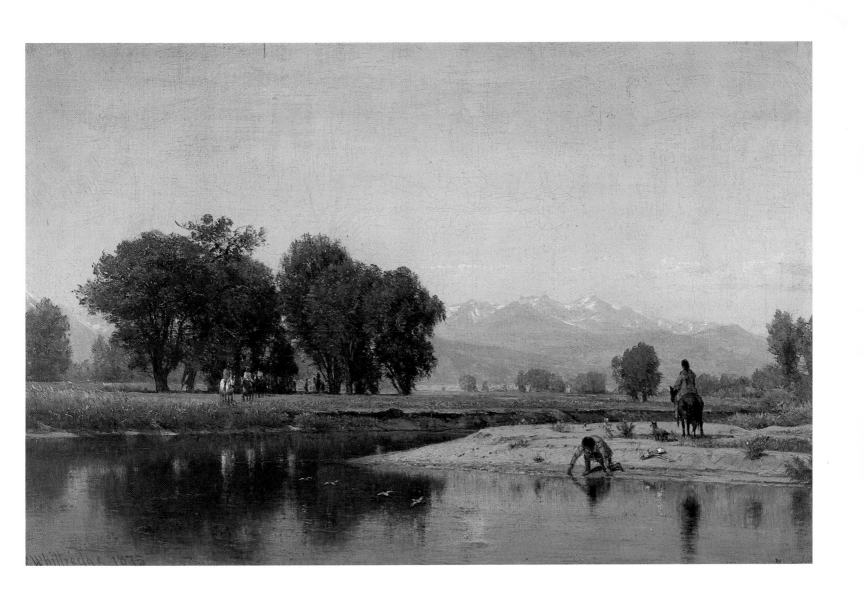

23
T. Worthington Whittredge
On the Platte River, Colorado 1875
oil on canvas, 39.4 × 63.5 cm. 16 × 25 inches
Collection of the San Antonio Museum Association
San Antonio, Texas

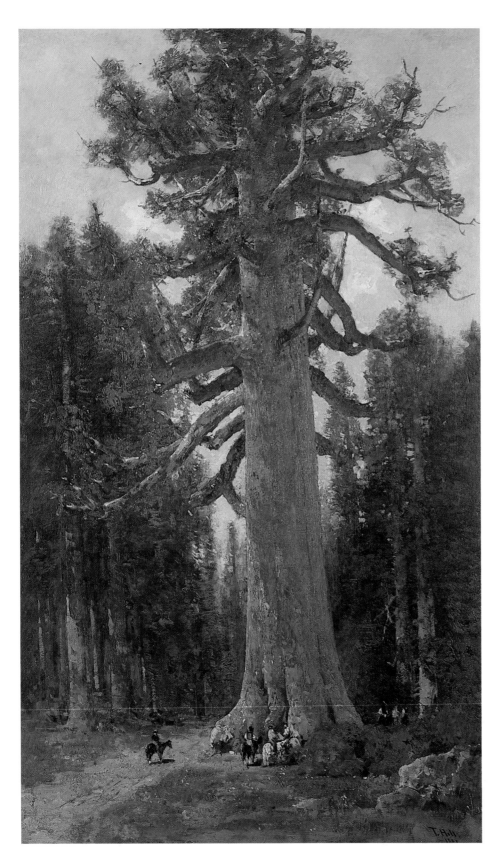

24
Thomas Hill
Among the Giant Redwoods 1884
oil on canvas, 119.4 × 71.1 cm. 47 × 28 inches
Lane Publishing Company
(Sunset Magazine, Books and Films)

25
Thomas Moran
Side Canyon of the Colorado 1878
oil on canvas, 113.7 × 98.4 cm. 44¾ × 38¾ inches
Thomas Gilcrease Institute of American History and Art
Tulsa, Oklahoma

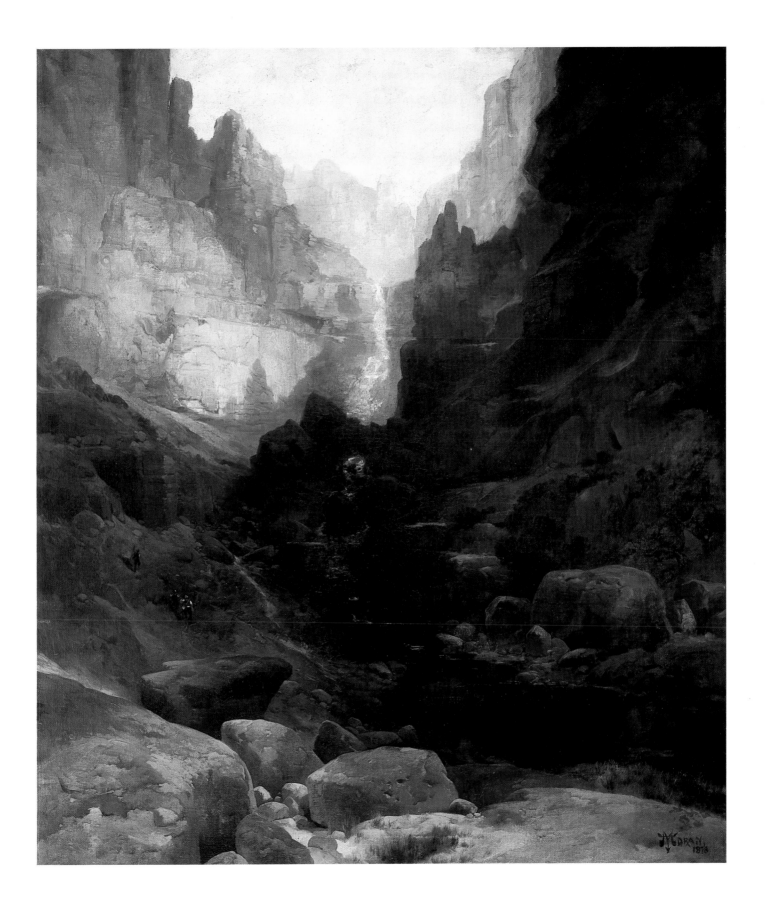

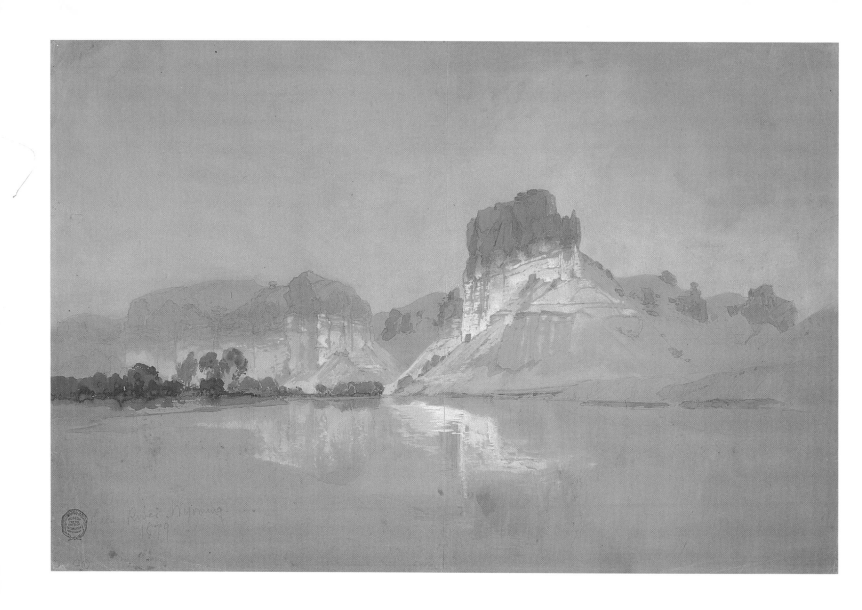

26
Thomas Moran
Green River, Wyoming 1879
watercolor on paper, 32.0 × 45.6 cm. 12⅝ × 18 inches
Cooper-Hewitt, Smithsonian Institution's
National Museum of Design (1917-17-39)

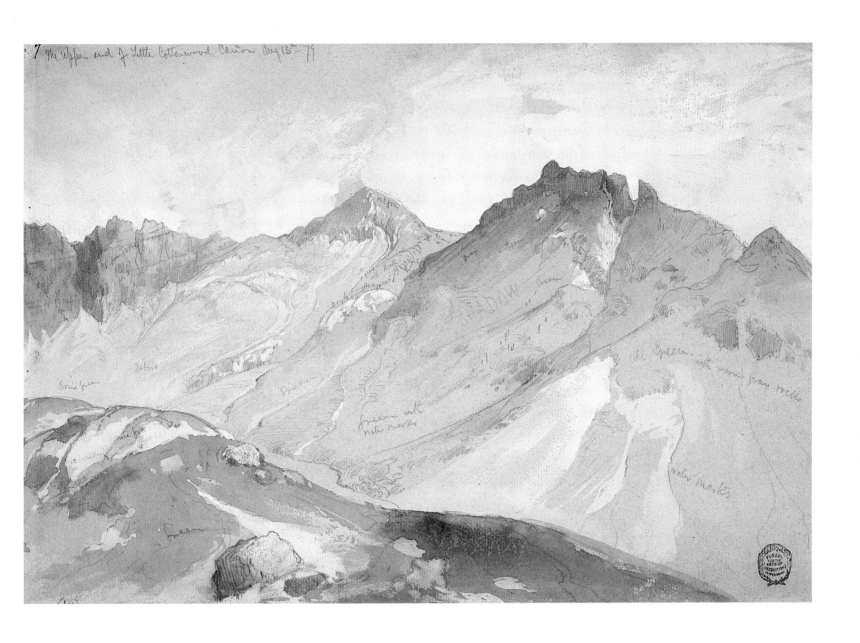

27
Thomas Moran
The Upper End of Little Cottonwood Canyon
watercolor over graphite on grey paper, 27.9 × 40.6 cm. 14 × 18 inches
Cooper-Hewitt, Smithsonian Institution's
National Museum of Design (1917-17-79)

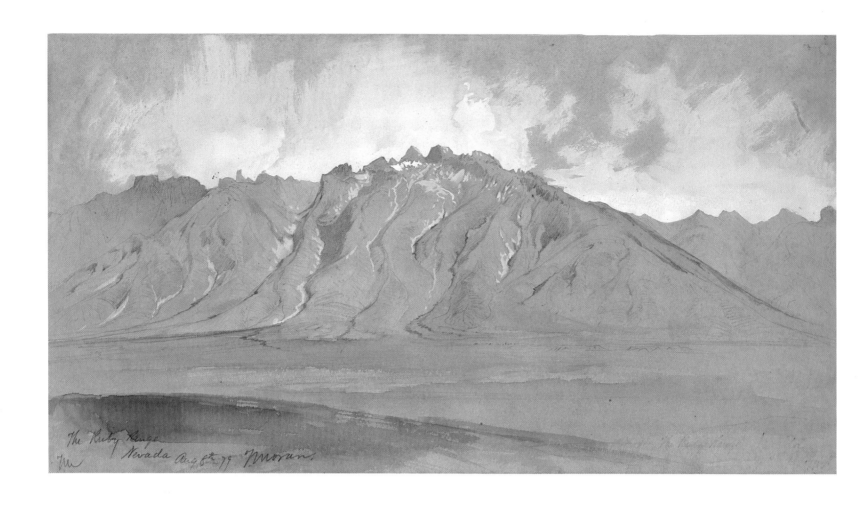

28
Thomas Moran
The Ruby Range, Nevada 1879
watercolor and pencil on tan paper, 51.4 × 36.5 cm. $7\frac{11}{16} \times 14\frac{3}{8}$ inches
The Cleveland Museum of Art
Bequest of Mrs. Henry A. Everett for the Dorothy Burnham Everett Memorial Collection

29
Thomas Moran
The Grand Canyon of the Yellowstone 1893
oil on canvas, 50.8 × 40.6 cm. 20 × 16 inches
The Fine Arts Museums of San Francisco
Gift of Mr. and Mrs. John D. Rockefeller, 3rd

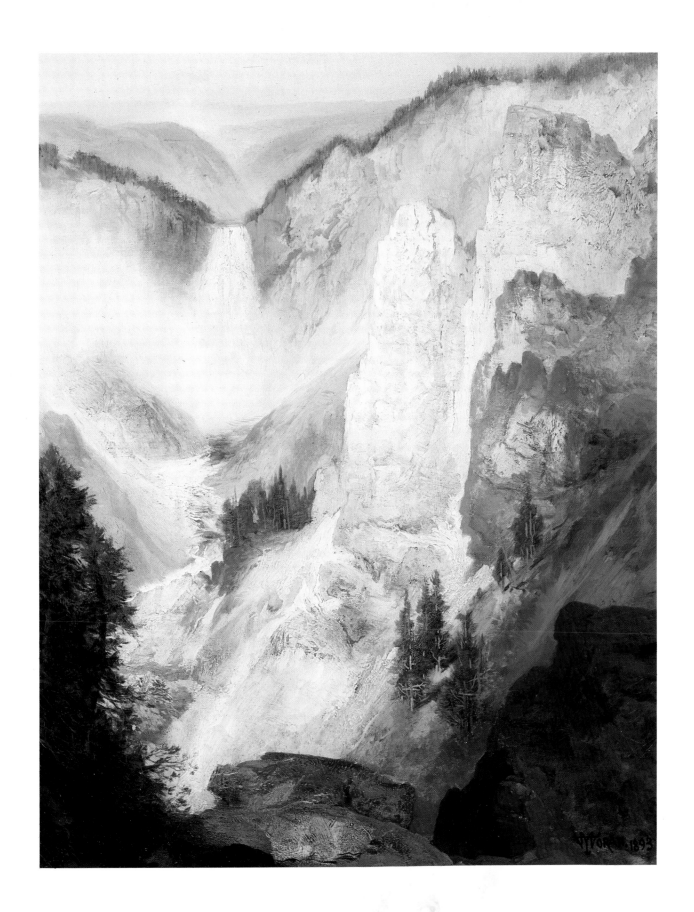

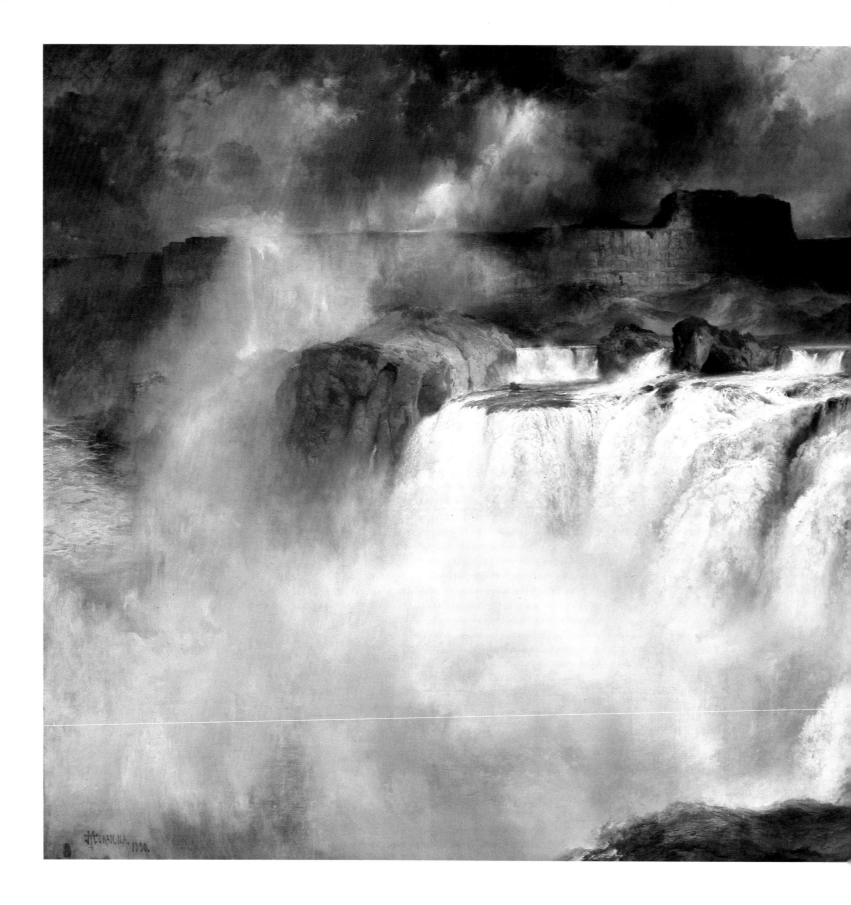

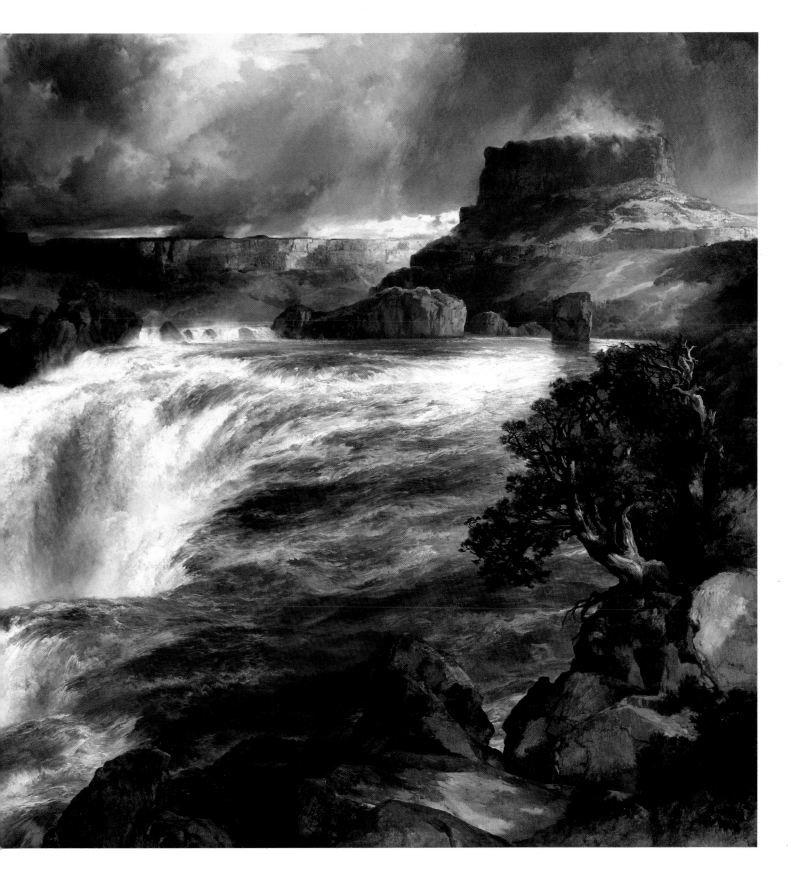

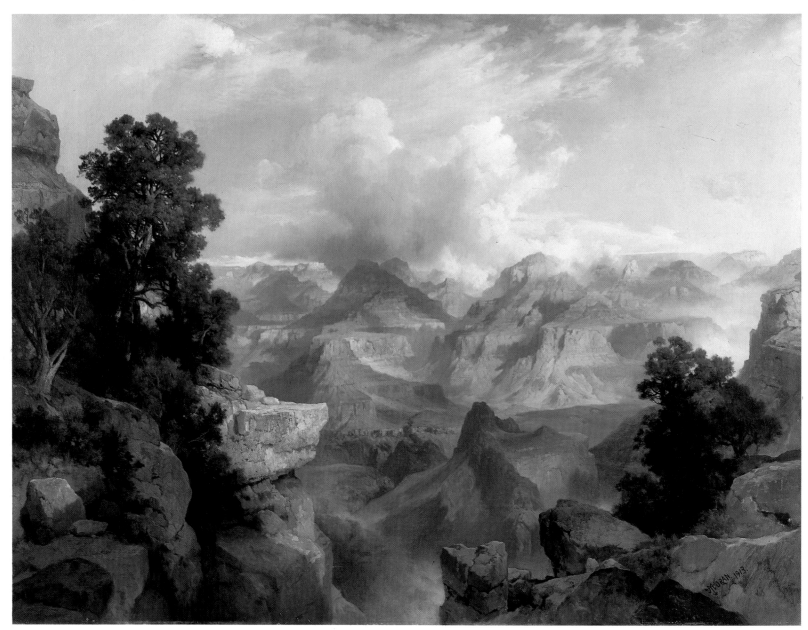

31
Thomas Moran
Grand Canyon 1913
oil on canvas, 76.2 × 101.6 cm. 30 × 40 inches
Thomas Gilcrease Institute of American History and Art
Tulsa, Oklahoma

30
Thomas Moran
Shoshone Falls on the Snake River 1900
oil on canvas, 180.3 × 335.3 cm. 71 × 132 inches
Thomas Gilcrease Institute of American History and Art
Tulsa, Oklahoma

32
George Inness
California 1894
oil on canvas, 152.4 × 121.9 cm. 60 × 48 inches
Gift of the Estate of Helen Hathaway White and
the Women's Board of the Oakland Museum Association

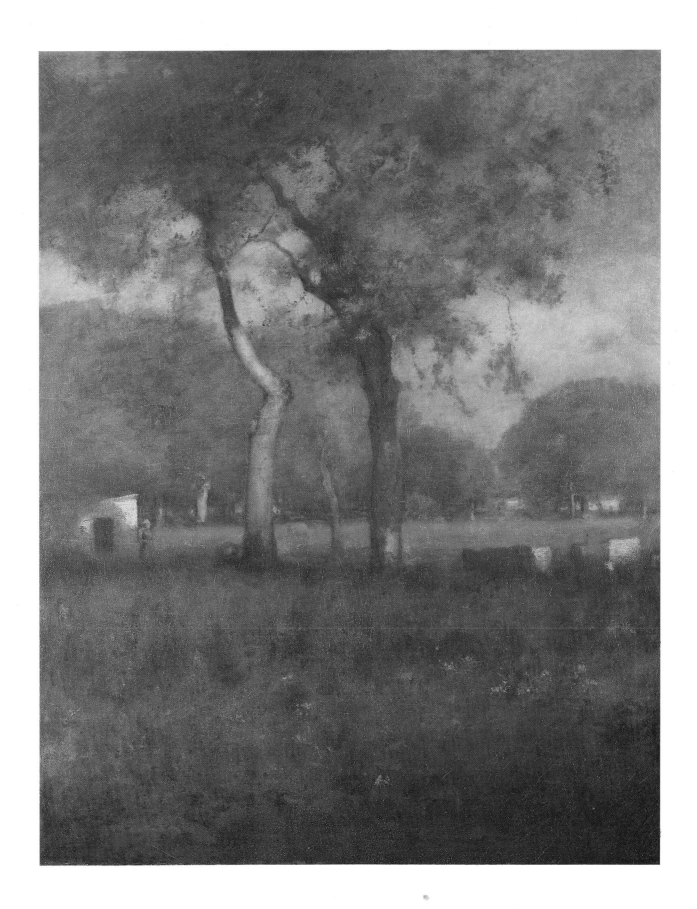

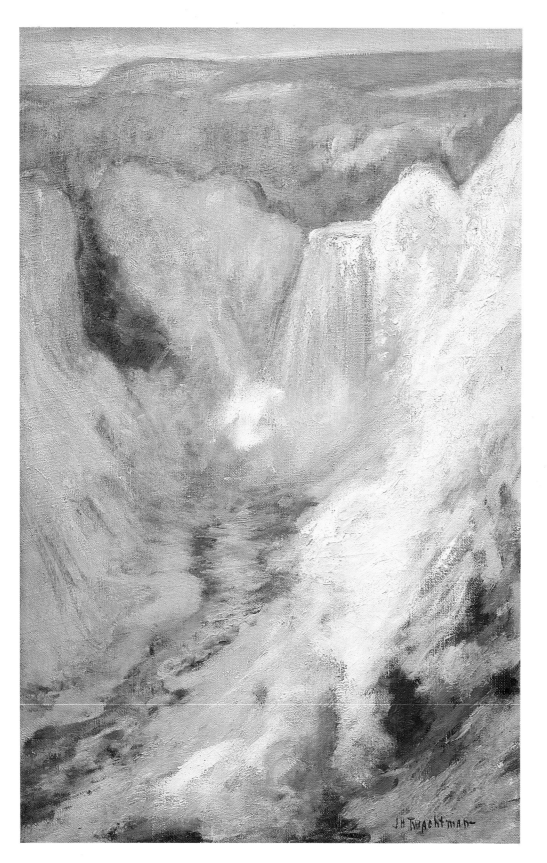

33
John Henry Twachtman
Waterfall in Yellowstone 1895
oil on canvas, 64.5 × 42.9 cm. 25⅜ × 16½ inches
Courtesy of the Buffalo Bill Historical Center
Cody, Wyoming

34
John Henry Twachtman
The Emerald Pool c.1895
oil on canvas, 63.5 × 63.5 cm. 25 × 25 inches
The Phillips Collection, Washington D.C.

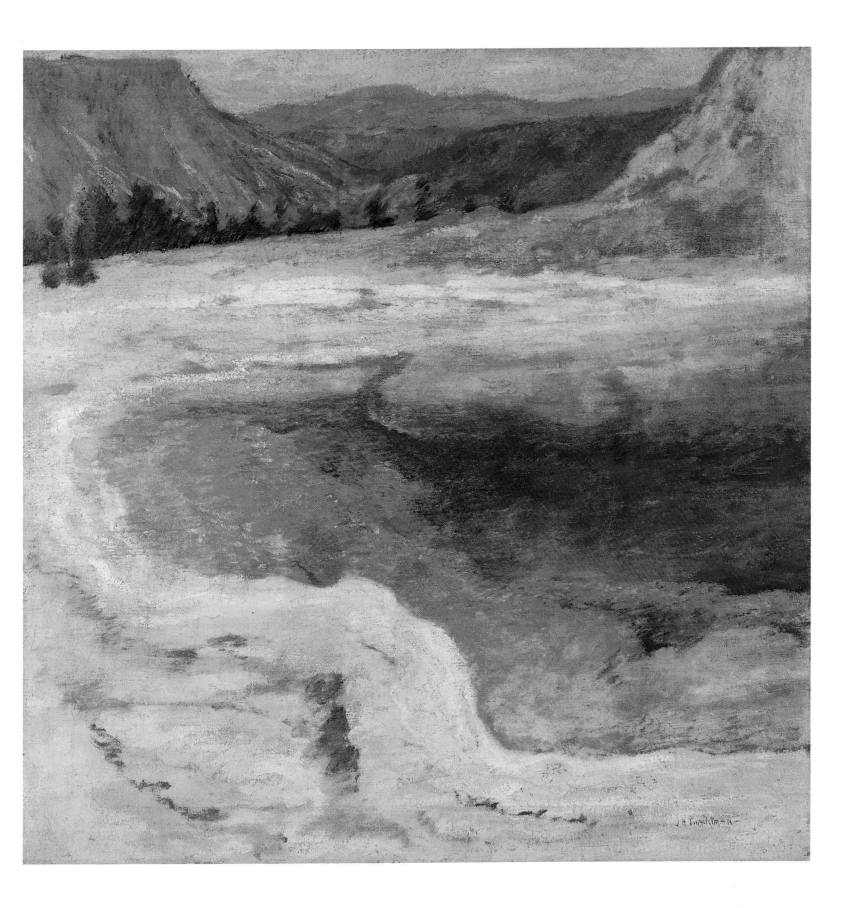

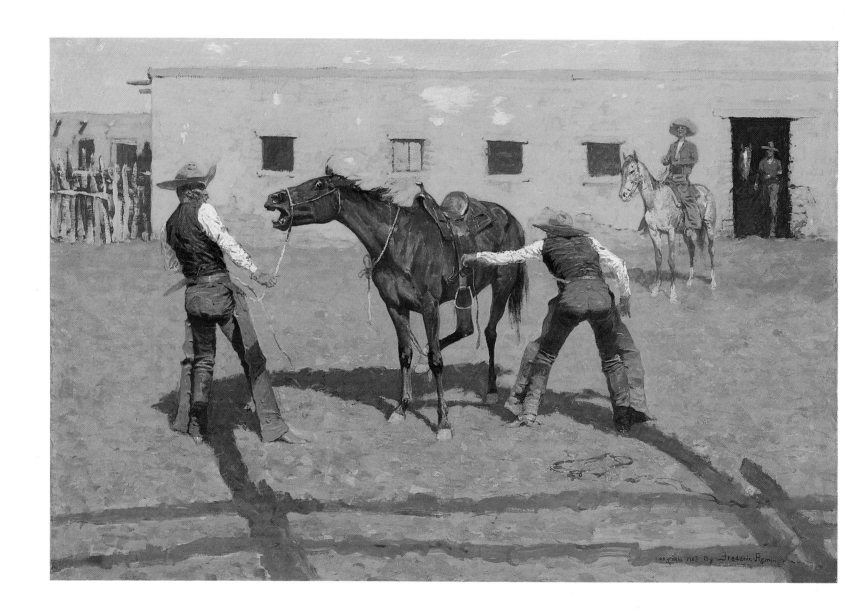

35
Frederic Remington
His First Lesson 1903
oil on canvas, 69.3 × 101.6 cm. 27¼ × 40 inches
Courtesy Amon Carter Museum, Fort Worth, Texas

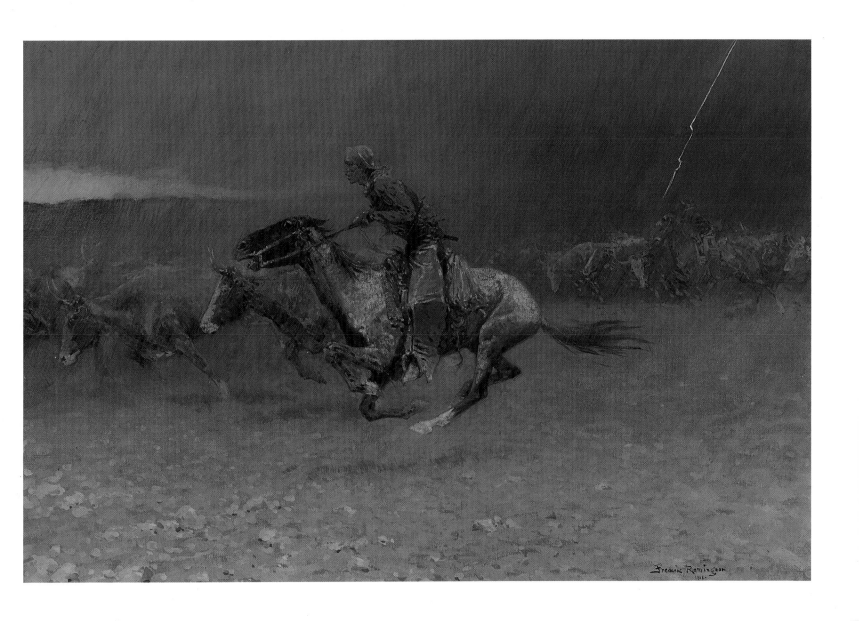

36
Frederic Remington
The Stampede 1908
oil on canvas, 68.6 × 101.6 cm. 27 × 40 inches
Thomas Gilcrease Institute of American History and Art
Tulsa, Oklahoma

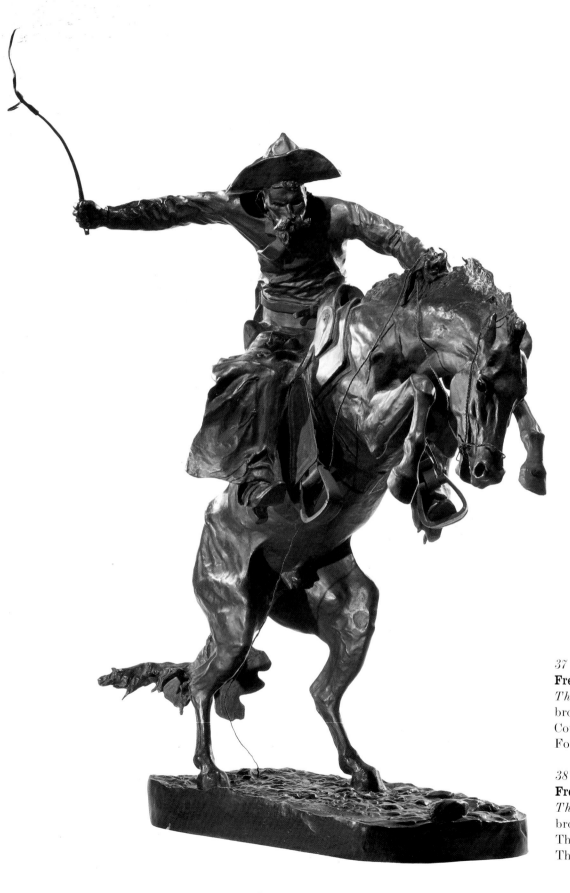

37
Frederic Remington
The Bronco Buster 1895
bronze, 59.7 × 38.7 cm. 23½ × 15¼ inches
Courtesy Amon Carter Museum
Fort Worth, Texas

38
Frederic Remington
The Cheyenne 1901
bronze, 53.3 cm. 21 inches
The Denver Art Museum, Museum purchase
The William D. Hewit Charitable Annuity Trust

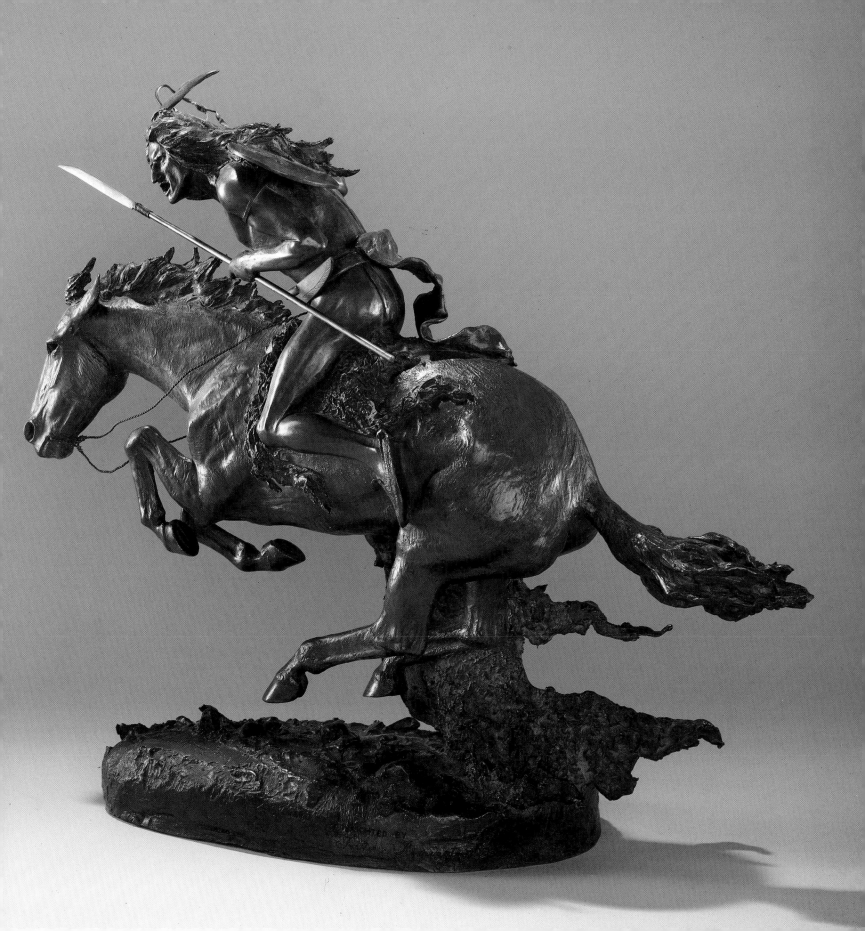

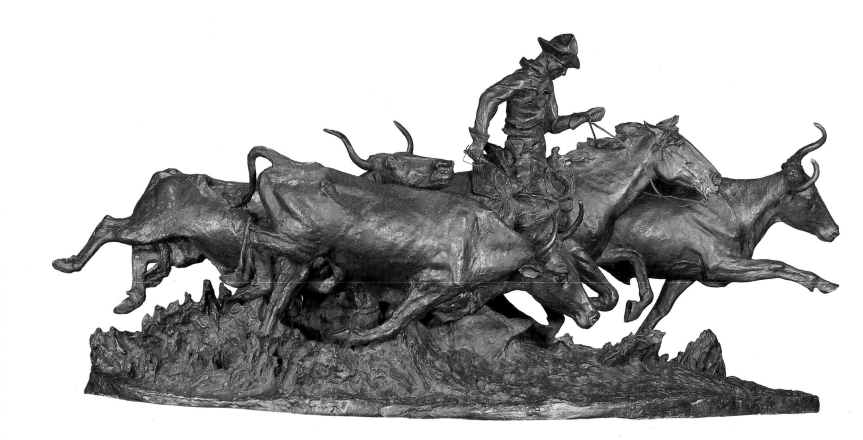

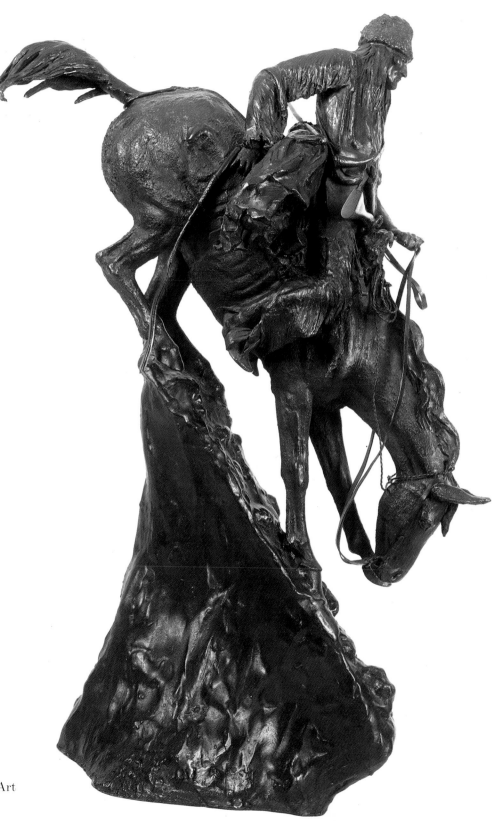

39
Frederic Remington
The Stampede 1910
bronze, 55.9 cm. 22⅝ inches
Courtesy Amon Carter Museum, Fort Worth, Texas

40
Frederic Remington
The Mountain Man 1903
bronze, 71.4 cm. 28¼ × 11 inches
Thomas Gilcrease Institute of American History and Art
Tulsa, Oklahoma

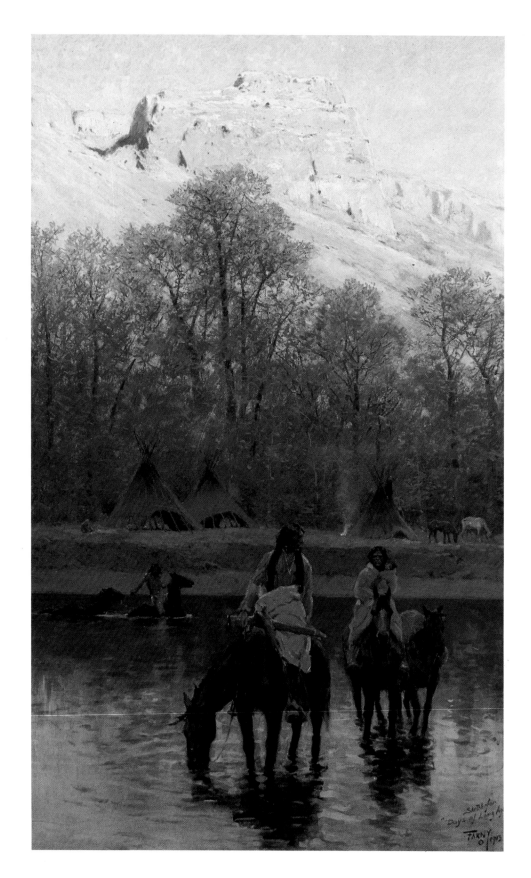

41
Henry Farny
Days of Long Ago 1903
oil on board, 95.3 × 60.4 cm. 37½ × 23¾ inches
Courtesy of the Buffalo Bill Historical Center
Cody, Wyoming

42
Arthur B. Davies
Mt. Tamalpais
oil on wood, 13.3 × 24.8 cm. 5¼ × 9¾ inches
The Oakland Museum, gift of the Concours d'Antiques, Art Guild

43
Arthur B. Davies
Lake Tahoe
oil on wood, 14.6 × 24.8 cm. 5¾ × 9¾ inches
The Oakland Museum, gift of the Concours d'Antiques, Art Guild

44
Arthur B. Davies
Emerald Bay
oil on wood, 30.5 × 41.3 cm. 12 × 16¼ inches
The Oakland Museum, gift of the Concours d'Antiques, Art Guild

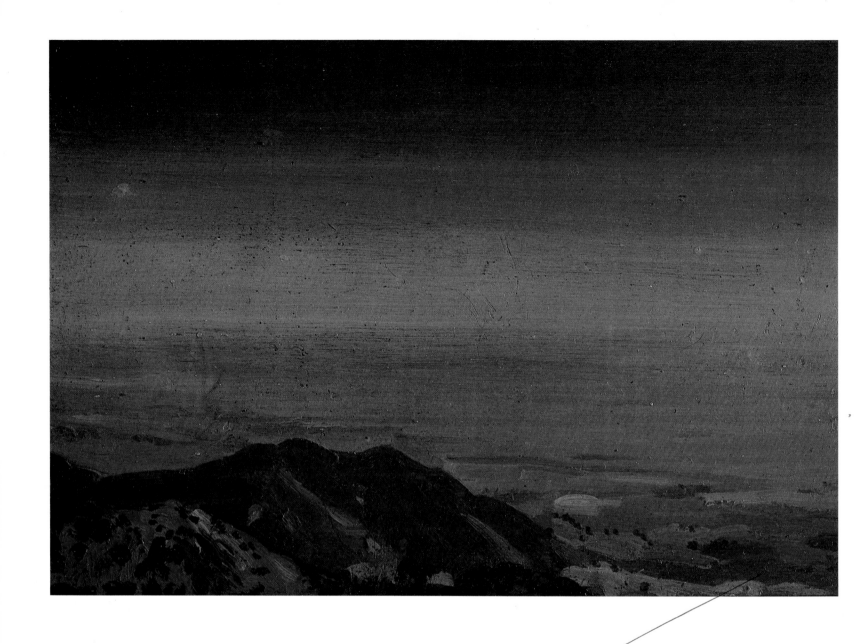

45
Arthur B. Davies
Mt. Diablo
oil on wood, 14.6 × 39.4 cm. 5¾ × 8¾ inches
The Oakland Museum, gift of the Concours d'Antiques, Art Guild

46
Marsden Hartley
Indian Composition 1914–15
oil on canvas, 119.7 × 119.4 cm. 47⅛ × 47 inches
Vassar College Art Gallery, Poughkeepsie, New York
Gift of Paul Rosenfeld

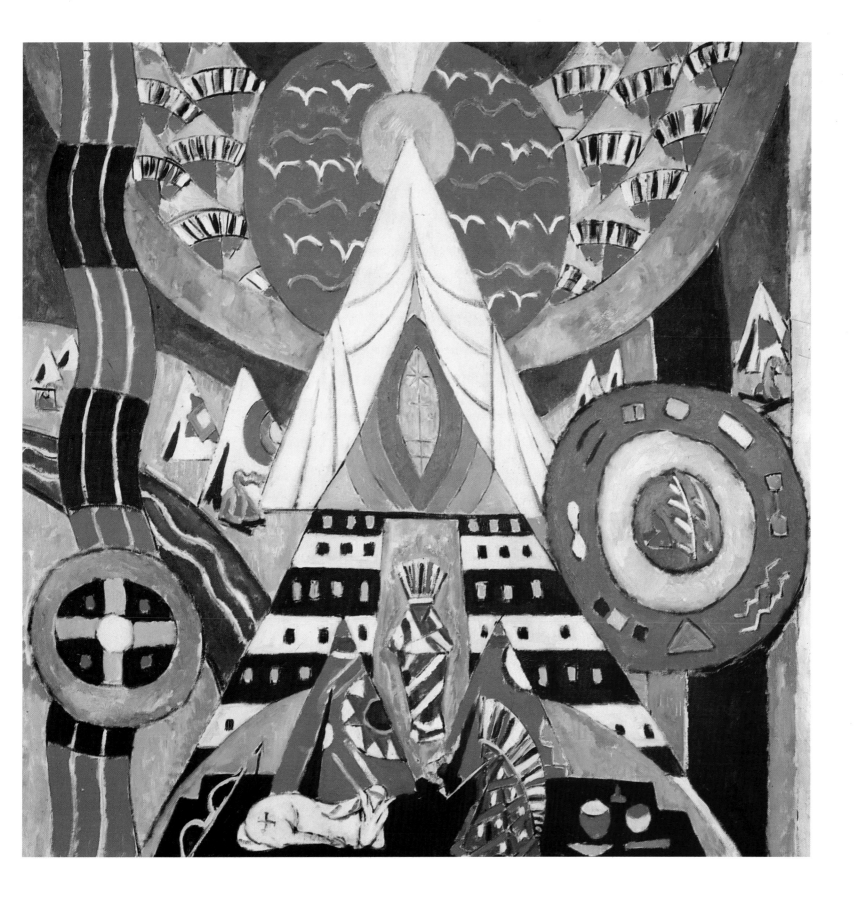

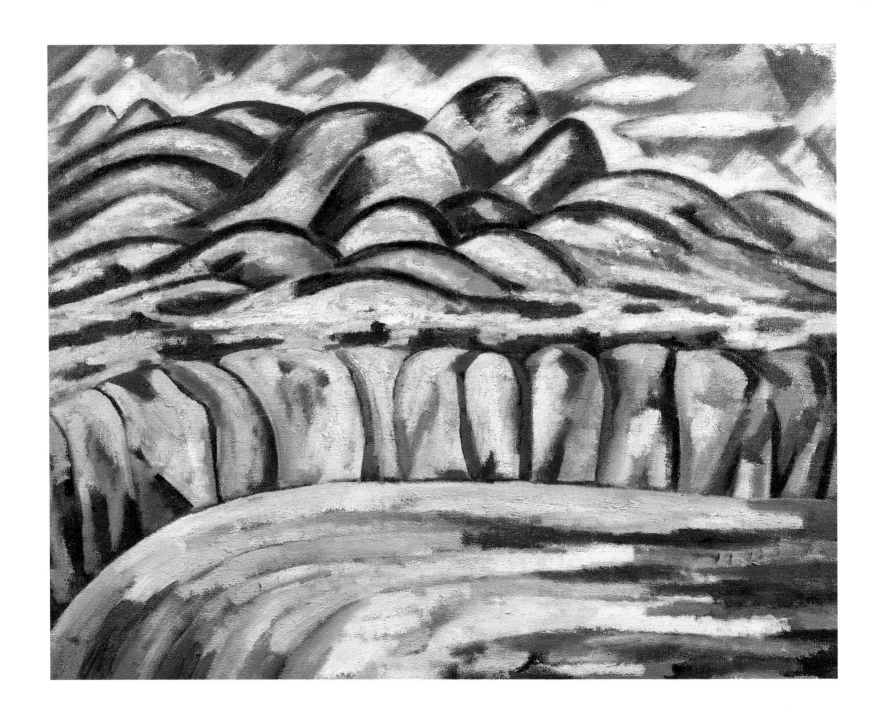

47
Marsden Hartley
Landscape, New Mexico 1919–20
oil on canvas, 55.9 × 81.3 cm. 28 × 36 inches
Lent by the Whitney Museum of American Art, New York
Purchase with funds from Frances and Sydney Lewis. 77.23

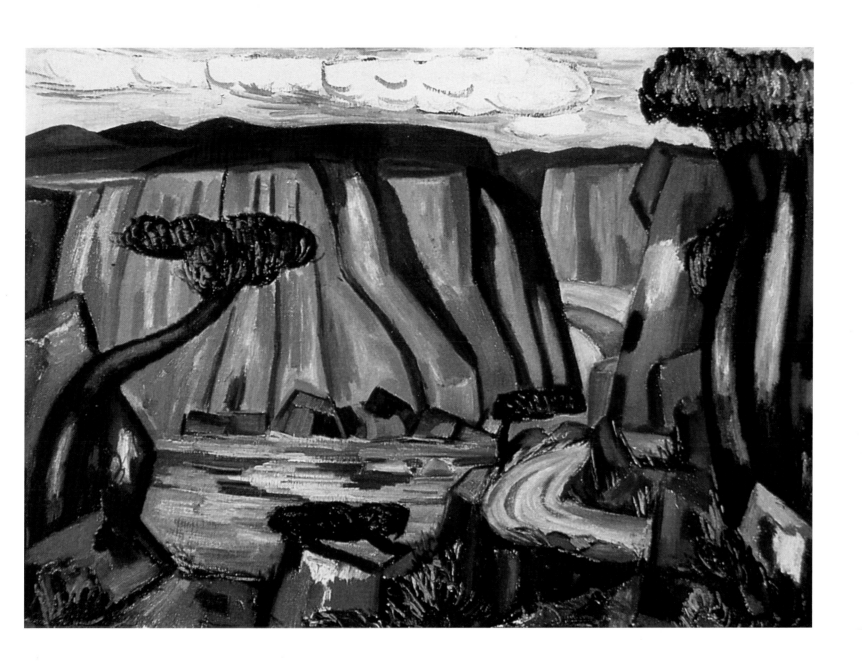

48
Marsden Hartley
New Mexico Recollection #6 1922–23
oil on canvas, 66.4 × 92.7 cm. 26 × 36½ inches
The Harmsen Collection

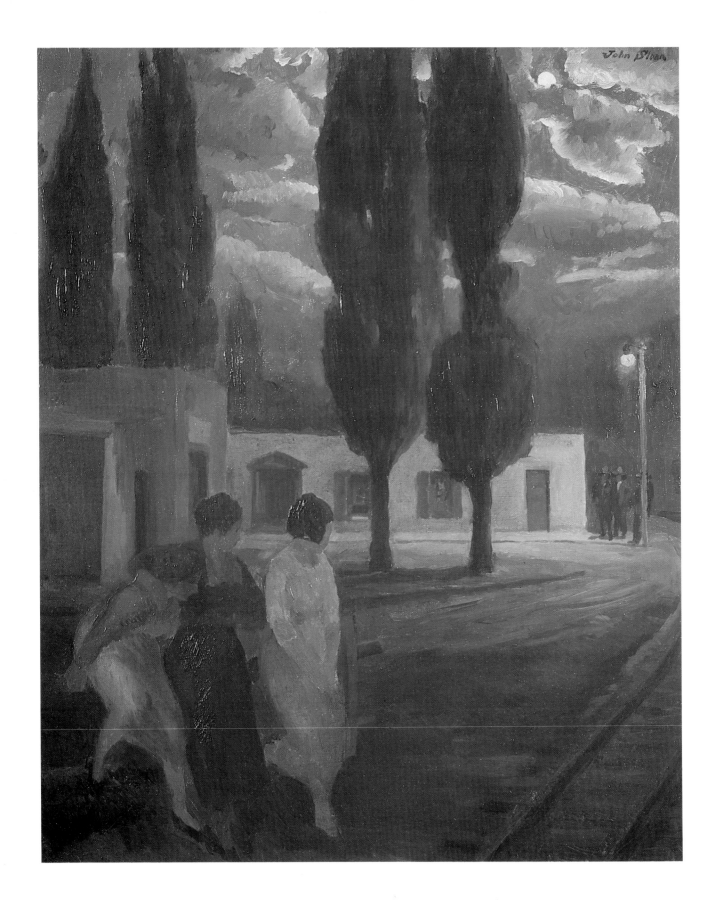

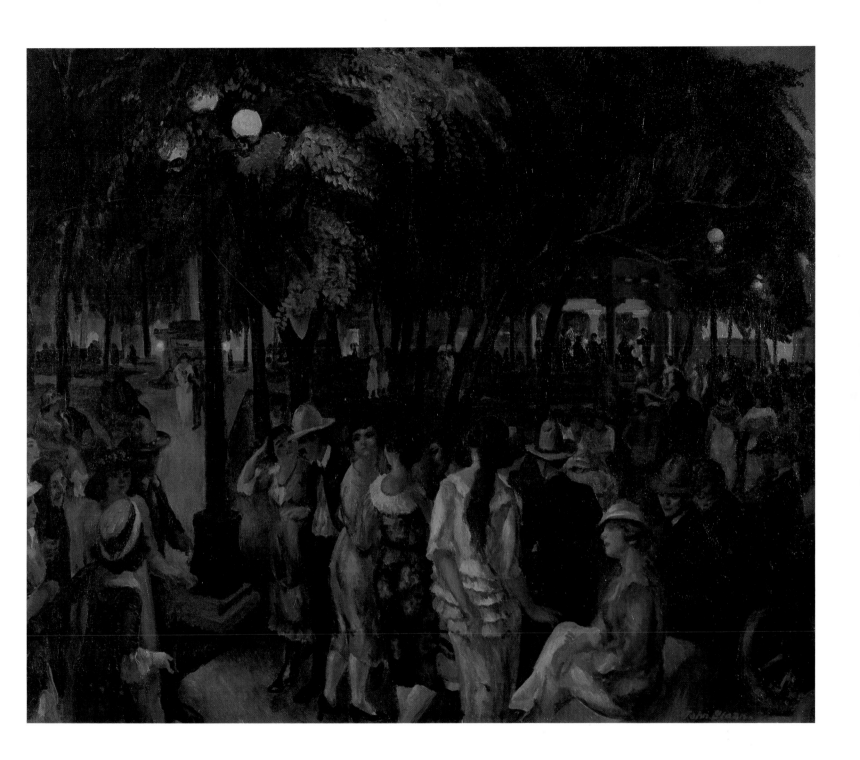

49
John Sloan
Down by the D & R, Santa Fe 1919
oil on canvas, 61.0 × 50.8 cm. 29½ × 25½ inches
Kraushaar Galleries, New York

50
John Sloan
Music in the Plaza 1920
oil on canvas, 66.0 × 81.3 cm. 26 × 32 inches
Museum of Fine Arts, New Mexico, Santa Fe

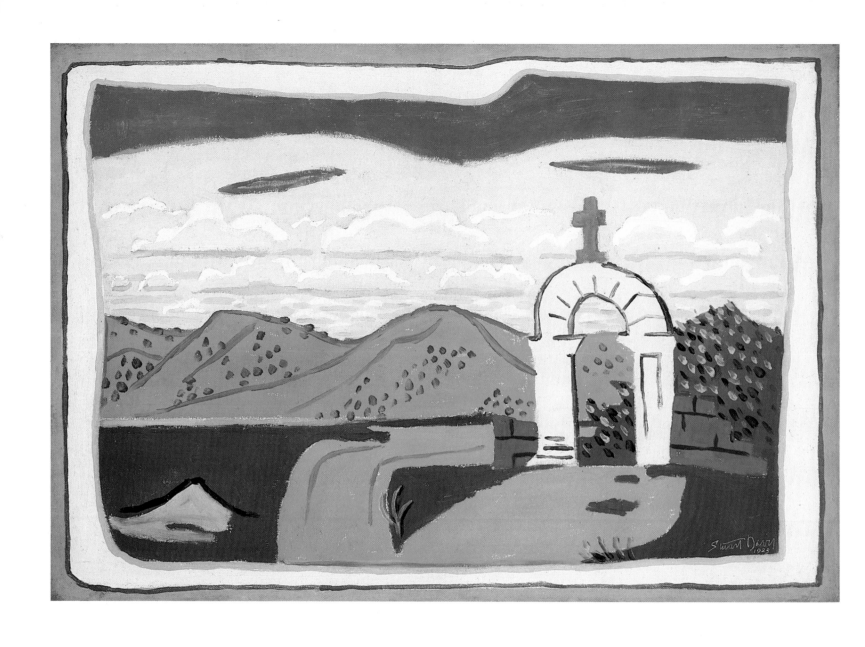

51
Stuart Davis
New Mexican Gate 1923
oil on linen, 55.9 × 81.3 cm. 22⅛ × 32⅛ inches
Roswell Museum and Art Center

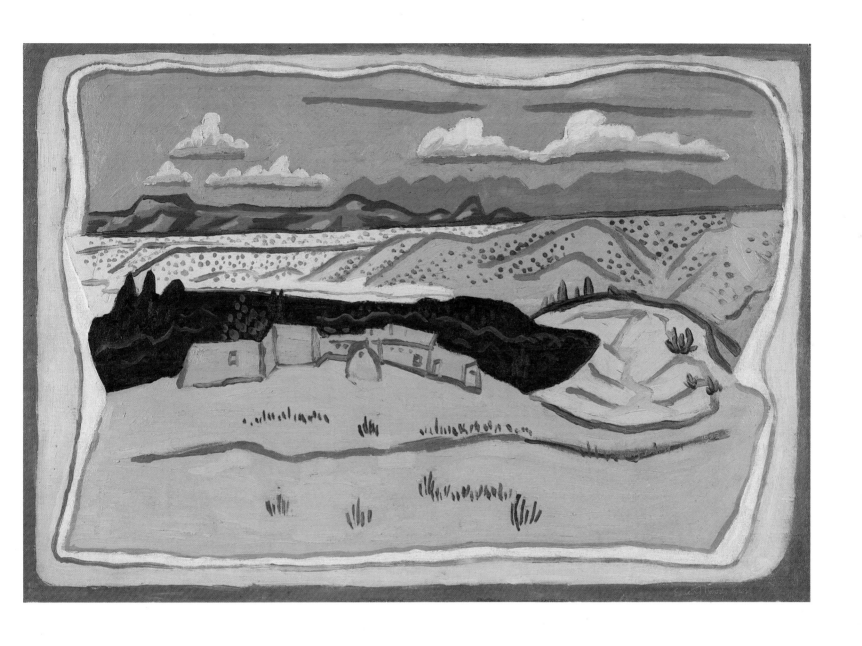

52
Stuart Davis
New Mexican Landscape 1923
oil on canvas, 55.9 × 81.3 cm. 22 × 32 inches
Lent by the Whitney Museum of American Art, New York
Gift of Gertrude Vanderbilt Whitney. 31.174

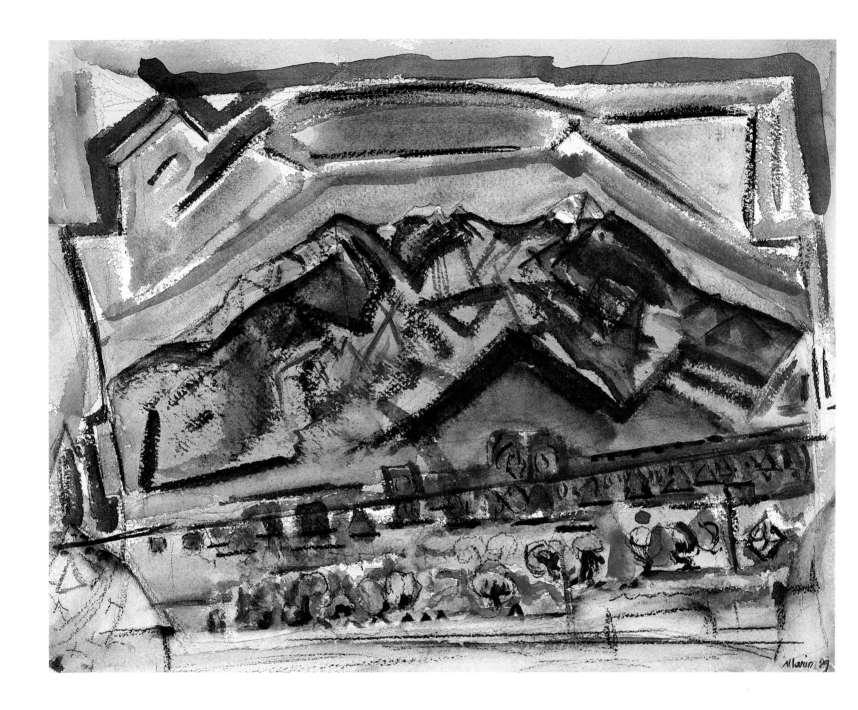

53

John Marin

Taos Mountain 1929

watercolor on paper, 44.5 × 55.9 cm. 17 × 22 inches

Maier Museum of Art, Randolph-Macon Women's College

Lynchburg, Virginia

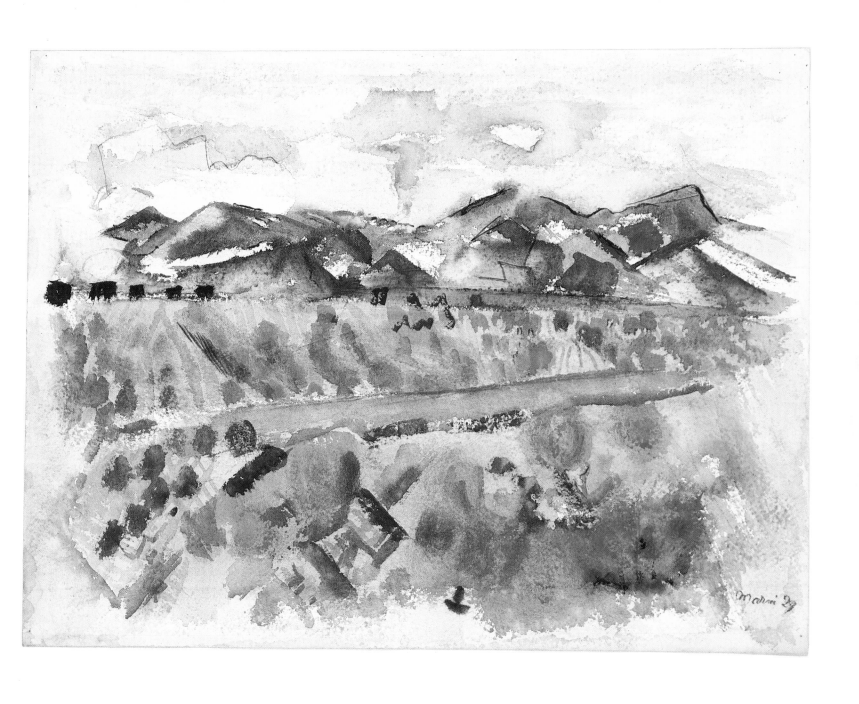

54
John Marin
New Mexico Landscape 1929
watercolor on paper, 39.4 × 53.0 cm. 15½ × 20⅞ inches
Kennedy Galleries, New York

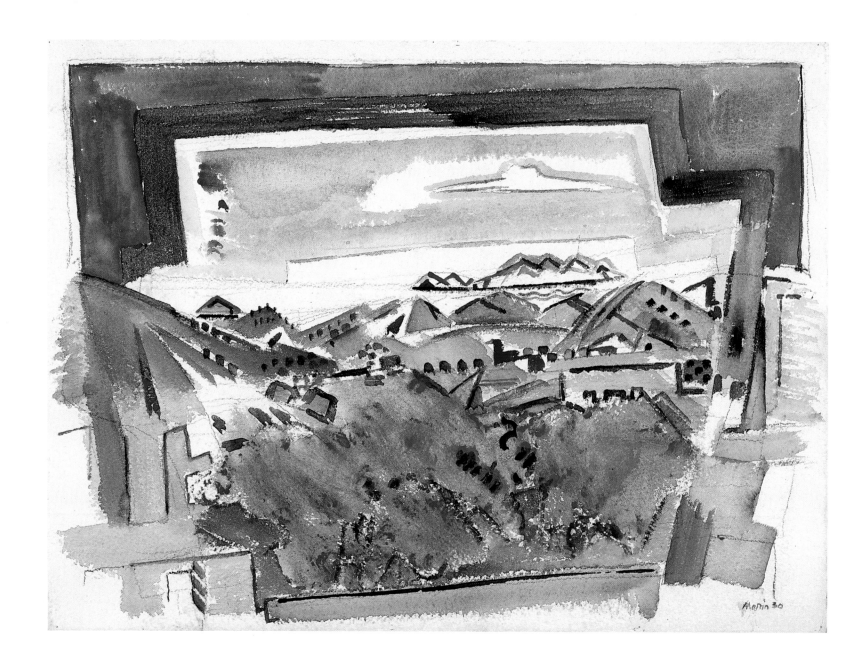

55
John Marin
Taos Canyon, New Mexico 1930
watercolor on paper, 38.7 × 52.7 cm. 15¼ × 20¾ inches
Courtesy Amon Carter Museum, Fort Worth, Texas

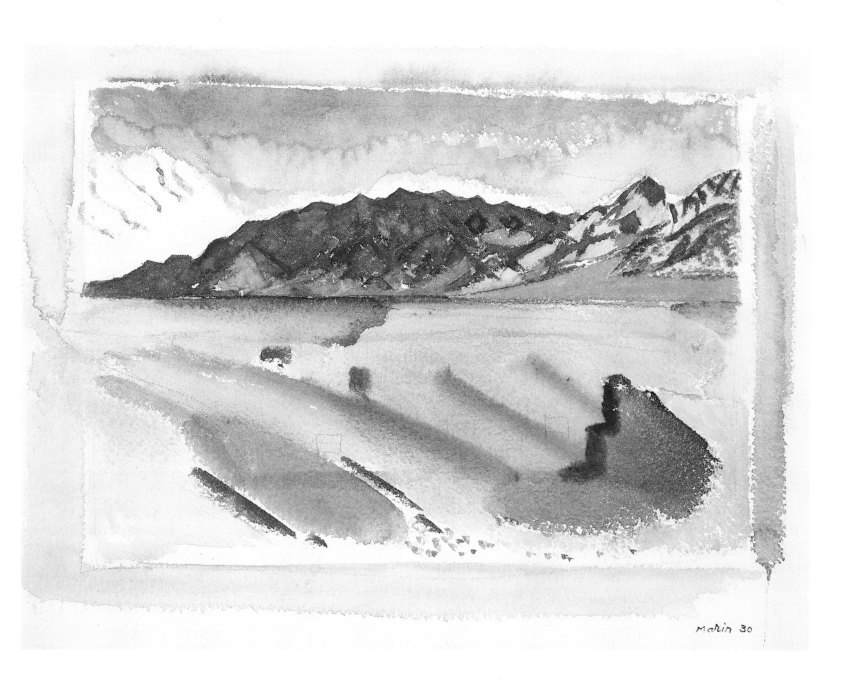

56
John Marin
New Mexico Landscape 1930
watercolor on paper, 39.4×53.0 cm. $15\frac{1}{4} \times 20\frac{1}{2}$ inches
Kennedy Galleries, New York

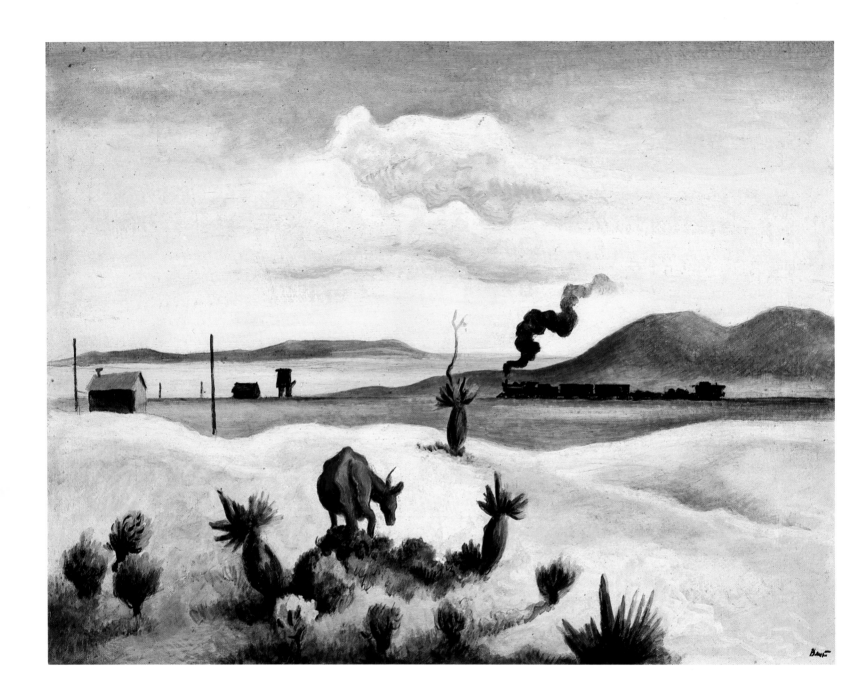

57

Thomas Hart Benton
New Mexico 1926
oil and egg tempera on board, 50.8 × 66.0 cm. $20\frac{1}{4} \times 26\frac{1}{4}$ inches
The Denver Art Museum, Helen Dill Collection

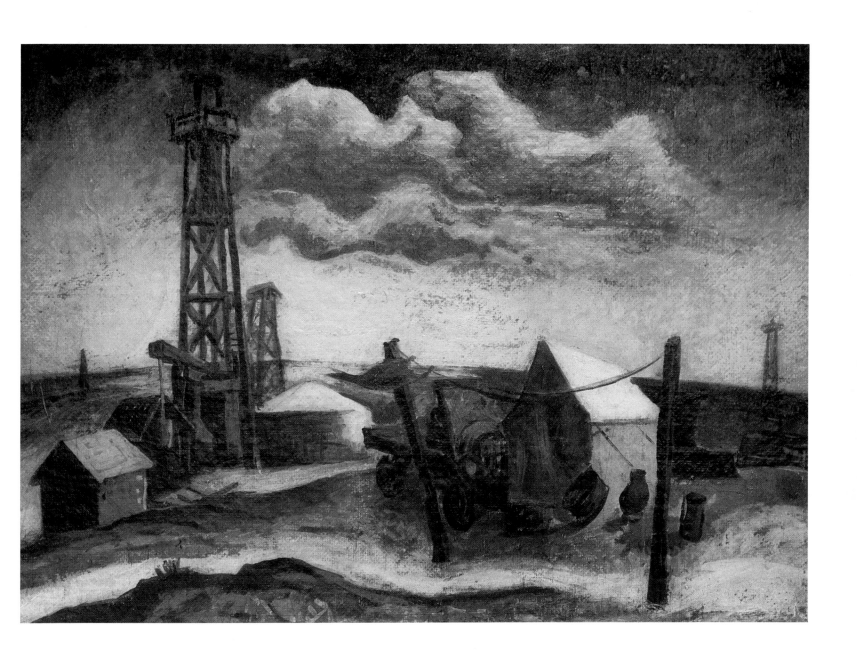

58
Jackson Pollock
Camp with Oil Rig 1930–33
oil on board, 45.7 × 64.1 cm. 18 × 25¼ inches
Mr. and Mrs. John W. Mecom, Jr.

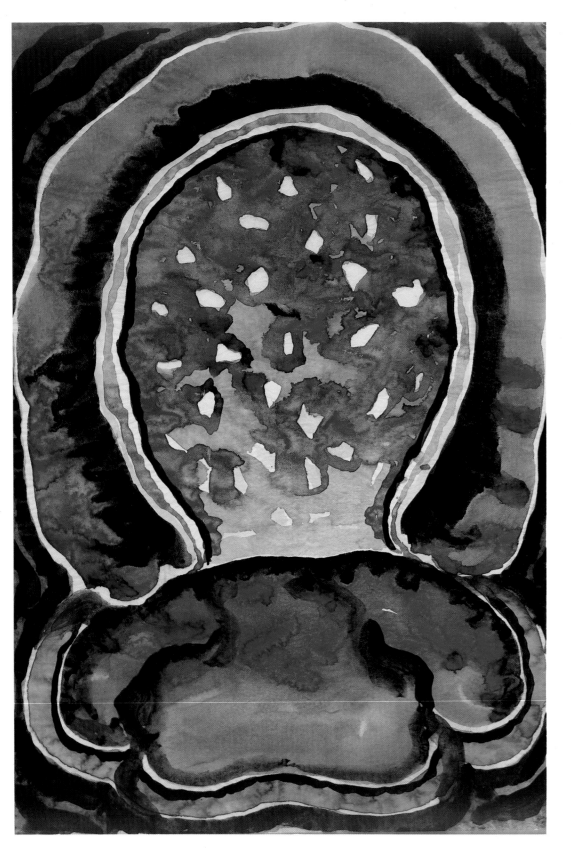

59
Georgia O'Keeffe
Abstraction 1917
watercolor, 40 × 26.5 cm. 15¾ × 10⅞ inches
Mr. and Mrs. Gerald P. Peters
Santa Fe, New Mexico

60
Georgia O'Keeffe
Black Cross with Red Sky c.1929
oil on canvas, 101.6 × 81.3 cm. 40 × 32 inche
Mr. and Mrs. Gerald P. Peters
Santa Fe, New Mexico

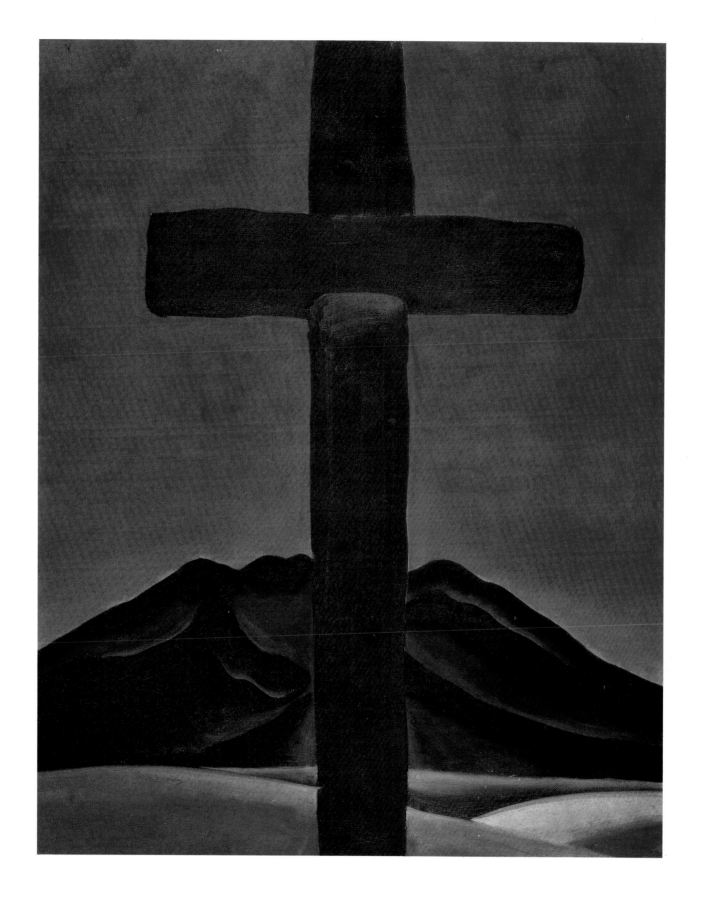

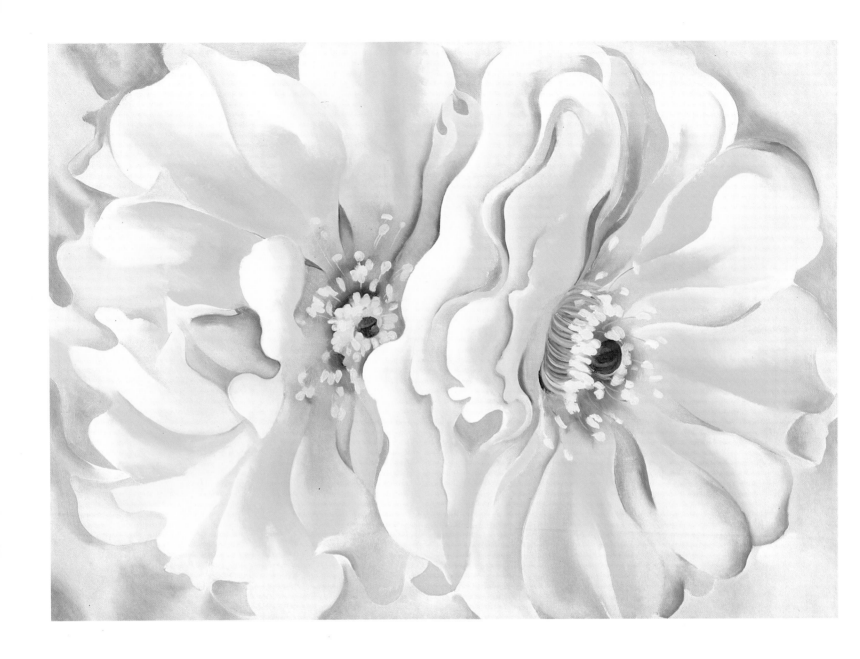

61
Georgia O'Keeffe
Yellow Cactus Flowers 1929
oil on canvas, 76.4 × 106.7 cm. $30\frac{3}{16}$ × 42 inches
Collection of the Fort Worth Art Museum
Gift of the William E. Scott Foundation

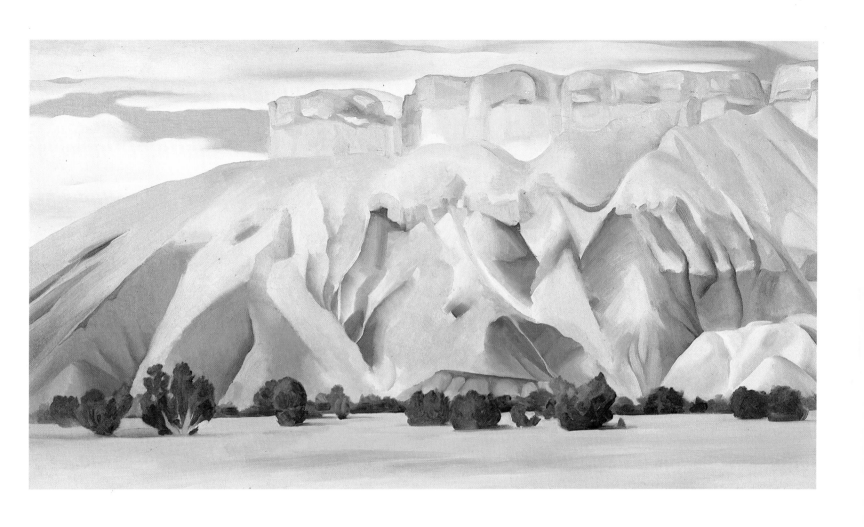

62
Georgia O'Keeffe
My Backyard 1937
oil on canvas, 50.8 × 91.5 cm. 20 × 36 inches
New Orleans Museum of Art : Museum Purchase through
City of New Orleans Capital Funds

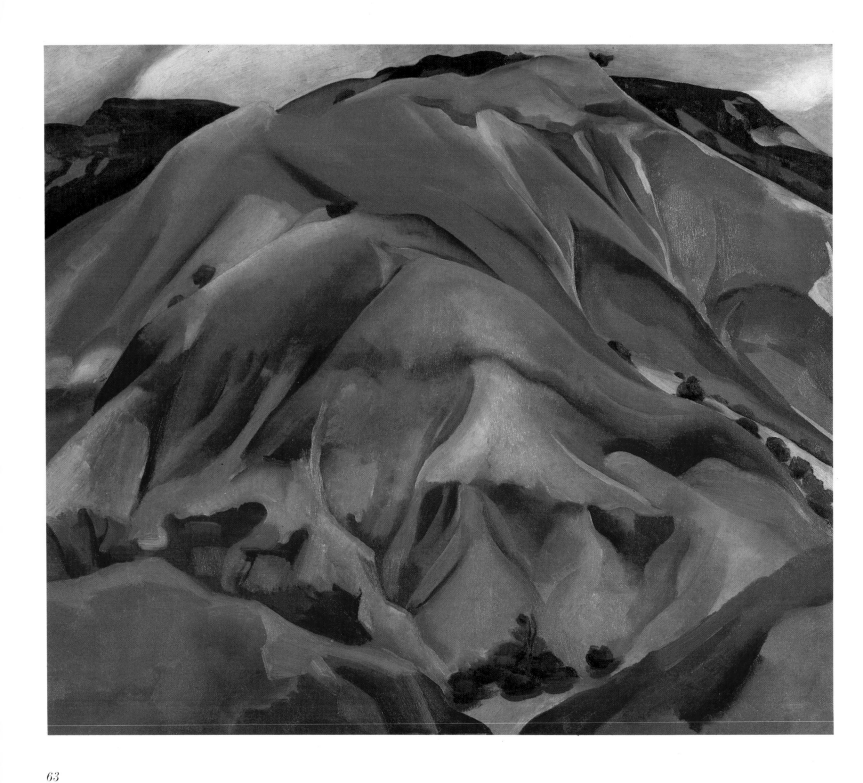

63
Georgia O'Keeffe
The Mountain, New Mexico 1931
oil on canvas, 71.1 × 91.4 cm. 30 × 36 inches
Lent by the Whitney Museum of American Art
New York; Purchase. 32.14

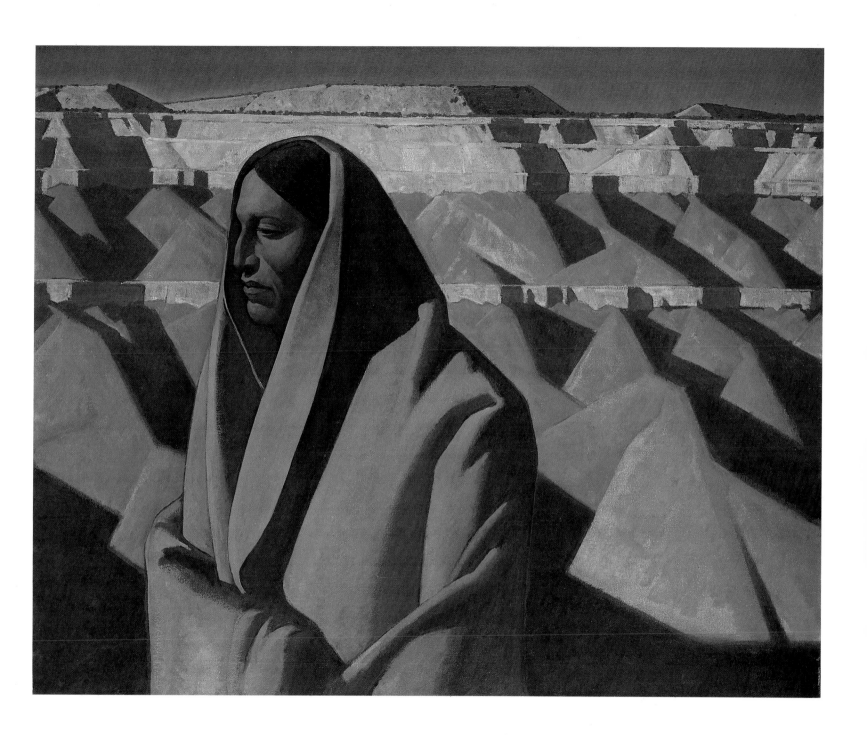

64
L. Maynard Dixon
Earth Knower 1931–35
oil on canvas, 76.2 × 101.6 cm. 40 × 50 inches
The Oakland Museum; Bequest of Dr. Abilio Reis

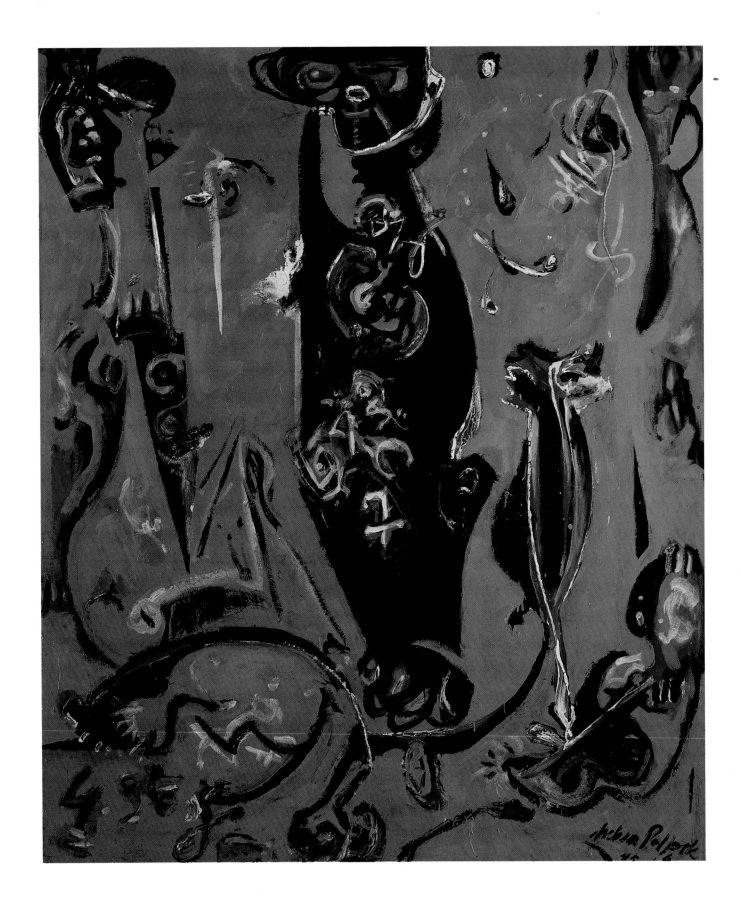

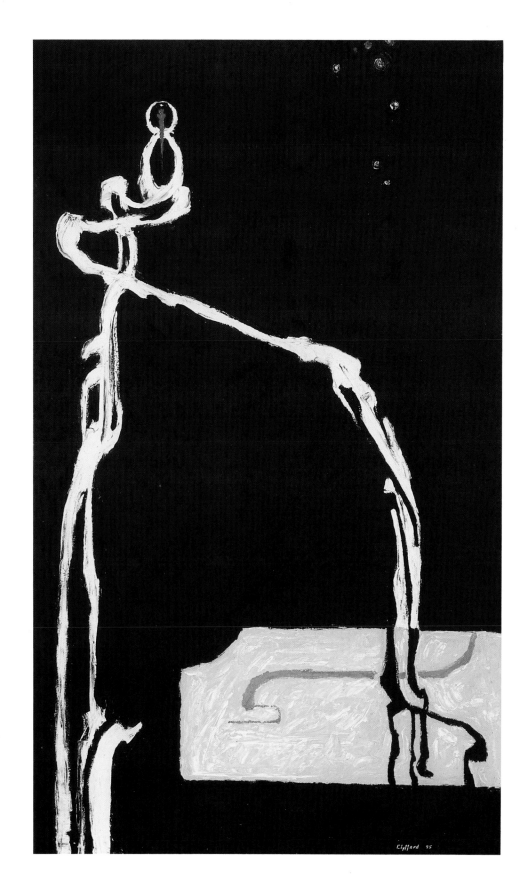

65
Jackson Pollock
Totem Lesson 2 1945
oil on canvas, 182.8 × 152.4 cm. 72 × 60 inches
Collection : Australian National Gallery, Canberra

66
Clyfford Still
Untitled 1945
oil on canvas, 284.4 × 369.6 cm. 70⅞ × 42 inches
San Francisco Museum of Modern Art
Gift of Peggy Guggenheim, 47.1238

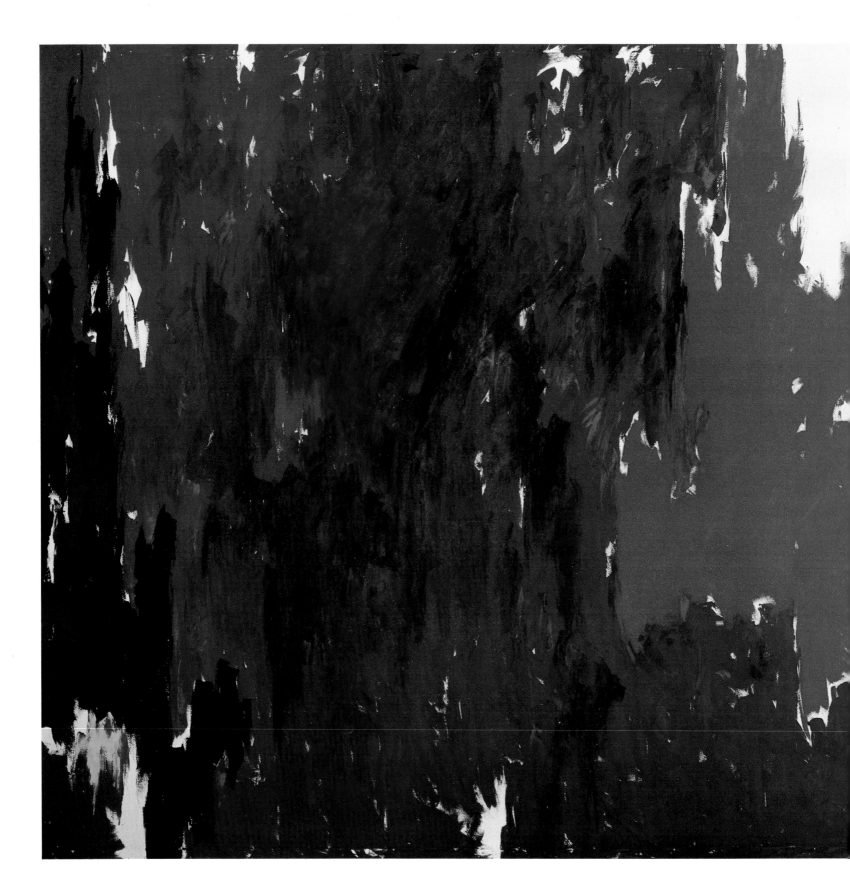

67
Clyfford Still
1960-F
oil on canvas, 284.4 × 369.6 cm. 112 × 145½ inches
Sarah Campbell Blaffer Foundation, Houston, Texas

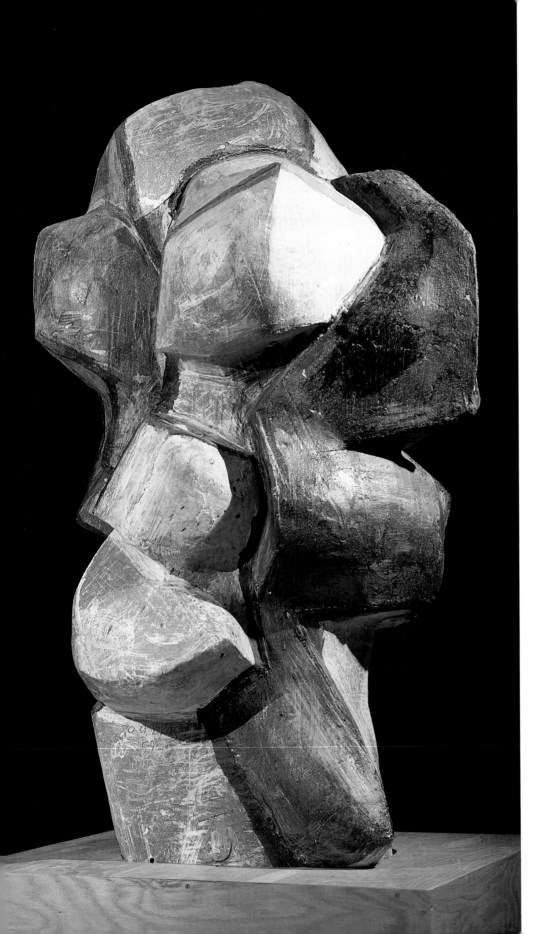

68
Peter Voulkos
Sitting Bull 1959
stoneware, wheel and paddled parts, slip and glaze
175.3 × 94.0 × 94.0 cm. 69 × 37 × 37 inches
Collection of the Santa Barbara Museum of Art
Bequest of Hans G. M. De Schulthess

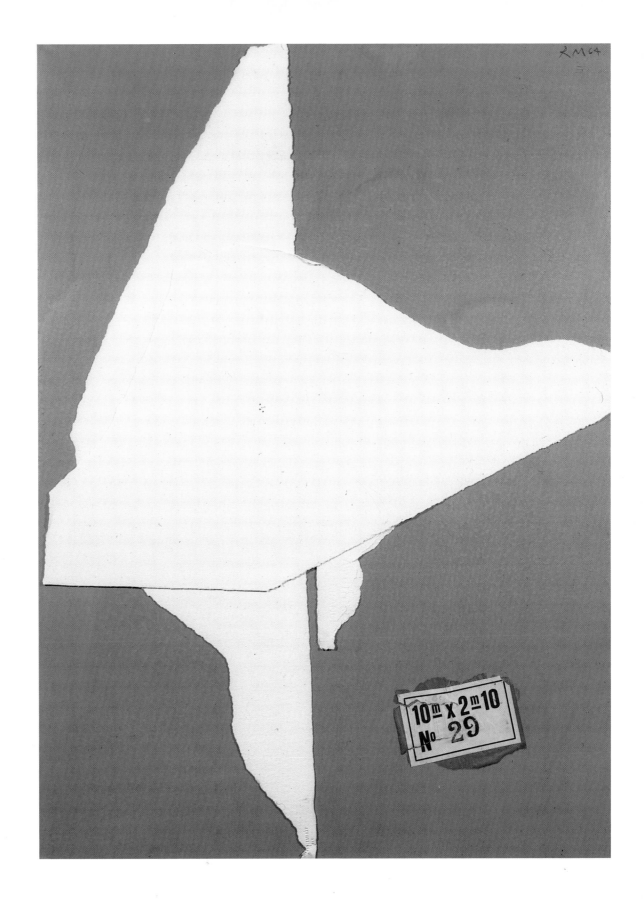

69
Robert Motherwell
The America Cup 1964
acrylic and collage on ragboard
76.2 × 55.9 cm. 29⅝ × 21⅞ inches
David Rockefeller, Jr.

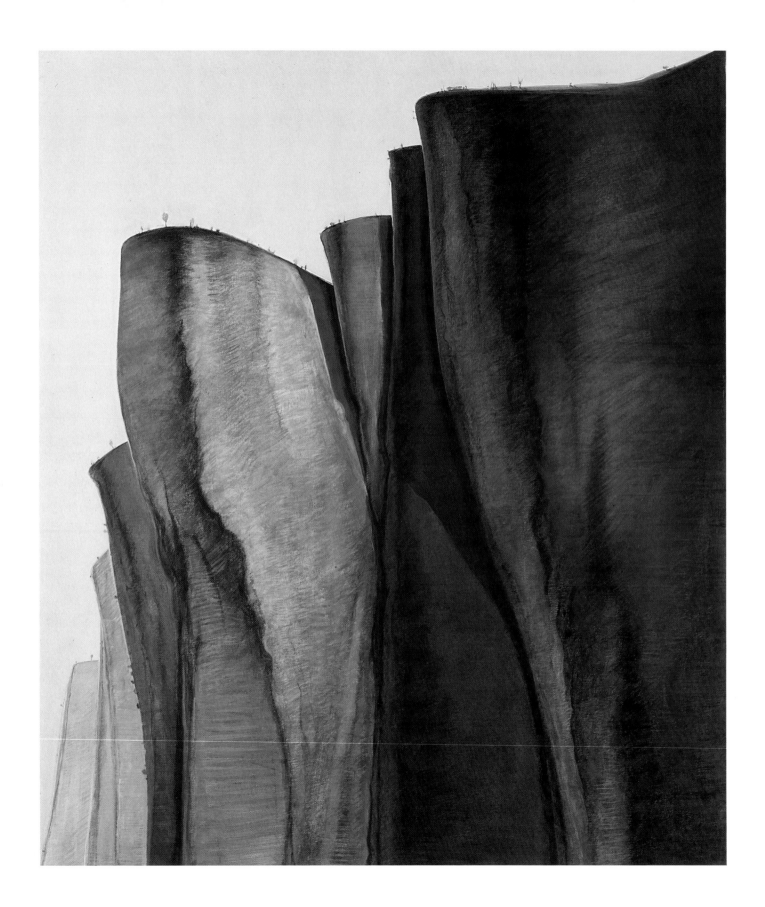

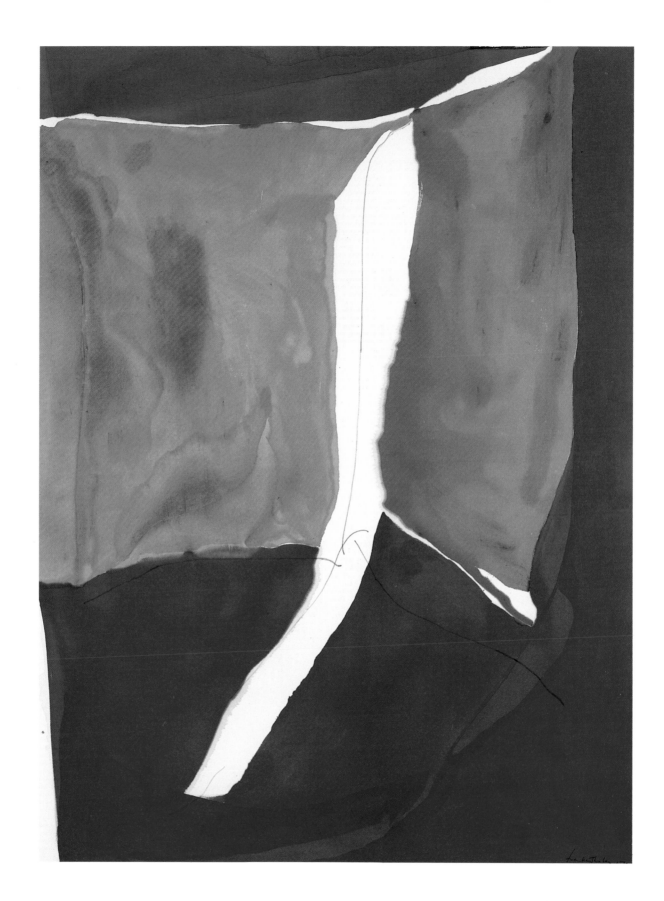

70
Wayne Thiebaud
Cliffs 1968
acrylic on canvas
257.2 × 223.5 cm.
101¼ × 88 inches
Private Collection

71
Helen Frankenthaler
Herald 1971
acrylic on canvas
274.3 × 205.7 cm.
108 × 81 inches
Mr. and Mrs. Alexander K.
McLanahan

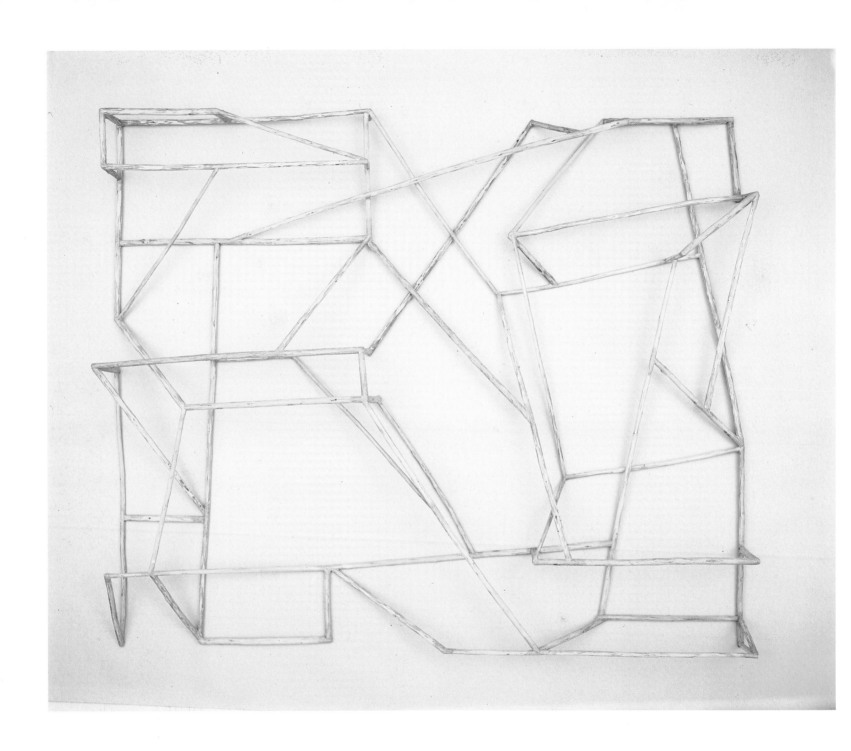

72
Charles Arnoldi
Untitled 1974
wall mounted assemblage of natural wood branches
201 × 246.5 × 28.2 cm. 78¾ × 104⅞ × 7⅞ inches
Collection : Australian National Gallery, Canberra

73
Philip Pearlstein
White House Ruin – Morning – Canyon de Chelly 1974
oil on canvas, 152.4 × 152.4 cm. 60 × 60 inches
Mr. and Mrs. James R. Patton, Jr.

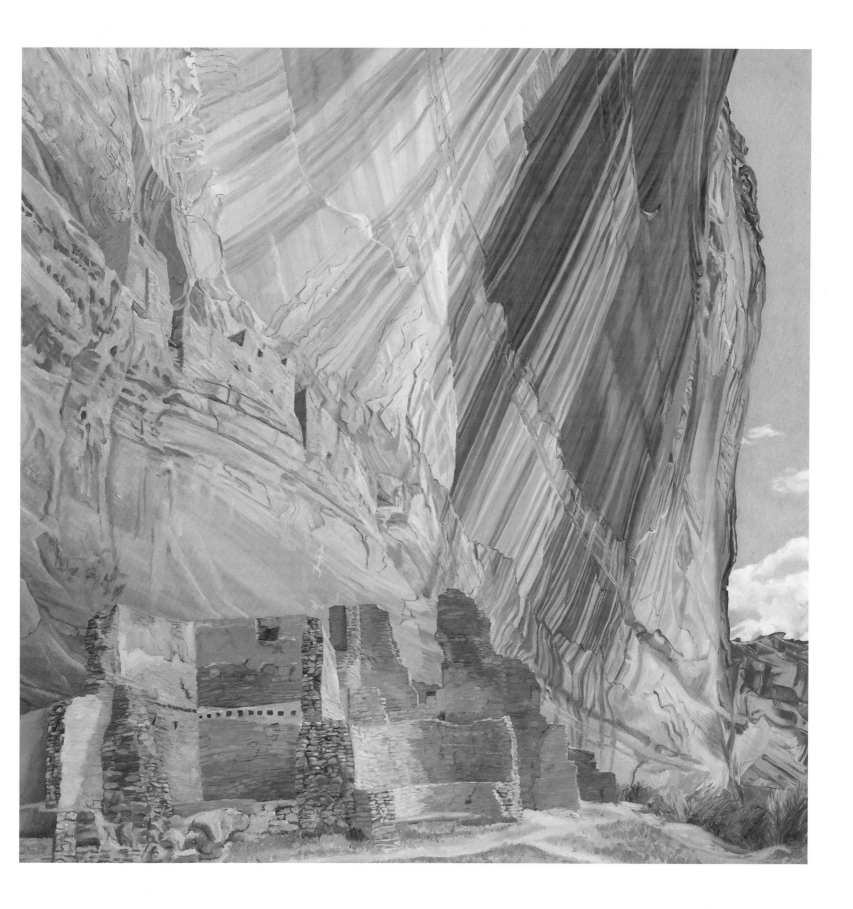

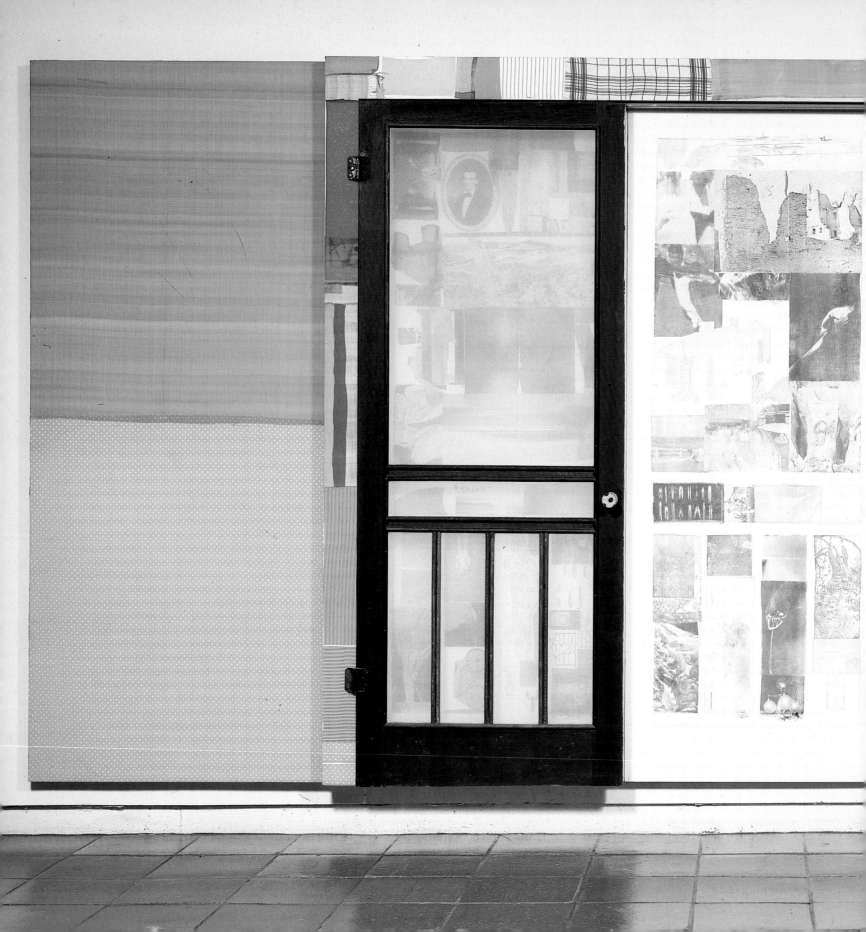

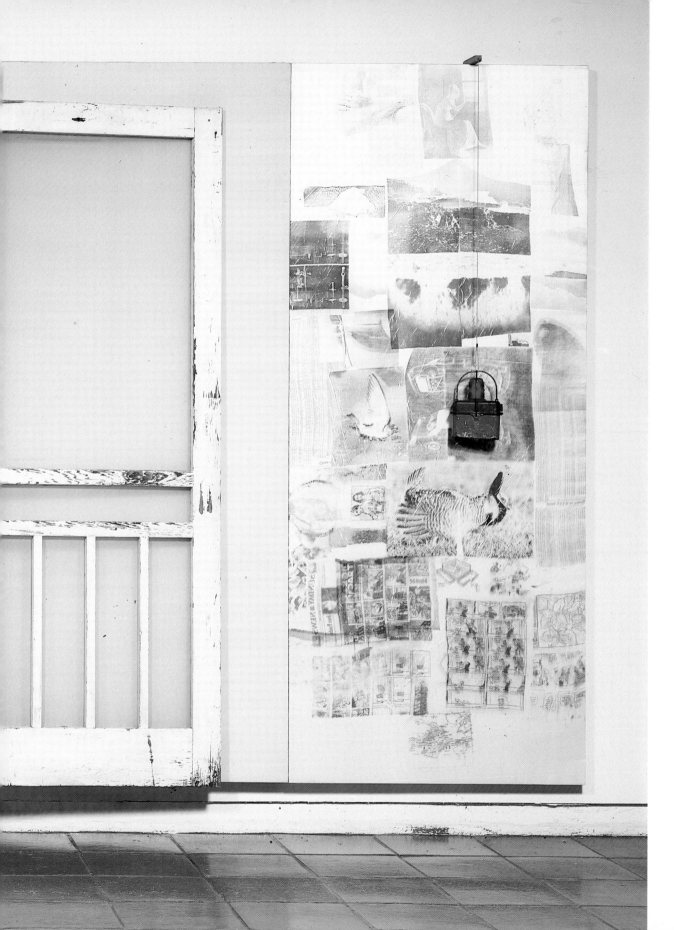

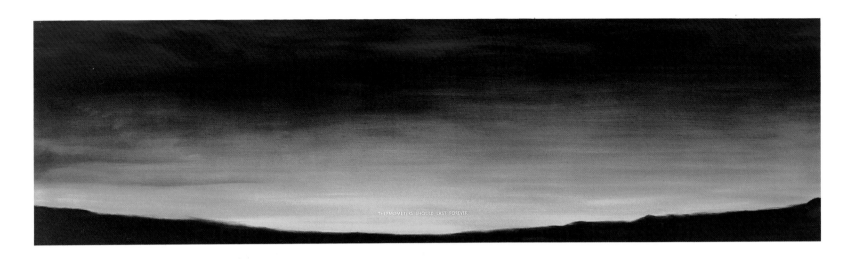

75
Edward Ruscha
Thermometers Should Last Forever 1977
oil on canvas, 55.9 × 203.2 cm. 22 × 80 inches
Mr. and Mrs. Roy S. O'Connor

74
Robert Rauschenberg
Whistle Stop (Port Arthur, Texas) 1977
combine painting, mixed media, five panels each 213.4 × 91.4 cm. 84 × 180 inches
Collection of the Fort Worth Art Museum, The Benjamin J. Tillar Memorial Trust

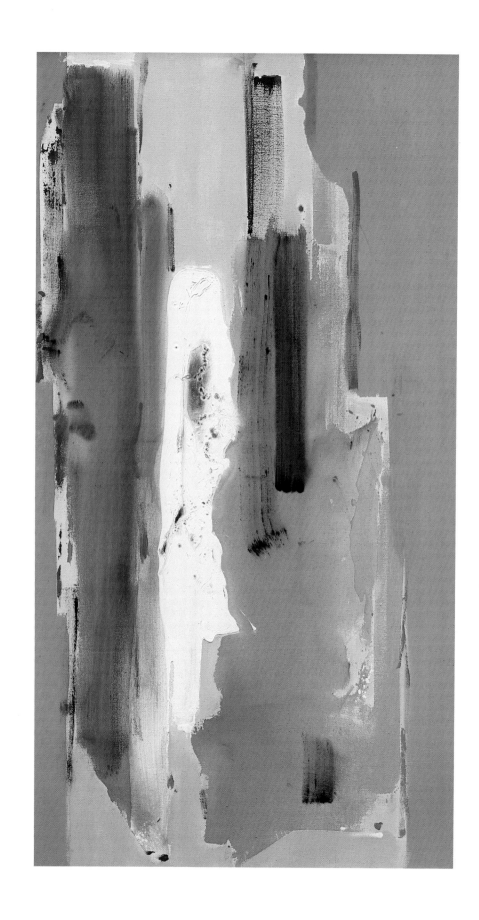

76
Helen Frankenthaler
White Totem 1978
acrylic on canvas, 198.1 × 106.7 cm. 78 × 42 inches
Private Collection

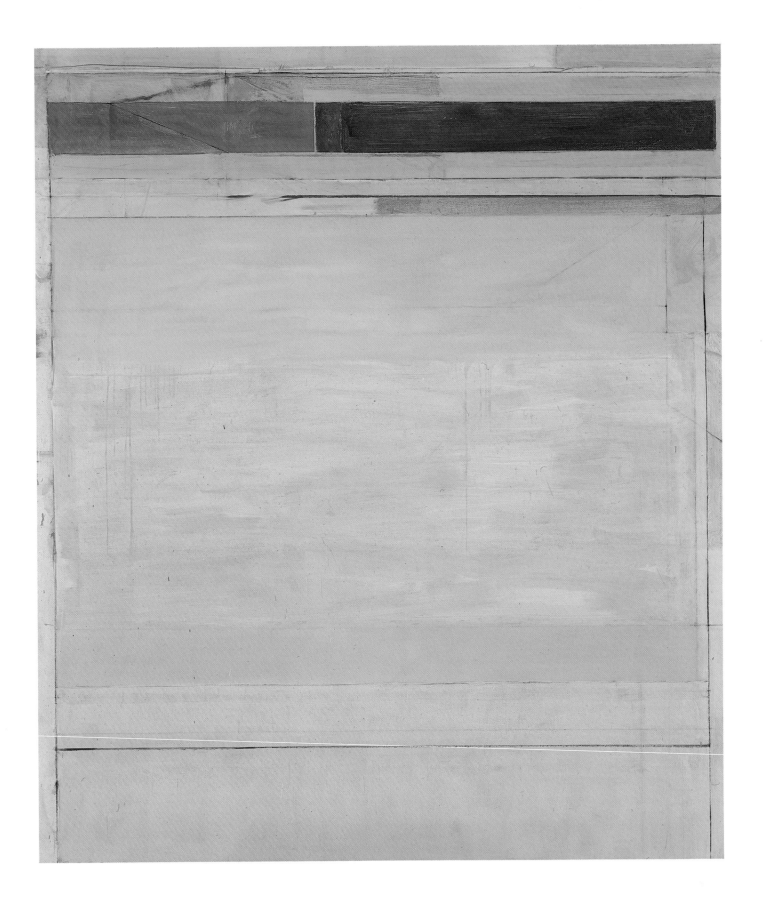

77

Richard Diebenkorn
Ocean Park #124 1980
oil on canvas, 236.5 × 206.1 cm. 93⅛ × 81⅛ inches
The Museum of Fine Arts, Houston
Museum purchase with funds given by George R. Brown
in honor of his wife Alice Pratt Brown

78

Agnes Martin
Untitled VII 1981
acrylic and pencil on canvas, 182.9 × 182.9 cm. 72 × 72 inches
The Pace Gallery, New York

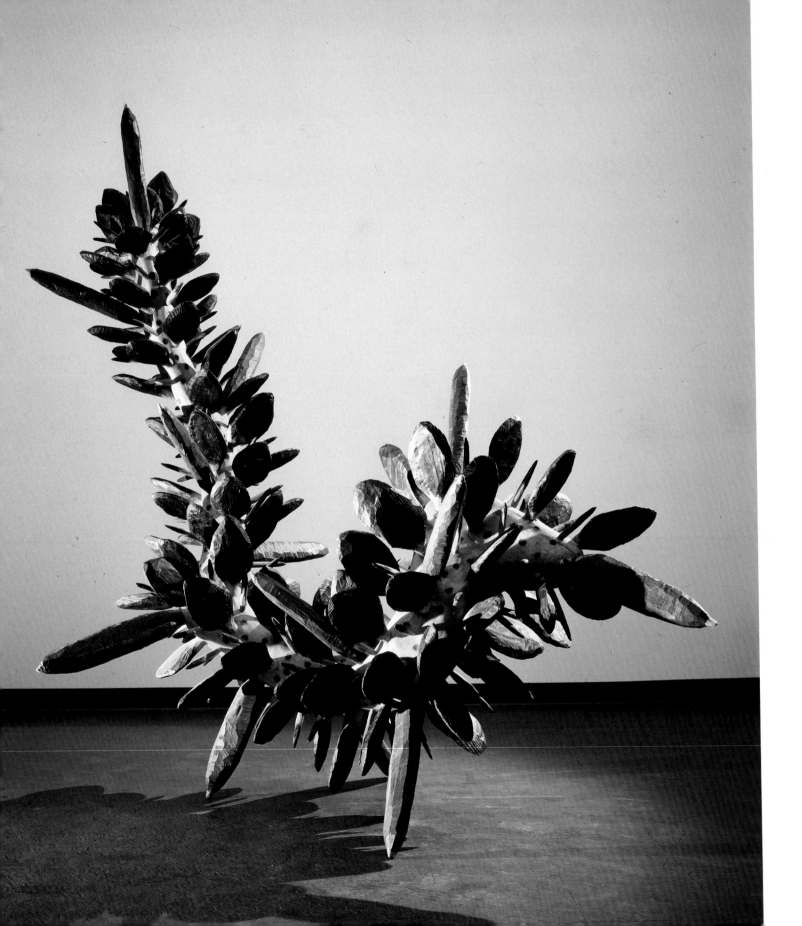

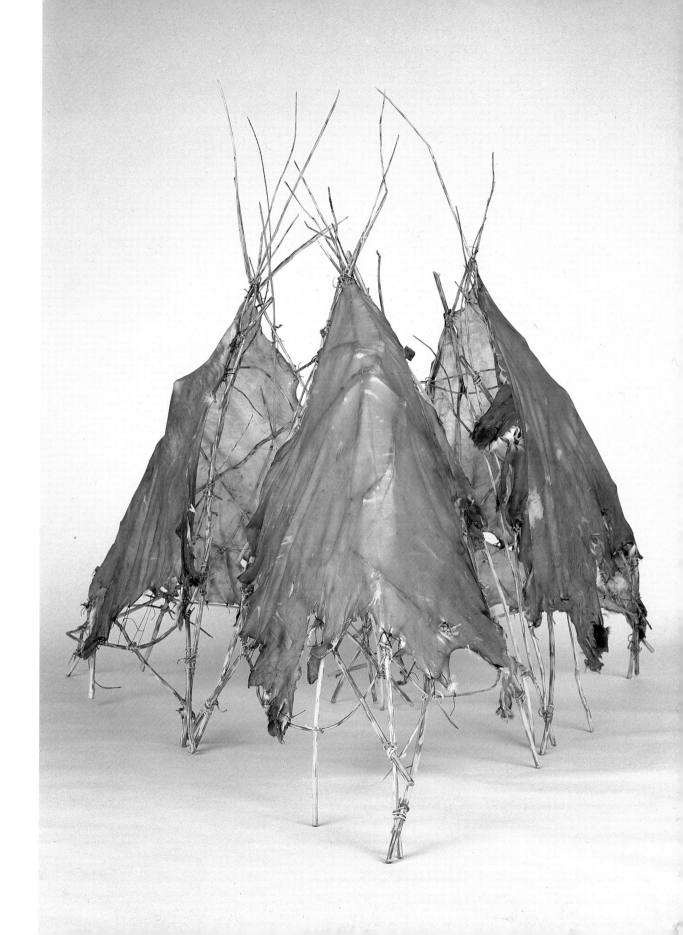

79
James Surls
Black Dragon 1981
pine, walnut, oak
228.6 × 243.8 × 152.4 cm.
90 × 96 × 60 inches
Michael and Stephanie Young

80
Carol Hepper
Three Chambers 1982
mixed media, deer skin, willow,
waxed linen thread
160.0 × 218.4 cm. 63 × 86 inches
Carol Hepper

Charles Arnoldi b. 1946

cat. no. 72

Charles Arnoldi was born in Dayton, Ohio, and spent his childhood there. He moved to California in 1964 and was accepted at the Art Center School, Los Angeles, to study commercial art. Before enrolling he visited New York where he saw the works of Kline, de Kooning, and Rauschenberg for the first time. He stated that he was 'overwhelmed by the size and handmade quality' of their art. He chose not to pursue a career in commercial art and left school after several months. 'I came to realize that discipline and hard work were the key elements in an artist's life. I felt that the studio took the place of school.'

Arnoldi uses wood as his material. 'I have become interested in wood as an alternative to painting. I especially like tree branches, which have a very distinct line quality. They feel hand-drawn, they have a certain gestural quality, a naturalness. They feel seductive.'

Thomas Hart Benton 1889–1975

cat. no. 57

Thomas Hart Benton was born in Missouri and began his studies in art at the Art Institute of Chicago in 1907. He made a three-year trip to Paris in 1908, returning to work in Missouri. Benton believed that it was important for an artist to explore and understand his heritage. It was this conviction which encouraged him to choose the midwestern American scene as the subject and inspiration of his art.
He became an important proponent of regionalism, which glorified American rural life. From 1926 to 1936, he taught at the Art Student's League in New York. Among his students was Jackson Pollock, who became a close personal friend, often staying with the Bentons at their Martha's Vineyard home. In 1964, following completion of his mural *Independence and the Opening of the West* for the Truman Library, Benton moved to Kansas City, Missouri.

Albert Bierstadt 1830–1902

cat. nos. 19 & 20

Albert Bierstadt was born in Germany and was brought to America at the age of two with his immigrant family. He returned to Germany in 1853 to study painting and continued his studies in Boston and in New York. In 1859 he accompanied General Frederick Lander's expedition to survey a wagon route to the Pacific Ocean. They followed the Oregon Trail, as Alfred Jacob Miller had done more than two decades before. Bierstadt made field sketches and took stereopticon photographs of the landscape that the party encountered on their way to California. In an effort to recapture the power and grandeur of the scenes he witnessed on the journey, Bierstadt translated his sketches into monumental oil paintings when he returned to New York. His paintings of Yosemite Valley were instrumental in influencing the United States government to establish this area as a national park.

Karl Bodmer 1809–1893

cat. nos. 5–14

Karl Bodmer, a professional Swiss painter, came to North America in 1832 to illustrate the expedition of Prince Maximilian of Wied-Neuwied to the American West. After nine months of research and preparation, Bodmer set out with the expedition in 1833. They traveled for seven weeks up the Missouri River to Fort MacKenzie on the American Fur Company's steamer. The expedition worked for five weeks at Fort MacKenzie before continuing on to Fort Clark for the winter.

Upon their return, Bodmer's highly detailed and accurate field sketches and watercolors were used as illustrations for the journal of their travels. The journal was published in Europe (1839–41) and includes a separate volume illustrating eighty-two of Bodmer's copperplate engravings.

George Catlin 1796–1872

cat. nos. 1–4

Although originally trained as a lawyer, George Catlin abandoned his career in 1823 and dedicated himself to painting an historical record of the native tribes of North America before they came under foreign influence and acculturation. It was not until seven years later, however, that he was financially able to devote himself completely to the task. In 1830 Catlin began his project with a visit to St. Louis to meet General William Clark. By Clark's authority, Catlin was able to attend

meetings for treaty negotiations and he began painting portraits of prominent Indians. On his first and most productive trip to the West he traveled 2000 miles up the Missouri River in 1832 on the American Fur Company's steamer, the Yellowstone. Over the next several years, Catlin made many trips west, including one to the Southwest. His last expedition was in 1836. Catlin completed more than 600 paintings of the American West and wrote a two-volume book based on his research, *Letters and Notes on the Customs and Conditions of the North American Indians*. He assembled his paintings in the Catlin 'Indian Gallery' which toured American and European capitals for the next thirty years.

Arthur B. Davies 1862–1928
cat. nos. 42–45
In 1881 at the age of nineteen, Arthur B. Davies traveled to the West, Southwest, and Mexico as a drafting engineer with an expedition. He returned to Chicago in 1883 to study at the Chicago Art Institute and moved to New York in 1886 to study at the Art Student's League. During the next decade, he began to exhibit his work and gained a reputation as an illustrator. In the summer of 1905, Davies took a trip to the Rocky Mountains and the Pacific Coast. He was deeply impressed by this experience and a new phase of his work began. He returned to New York in September with ninety panels of landscape sketches, which he used to create full-scale paintings, and quickly established a reputation as an artist of ability.

Davies is best known for organizing the Armory Show, which introduced Americans to European modernism and initiated great changes in subsequent American art. As president of the Association of American Artists and Sculptors, Davies traveled in Europe with Walt Kuhn, selecting works by European modernist painters and sculptors for the exhibition. Davies was among the first to recognize the importance of European modernism and he made a monumental contribution to American art with his work on the Armory Show. In his later years he continued painting, making frequent sketching trips to Europe, where he died in 1928.

Stuart Davis 1894–1964
cat. nos. 51 & 52
Stuart Davis was born in Philadelphia and began his formal art training at the age of fifteen at the Henri School in New York. He was successful there and was included in the Exhibition of Independent Artists in 1910. Within two years he had established himself in his own studio; in 1913 five of his works were accepted for the Armory Show. This exhibition had a great impact on Davis and stimulated him to re-evaluate his work.

Davis believed that subject matter should be secondary to the formal aspects of a painting. This philosophy was the source of conflict for Davis, when he arrived in Santa Fe during the summer of 1923. He found the location too visually interesting and too picturesque. It was difficult for him to avoid producing representational work. His work from this period foreshadows the direction of his later work as one of the leading American modernists.

Richard Diebenkorn b. 1922
cat. no. 77
Richard Diebenkorn was born in Portland, Oregon, and moved with his family to San Francisco two years later. He began his studies at Stanford University in 1940, but his academic career was interrupted by military service. Diebenkorn returned to California in 1945 and resumed studies at the California School of Fine Arts in San Francisco. It was here that he met David Park, his close friend and mentor. In 1947 he accepted a teaching position at the school.

Attracted by the appearance of New Mexico, Diebenkorn enrolled for graduate studies at the University of New Mexico in 1950. His paintings done while studying there are abstract expressionist works that reflect the rich color and light of New Mexico. After completion of his degree in 1952, Diebenkorn accepted a teaching position at the University of Illinois at Urbana and returned to California two years later. By 1960, the year of his first retrospective exhibition, Diebenkorn was a nationally known artist who was highly influential on the West Coast. In 1966 Diebenkorn became Professor of Art at the University of California at Los Angeles, where he currently teaches. He set up a

studio in Ocean Park the same year he began teaching at UCLA. The following year he began the *Ocean Park* series, which has absorbed him over the last two decades.

Maynard Dixon 1875–1946
cat. no. 64
Maynard Dixon was born in California and was primarily a self-taught painter, except for a term at the California School of Design. He began his career as an illustrator in New York where he worked from 1907 to 1912. He was disillusioned by his experience as a commercial artist and returned to California in 1912. As his painting developed, his style became more formalist. He simplified his subject matter and emphasized the dominance of pattern and line. In 1931 Dixon visited New Mexico with his wife, Dorothea Lange. During his six months in Taos, Dixon completed more than forty paintings, including *Earth Knower*, which is an exceptional example of his mature style.

Henry Farny 1847–1916
cat. no. 41
Henry Farny emigrated to Cincinnati, Ohio, from France in 1852. At the age of twenty, Farny returned to Europe to study art for three years in Düsseldorf, Vienna, and Italy. Back in America, he supported himself as an illustrator, but devoted increasing energy to his painting. He made his first trip to the West in 1881. He painted sympathetic and realistic paintings of Indian life. The West was becoming the material of nostalgia and Farny's paintings were successful. He worked principally in his studio where he composed paintings on Indian life from sketches and field photographs as well as from artifacts he had collected on his trips. He concentrated on portraying the light and mood of the scene which imbues his Indian subjects with a feeling of sympathetic intimacy.

Helen Frankenthaler b. 1928
cat. nos. 71 & 76
Helen Frankenthaler was born in New York City. She studied simultaneously at Bennington College in Vermont and at the Art Student's League in New York, graduating from Bennington in 1949. She later studied with Rufino Tamayo and Hans Hofmann. Three years after

Frankenthaler's graduation from Bennington, her mentor, Clement Greenberg, introduced her to Jackson Pollock. She was deeply impressed by his work. Frankenthaler's soak-stain technique in the automatist tradition follows the precedent of Pollock's allover technique.

Frankenthaler resides in New York. She made three trips to Arizona in the late 1970s. Her first visit in 1976 was to the mountains and desert surrounding Phoenix, and in March of 1977, she toured the red rock region of Sedona. Frankenthaler was greatly inspired by the visual impact of the Southwest and has returned on numerous occasions, most recently to teach a painting class in Santa Fe, New Mexico.

Carl William Hahn 1829–1887
cat. no. 21

Carl William Hahn was born and educated in Germany. He studied at the Royal Academy of Art in Dresden and at the Düsseldorf Academy. In Düsseldorf, Hahn became acquainted with and was influenced by Emanuel Leutze, the founder of the independent artists' club, the Malkasten. During this period Hahn had many opportunities to meet American artists visiting in Düsseldorf.

By the time he arrived in the United States in 1871, Hahn was already an established painter. His work had been widely exhibited in New York and Boston. In 1872 he moved to San Francisco, where he shared a studio with William Keith. He made frequent sketching trips through California to the Sequoia Groves and Yosemite and is best known for the work he created during this period.

Marsden Hartley 1877–1943
cat. nos. 46–48

Marsden Hartley was born in Maine and studied art principally at the National Academy of Design in New York. In 1909 he met Alfred Stieglitz, under whose sponsorship he traveled to Europe for the first time. Hartley studied in Paris and Berlin, where he first used American Indian symbols in his work. In 1918, a few years after his return to New York, Hartley traveled to New Mexico in 1918 at the invitation of Mabel Dodge. He found the landscape and the Indian culture inspiring, but rejected the Taos and Santa

Fe art colonies and returned to New York in November of 1919. Hartley spent the next six years in Europe where he worked on a series of paintings titled *New Mexico Recollections*. Hartley's paintings are ultimately a reflection of his strong spirit of individualism and commitment to an American modernism.

William Jacob Hays 1830–1875
cat. nos. 17 & 18

In 1860, years after the expeditions of Karl Bodmer and George Catlin, William Jacob Hays made his journey up the Missouri River to Fort Union. A native of New York City, he studied painting with John Rubens Smith and participated in his first exhibition at the National Academy of Design in 1850. He is known as a painter of the animals which inhabited the Great Plains. During the Missouri River trip, Hays made field sketches of wildlife and of the various trading posts along the way. On his return to New York, he produced many large canvases based on these sketches. In later years, he successfully reproduced his work as lithographs.

Carol Hepper *b. 1953*
cat. no. 80

Carol Hepper was born in McLaughlin, South Dakota, and grew up there on a Sioux Indian reservation. She received her B.S. degree from South Dakota State University in 1975 and has exhibited nationally. In creating her sculptures, Hepper uses the hides of deer and cattle, as well as buffalo and rabbit, which she tans herself. Although she now lives and works in New York, the forms and materials in Hepper's sculptures are derived from her life in South Dakota. She recently remarked, 'The images in my mind are the ones that I saw when I was young They're the tools that you carry with you and that you continue to refine or throw away.'

Thomas Hill 1829–1908
cat. no. 24

Born in Birmingham, England, Thomas Hill immigrated to the United States in 1844 and in the ensuing three years, was employed as a carriage painter, furniture decorator, and interior designer. In 1853 he attended classes at the Pennsylvania Academy of

Fine Arts, after which he worked in the Boston area where he painted with a group which included Durand, Inness, and Bierstadt. Hill moved to California in 1861 to improve his health and settled in San Francisco. He made his first trip to Yosemite in 1862. Yosemite became a source of inspiration, and he returned to paint and sketch there over the next thirty years.

Although he is known as the 'artist of the Yosemite,' Hill also spent time in other areas of the West and the East. He painted the Rocky Mountains, the Yellowstone Park area, the Muir Glacier in Alaska, and the White Mountains. He died in Raymond, California, in 1908.

George Inness 1825–1894
cat. no. 32

At the age of sixteen George Inness was apprenticed to a map engraver in New York, but he rejected that career in favor of painting. His brief studies with Regis Gignoux in 1843 were curtailed by recurring epileptic episodes. He continued to paint and enjoyed early recognition. In 1847 a patron sent him to study in Europe, where he was influenced by Camille Corot and the Barbizon School. His election in 1853 to the National Academy further enhanced his professional reputation as the outstanding landscapist of the late nineteenth century. Inness' late works were strongly influenced by his religious mysticism. He stated that a work of art should 'awaken an emotion,' rather than instruct or edify. He died in Scotland in 1894.

John Wesley Jarvis 1781–1840
cat. no. 15

John Wesley Jarvis was born in England and immigrated to Philadelphia, Pennsylvania, with his family when he was five. Jarvis moved to New York in 1800 with Edward Savage, a printmaker to whom he was apprenticed. He remained in New York after his apprenticeship and began making his own prints and painting portraits. Around 1807 Jarvis began traveling south each winter to paint portraits, while maintaining his prosperous studio in New York. He was popular as a witty, bohemian personality and in New York was considered the foremost portrait

painter of his time. He painted a well-known series of naval heroes of the War of 1812, many of which are now owned by the New York Historical Society.

John Marin 1870–1953
cat. nos. 53–56

John Marin studied architecture at his family's insistence, turning to the study of art at the age of twenty-eight. Marin attended the Pennsylvania Academy of Fine Arts, the Art Student's League in New York, and in 1905, the Académie Julian in Paris. While in Paris from 1905 to 1911, Marin met Alfred Stieglitz and began their long association which lasted until Marin's death. In the early years of their acquaintance, Stieglitz guaranteed Marin an income and handled his business affairs, which freed him from financial pressure and allowed him to paint full time.

In 1916 Marin moved to New Jersey, living there during the winter and spending summers in Maine. He was fifty-nine when he first traveled to New Mexico in 1929. Marin viewed the trip as an opportunity for artistic revitalization through contact with fundamental natural forms. The New Mexico landscape provided a stimulating environment, and Marin produced more than 115 watercolors during the two summers he spent in Taos.

Agnes Martin b. 1912
cat. no. 78

Agnes Martin was born in Maklin, Canada, and came to the United States at the age of twenty. She settled in New York and attended Columbia University intermittently between 1941 and 1954, receiving her M.F.A. degree in 1954. In the early 1950s, Martin traveled west where she taught at Eastern Oregon College and at the University of New Mexico. She returned to New York in the late 1950s, and although she was deeply impressed by the abstract expressionists, she began working in a reductionist manner. Her gridlike compositions with their philosophical allusions brought Martin serious critical attention by the mid sixties as a pioneer of minimalist art. In 1967 she abruptly stopped painting for seven years and left New York. She traveled for a year and a half before settling permanently in the

Southwest. She resumed painting in 1974 and continues to live and work in New Mexico.

Alfred Jacob Miller 1810–1874
cat. no. 16

Alfred Jacob Miller was born in Baltimore. After studying at the Ecole des Beaux-Arts in Paris and touring Italy from 1833 to 1834, he returned home to pursue painting. He remained in Baltimore until the death of his parents a few years later, when he moved to New Orleans to open a studio. He had just established himself there when Sir William Drummond Stewart commissioned him to accompany an expedition to the Rocky Mountains. The six-month tour took them to St. Louis to meet with Governor William Clark and then on to the Oregon Trail and the Rendezvous of 1837. Miller was one of the few artists to record this large annual meeting of trappers and traders that convened to trade with a caravan from St. Louis. After the expedition, Miller returned to New Orleans to finish his work from sketches made on the journey. In the following two years, he completed eighteen finished oils and eighty-seven washes, all intended for Stewart. Miller returned to Baltimore, and for nearly three decades, produced portraits, paintings, and pictures of western subjects.

Thomas Moran 1837–1926
cat. nos. 25–31

Thomas Moran immigrated to the United States from Great Britain with his family at the age of seven. He was apprenticed to a firm of wood engravers and subsequently developed an interest in watercolor. He pursued this medium and exhibited one of his paintings at the Pennsylvania Academy of Fine Arts in 1858. In 1861 Moran made his first trip to Europe and spent time copying and studying the works of J.M.W. Turner. In 1866, while on a second trip there, Moran made the acquaintance of Camille Corot who deeply influenced his style.

Moran's first trip to the American West was with Dr. Ferdinand Haydens' scientific expedition to investigate Yellowstone. Hayden later used Moran's watercolors to successfully lobby for the preservation of Yellowstone as a national park. In

recognition of his talent and service to the nation, the Hayden survey party honored Moran by naming a 1200-foot peak after him. He continued to make sketching trips to the West and to translate his sketches into luminous, monumental paintings. He remained an active and popular painter to the end of his life.

Robert Motherwell b. 1915
cat. no. 69

Robert Motherwell was born in Aberdeen, Washington. In 1926 his family moved to California and he enrolled in Otis Art Institute to begin his art studies at the age of eleven. He attended Stanford University where he graduated in 1937 with a B.A. in philosophy. Motherwell attended graduate school at Harvard University, but left his studies to live in France for two years. He moved to New York in 1939 and began to study with Meyer Shapiro at Columbia University. Shapiro introduced Motherwell to European artists in exile and encouraged him to pursue painting instead of an academic career. In 1941 Motherwell traveled to Mexico, where he painted his first major pictures. After this trip he returned to New York to devote himself to painting. He first experimented with collage in 1943, and is now recognized as one of the masters of collage.

Georgia O'Keeffe 1887–1986
cat. nos. 59–63

Georgia O'Keeffe was born on her family's Wisconsin farm where she lived until the age of fifteen, when her family moved to Virginia. Her first formal studies in art were at the Art Institute of Chicago in 1905. In 1907 she began studying at the Art Student's League in New York with William Merrit Chase. In the autumn of 1912, she accepted a position as supervisor of the art program for the public schools in Amarillo, Texas. She worked there for two years, returning to work in Virginia during the summers.

In 1915 a friend showed her work to Alfred Stieglitz, owner of the gallery 291. He was impressed by the work and exhibited several of her paintings in an exhibition at his gallery. The following year O'Keeffe returned to Texas and taught for two years in Canyon. She made her first visit to New

Mexico on a brief vacation trip during that period. O'Keeffe married Stieglitz in 1924 and spent her summers painting at the Stieglitz family farm at Lake George, New York. Her work had gained recognition in New York, and by the summer of 1929 when she returned to New Mexico she was an established American painter. The quality of light and forms of the New Mexican landscape appealed to her. She spent every summer working there from 1929 to the year of Stieglitz' death in 1946 when she moved to New Mexico permanently, making the isolated village of Abiquiu her home until her death at the age of ninety-nine.

Philip Pearlstein b. 1924
cat. no. 73
Philip Pearlstein was born in Pittsburgh, Pennsylvania, receiving his B.F.A. from Carnegie Institute of Technology in 1949. Following graduation he moved to New York and worked as a graphic designer for Ladislav Sutnar. At Sutnar's suggestion, Pearlstein returned to school and received a master's degree in art history from the Institute of Fine Arts, New York University, in 1955. He painted steadily through this period, and in 1958 received a Fulbright Grant enabling him to spend a year in Italy. It was there that he first produced work in his mature style, a series of ink and wash drawings of Roman ruins and the cliffs at Positano. In the early sixties, Pearlstein began teaching, first at Pratt Institute, later at Yale University and Brooklyn College, City University of New York.

During a 1952 driving trip through the western states, including visits to the Grand Canyon and Petrified Forest, Pearlstein began to turn his attention to studies of rock formations. A 1973 commission by the Department of the Interior took him to Arizona to paint *White House Ruin-Morning-Canyon de Chelly*. The ancient Indian site renewed his interest in landscape and ancient ruins. He described the subject of ruins as having emotional impact : 'You can't help but be aware of the metaphorical overtones. A world has died and you are seeing the remains.'

Jackson Pollock 1912–1956
cat. nos. 58 & 65
Jackson Pollock was born in Cody, Wyoming, and spent his childhood there, in Arizona, and in California. Pollock was fascinated by the Indian culture and artifacts of the region. During 1928–29, he worked with his father and brother on a geographical survey of areas in Arizona and California, including the Grand Canyon. Later that year Pollock moved to New York and began to study at the Art Student's League with Thomas Hart Benton. He made several trips west during the two years he studied with Benton. Although his style eventually diverged from that of his teacher, Pollock remained a friend of Benton and considered him an important catalyst in his development.

One aspect of Indian culture that continued to fascinate Pollock was Navajo sand paintings. The ritualistic gestures involved in sand painting are echoed by Pollock's revolutionary painting technique. In 1942 Robert Motherwell introduced Pollock to Peggy Guggenheim, the owner of the influential This Century Gallery. She commissioned a large painting and subsequently held an exhibition of his work. This exhibition drew wide acclaim and the attention of art critics such as Clement Greenberg. By 1949 Pollock was established as one of America's leading painters of the twentieth century.

Robert Rauschenberg b. 1925
cat. no. 74
Robert Rauschenberg grew up in Port Arthur, Texas. After studying briefly at the University of Texas in 1942, he was drafted into the U.S. Navy. Discharged in 1947, Rauschenberg studied at the Kansas City Art Institute, and traveled to Paris the next year to study at the Académie Julian. He returned to the United States to study with Joseph Albers at the Black Mountain College in 1949. The following year Rauschenberg moved to New York to expose himself to the contemporary art scene there. He studied at the Art Student's League until 1952, while continuing to visit Black Mountain College. Rauschenberg began creating his 'combine' paintings in 1955. These giant compositions of unlikely yet evocative objects artfully 'combined,'

constitute Rauschenberg's unique artistic statement. *Whistle Stop*, a work commissioned by the Fort Worth Art Museum in 1976, is part of a combine subgroup called 'Spreads.' The title refers to Port Arthur, Texas, and the red semaphore light hanging on the work's right side suggests the train that ran through the small East Texas town of his boyhood. The many silkscreened images depicting wildlife native to the region combined with real screen doors rehung with translucent white silk present a total 'spread' of contrasting images, like the variety of articles on the front page of a newspaper. Rauschenberg said, 'Painting relates to both art and life. I try to act in the gap between the two.'

Frederic Remington 1861–1909
cat. nos. 35–40
Frederic Remington was born in Canton, New York, and studied art at Yale University. In 1879 Remington's studies were cut short by his father's critical illness. Remington made his first trip west soon after his father's death in 1880. Upon his return to New York, he sold one of his sketches to *Harper's Weekly*. Although he briefly returned to his studies at the Art Student's League with J. Alden Weir, Remington's successful career as an illustrator had already begun.

He made many trips west over the next several years and sold all the work he could produce to a wide variety of magazines. Remington considered himself to be more than just an illustrator and regularly submitted work to the National Academy of Design and American Watercolor Society exhibitions. As his career progressed, the distinction between fine art and illustration became increasingly important to him. Although he supported himself as an illustrator until late in life, he gained recognition as an original artist. He began to produce sculpture in 1895 and felt that he achieved his aspirations for artistic legitimacy through his bronzes.

Edward Ruscha b. 1937
cat. no. 75
Edward Ruscha was born in Nebraska, and at the age of five, moved with his family to

Oklahoma City. The flat horizontality of the terrain surrounding Oklahoma City made a lasting impression on Ruscha. After high school, he moved to Los Angeles in 1956 with the intention of studying commercial art. He gravitated toward painting while studying at the Chouinard Art Institute. In 1960 Ruscha left Chouinard to begin a full time job at an advertising agency. He disliked the work and left for Europe within a year.

Ruscha completed some of his earliest lithographs in 1962 and published his first book, *Twenty-six Gasoline Stations*, in January of 1963. He moved to his present studio in Hollywood in 1965 and continued to work steadily. He received a grant from the National Council of the Arts in 1967, a fellowship to Tamarind Lithography Workshop in 1969, and a Guggenheim Foundation Fellowship for a film in 1971. His works comment on the slick, sophisticated culture of the modern West using humor through the manipulation of language in print.

John Sloan 1871–1951
cat. nos. 49 & 50

John Sloan was born in Pennsylvania. He began his artistic career by teaching himself to sketch while working in a book and print shop, and subsequently worked in the art department of a Philadelphia newspaper. In 1892 he attended the Pennsylvania Academy of Fine Arts. He met Robert Henri in December of that year, and although Sloan never studied with him, Henri's artistic philosophy had great impact on Sloan's work. Sloan participated with Henri in the formation of The Eight, an informal group of progressive painters united by friendship and by their opposition to the artistic domination of the National Academy of Design. Sloan later participated in the Association of American Painters and Sculptors, which organized the Armory Show in 1913. He contributed work to the exhibition and his exposure to European modernist art encouraged him to re-examine his work. In 1919 Sloan made his first trip to Santa Fe at the encouragement of Robert Henri. Thereafter, he spent every summer, with the exception of two, painting in New Mexico until his death there in 1951.

Clyfford Still 1904–1980
cat. nos. 66 & 67

Clyfford Still was born in North Dakota, and shortly after his birth, his family moved to Spokane, Washington. In 1905 his family began to homestead in Alberta, Canada, while retaining their house in Spokane. Consequently, Still's childhood was divided between the two locations. He studied at Spokane University, and after graduation, he taught at Washington State College from 1933 to 1941. Still had his first retrospective exhibition in March 1943, at the San Francisco Museum of Art. He taught at the California School of Fine Arts from 1946 until 1950 when he moved to New York. Between 1950 and 1961 he made many trips to the West Coast for extended periods of time.

Still refused to exhibit his painting publicly from 1952 to 1959. He felt that he needed privacy to work. He disliked art critics and shunned the art market. During his lifetime Still sold or gave away 150 of his paintings. He sold paintings only to persons who, he believed, understood their significance. At the time of his death, his estate contained 2,200 works, including 750 oil paintings. He bequeathed his estate to any American city that would agree to build permanent quarters and not give, sell, or exchange any of his work. As long as this condition remains unfulfilled, Still's complete and unique artistic statement cannot be fully recognized.

James Surls b. 1943
cat. no. 79

James Surls was born in Terrell, Texas. He began his studies at Henderson County Junior College and continued at Sam Houston State University. He attended Cranbrook Academy of Art in Michigan from 1967 to 1969. After receiving an M.F.A., he moved to Buffalo, New York, for a brief period to work on the foundry at the Ashford Hollow Foundation. He returned to Texas in 1970 to teach at Texas Southern Methodist University. From 1970–75 Surls spent summers teaching in Taos, New Mexico. In 1976 he purchased land in Splendora, Texas, a wooded area near Houston where he continues to live and work.

From 1976 to 1982 he taught at the University of Houston, establishing the Lawndale Annex for avant-garde art, music,

dance, and theater. Surls was included in the exhibition, *Nine Artists: Theodoran Awards*, at the Guggenheim Museum in 1977, and a major retrospective of his work was organized by the Dallas Museum of Art in 1985. His powerful, evocative sculptures are deeply personal statements that set him apart from other sculptors of his generation.

Jules Tavernier 1844–1889
cat. no. 22

Jules Tavernier was born in Paris and immigrated to New York in 1871. While working as an illustrator in New York in 1873, Tavernier was commissioned by *Harper's Weekly* to make a pictorial record of a trip across America. He was impressed by California and remained there, becoming a member of San Francisco's active art colony. Soon after his arrival, he was invited to become a member of the Bohemian Club. He eventually became one of California's best known artists. Tavernier had studios in Monterey and San Francisco. He painted in California until 1884, when he moved to Hawaii to avoid financial problems. He remained there until his death five years later.

Wayne Thiebaud b. 1920
cat. no. 70

Wayne Thiebaud is a member of the faculty of the University of California at Davis where he has taught since 1960. He was born in Mesa, Arizona, and grew up in California. He worked as a set designer, an illustrator, and a cartoonist for Disney Studios before turning full time to painting and teaching.

During the 1960s, Thiebaud gained recognition for his still-life paintings of American foods and mass-produced objects of popular culture. The Pop subject matter of his work in the sixties has now been replaced by a wide range of subjects, including figures, landscapes, and cityscapes. He lives in Sacramento and in San Francisco where he bought a house in 1974. His bright, orderly pictures have been compared to the still lifes of Chardin. Like the work of his contemporary Richard Diebenkorn, Thiebaud's art is concerned with issues of light and color. A major retrospective of his work was organized by the San Francisco Museum of Modern Art in 1985.

John Henry Twachtman 1853–1902
cat. nos. 33 & 34

John Twachtman is one of America's best known impressionists. He was influential in the formation of the 'Ten American Painters,' whose members constituted the American impressionist movement. Twachtman was born in Cincinnati and studied at the McMicken School of Design. During this period Twachtman met Frank Duveneck who profoundly influenced him. In 1875 Twachtman went with Duveneck to Munich. He studied there for two years with Ludwig Loefftz at the Royal Academy of Fine Arts. On the death of his father in 1878, Twachtman returned home and began teaching.

After marriage and the birth of his first child, Twachtman studied in Paris at the Académie Julian for two years. By 1888 when he won the prestigious Webb Prize at the Tenth Annual Exhibition of the Society of American Artists, Twachtman's career was well established. The following year he began teaching at the Art Student's League in New York. Twachtman was commissioned by Major W.A. Wadsworth to paint a series of paintings of Yellowstone in 1895. The works from this commission are now dispersed among public and private collections.

Peter Voulkos b. 1924
cat. no. 68

Peter Voulkos was born in Bozeman, Montana. He began his working career as a painter, and turned seriously to ceramics in the late forties and early fifties. He attended Montana State College, receiving an M.F.A. degree in 1952 from California College of Arts and Crafts. His earliest ceramic pieces are within the classical tradition of craftsmanship. He visited New York in 1953 and spent the summer teaching at Black Mountain College. It was at Black Mountain that Voulkos first met the abstract expressionist painters whose artistic attitudes he would integrate into his ceramic work. During this period, he also met the Japanese master potter Hamada and became fascinated by the Zen concept of the embraced accident applied to the construction of pottery. The improvisational method and large scale of Voulkos' work developed into a highly personal sculptural style. Confronting many of the central issues of contemporary art, he elevated fired clay from a craft to a major sculptural medium. Voulkos made a unique contribution to abstract expressionism. He began working in bronze in 1961, and continued to explore scale and spacial relationships in these works. Since 1968 he has been working in clay again, although he continues to use bronze for many of his commissioned works.

Thomas Worthington Whittredge 1820–1910
cat. no. 23

At the age of seventeen, T. Worthington Whittredge began his art studies in Cincinnati, Ohio. He worked there for several years before traveling to Europe to further his education. During his ten years in Europe, Whittredge traveled through Italy and visited Düsseldorf, where he became friends with Emanuel Leutze and Albert Bierstadt.

His first expedition west was with General John Pope's 1866 tour from Fort Leavenworth through Colorado and New Mexico, returning via the Santa Fe Trail. This trip was followed by another brief tour in 1870. Whittredge was impressed by the scale and primitive character of the landscape in the West. When he returned to New York, he used the field sketches made on his two expeditions to create large scale paintings of the West, which retained a pastoral quality evoking his awareness of European landscape tradition.

Photographic Credits

Acknowledgement is made to the following photographers, lenders, and institutions, for the supply and use of transparencies and photographs in this catalogue.

Amon Carter Museum (cat. nos. 39, 55, 37, 35); Australian National Gallery (cat. nos. 72, 65); Sarah Campbell Blaffer Foundation (cat. no. 67); Doris Bry (cat. no. 62); Buffalo Bill Historical Society (cat. no. 41); California Historical Society (cat. no. 21); Geofrey Clements Inc. (cat. no. 49); The Cleveland Museum of Art (cat. no. 28); Cooper-Hewitt Museum, the Smithsonian Institution's National Museum of Design (cat. nos. 26, 27); Crossley Pogne Lemine (cat. no. 71); The Denver Art Museum (cat. nos. 18, 38, 57); The Enron Art Foundation/Joslyn Art Museum (cat. nos. 5–14); Thomas Feist (cat. no. 69); The Fine Arts Museums of San Francisco (cat. no. 29); The Fort Worth Art Museum (cat. nos. 61, 74); Roger H. Fry (cat. no. 23); Gamma One Conversions, Inc. (cat. no. 73); Rick Gardner (cat. no 75); The Thomas Gilcrease Institute of American History and Art (cat. nos. 15, 16, 17, 22, 25, 30, 31, 36, 40, 20); Juan Hamilton (cat. nos. 59, 60, 63); Susan Hanlon (cat. no. 58); The Harmsen Foundation (cat. no. 48); Harvard University Art Museums, Fogg Art Museum (cat. no. 19); Kennedy Galleries (cat. nos. 54, 56); Lane Publishing Co. (cat. no. 24); Maier Museum of Art/Randolph-Macon Woman's College) (cat. no. 53); Modernage (cat. no. 80); The Museum of Fine Arts, Houston (cat. no. 77); Museum of Fine Arts, Museum of New Mexico (cat. no. 50); National Gallery of Art (cat. no. 4); National Museum of American Art, Smithsonian Institution (cat. nos. 1, 2, 3); New Orleans Museum of Art (cat. no. 62); The Oakland Museum (cat. nos. 42, 43, 44, 45, 61, 32); Edward Owen (cat. no. 73); The Pace Gallery (cat. no. 78); The Phillips Collection, Washington (cat. no. 34); Roswell Museum and Art Center (cat. no. 51); San Francisco Museum of Modern Art (cat. no. 66); Santa Barbara Museum of Art (cat. no. 68); Wayne Thiebaud (cat. no. 70); Vassar College Art Gallery (cat. no. 46); Whitney Museum of American Art (cat. nos. 52, 63, 47).

Essay illustrations:
Amon Carter Museum, pp. 16, 19; The Enron Art Foundation/Joslyn Art Museum, p. 17; Walters Art Gallery, p. 18; Yale University Art Gallery, p. 22; The Saint Louis Art Museum, p. 23; The Metropolitan Museum of Art, pp. 26, 32, 33; United States Department of the Interior, p. 29; Vassar College Art Gallery, p. 31; San Francisco Museum of Modern Art, p. 34.